HEROES
ASCENDANT

CORINNE DUYVIS ▪ LYNDSAY ELY ▪ JUSTIN GROOT ▪ GAVIN JURGENS-FYHRIE
SANGU MANDANNA ▪ MOHALE MASHIGO ▪ MIRANDA MOYER ▪ E. C. MYERS
TOBI OGUNDIRAN ▪ ANDREW ROBINSON ▪ MELISSA SCOTT

© 2024 Blizzard Entertainment, Inc.
Blizzard and the Blizzard Entertainment logo are trademarks or registered trademarks of Blizzard Entertainment, Inc. in the U.S. or other countries.

Published by Blizzard Entertainment.

This book is a work of fiction. Names, characters, places, and incidents are either products of the author's imagination or are used fictitiously, and any resemblance to actual persons, living or dead, business establishments, events, or locales is entirely coincidental.

Blizzard Entertainment does not have any control over and does not assume any responsibility for author or third-party websites or their content.

Library of Congress Cataloging-in-Publication Data available.

ISBN: 978-1-956916-30-0

Manufactured in China

Print run 10 9 8 7 6 5 4 3 2 1

CONTENTS

REBUILDING RUINS · 09
Corinne Duyvis and Sangu Mandanna

UNITY · 53
Tobi Ogundiran

LUCK OF THE DRAW · 85
Lyndsay Ely

A FRIENDLY RIVALRY · 125
Justin Groot, Gavin Jurgens-Fyhrie,
and Miranda Moyer

THOUGHTLESS GODS · 145
Andrew Robinson

WHERE HONOR LIVES · 183
E. C. Myers

LOST GHOSTS · 215
Mohale Mashigo

LUCKY MAN · 243
Melissa Scott

REBUILDING RUINS

Eleven years since Satya Vaswani had last seen Niran PruksaManee.

Eleven years since he vanished from her life.

And now here she was, practically at his front door, ordered to swallow her hurts and ask for a favor. A whirlwind coaching session from Sanjay, some hastily scribbled scripts from the Vishkar Corporation legal team, a false smile on her face, and off she went.

Satya always saw her missions through. That didn't mean she enjoyed the prospect of this one.

"Thank you." She nodded a goodbye at the pilot as she exited the helijet, stepping onto one of the Atlantic Arcology's landing platforms. She'd admired the complex from above as they neared, but out here—fresh salt scent, a firm sea breeze tugging at her hair—the experience was grander than she'd imagined.

CORINNE DUYVIS · SANGU MANDANNA

Her work took her to many fascinating locations, but she'd waited years to see the Atlantic Arcology up close. A wide bridge connected the landing platform to the central spire—a miracle molded from durovidro, the ultrahard sea glass sparkling in the sun. Automatically, she found herself approaching it, her neck craning as she took in the place where Niran now lived and worked.

Not only Niran, of course. Many of the world's preeminent scholars and artists had taken up residence in the Arcology, happy to lend their talents to the Collective. The idea of banding together with like minds held great allure. A shared goal: to better humanity. No ties to any governments or multinationals. Satya saw the appeal. She also saw the many potential pitfalls. Working for Vishkar had taught her that if something appeared too good to be true, it often was.

The spire itself, at least, lived up to the images she'd seen. It even surpassed them. The elegant curves, the fluid movements of the elevators shifting along the outside edges, the durovidro casting prisms of color in the noonday light . . .

The structure struck a delicate balance. It was a brilliant feat of engineering, every curve and support beam a glowing testament to the precision and innovation of the Collective's architects; yet, at the same time, the spire appeared as much a natural part of the sea as the schools of fish that darted around it, as though shaped over time by the water itself rather than placed by human hands.

REBUILDING RUINS

The spire shot high into the sky, clouds obscuring its tip, and its base delved deep into the ocean. The water was unusually clear and blue, more reminiscent of the water around the Maldives. Colorful corals and wafting seaweed farms clung to the sides of both the structure and the artificial islands dotting the area. There was no fencing around the platforms—nothing around any of the spire segments or islands to obscure the expansive, beautiful sight of the ocean around them—but her trained eye spotted the slight distortion of passive energy barriers curving the edges, protecting anyone from falling into the water below.

Behind her, the helijet whirred to life, cutting short Satya's mesmerized study of the Arcology. For several moments, she stood frozen, her fists balled by her sides as she waited for the worst of it to pass. The noise, the wind, the locks of hair tugging free from the tight bun she wore it in and now whipping violently around her face—the sensations screeched across her skull.

After the helijet passed, Satya took a few moments to regain her composure, then pulled the remains of her bun loose and raked her fingers through. She'd have preferred to wear her hair up, as she usually did during business meetings, but she'd have to settle for wearing it loose and at least coaxing it into a presentable state. She wouldn't even like to face the mirror with untidy hair, let alone a business contact, let alone Niran PruksaManee—her former roommate at Vishkar's Architech Academy and once her closest friend.

CORINNE DUYVIS · SANGU MANDANNA

Niran, who, Satya realized, was late. He should have been here to welcome her.

Interesting.

It could be perceived as a slight, but if she knew Niran at all, he might simply have gotten caught up with his work. In their younger years, she'd heard others describe him as distracted and prone to daydreaming, but Satya knew the truth. Whatever occupied his mind at the moment, he had the tendency to give it his full attention. She'd always found it an admirable trait, whether they were deep in conversation or up late studying.

Or working on the technology that Sanjay insisted belongs to Vishkar. The technology that brought her here today.

Ah, there he was.

Satya abruptly dropped her hands to her sides.

Niran strode down the walkway to the helijet platform, all poise, from his movements to the gentle waves of his white hair. The sun cast a warm glow over his tan skin. His outfit struck her: an unusual mix of white, pink, and pale green, with golden flourishes like the sash tied intricately around his waist.

It was nothing like the uniforms they'd worn back at the Academy, but it was so elegant and playful—so uniquely *Niran*—that it was as though she'd never seen him wear anything else.

Her own crisp Vishkar uniform felt ill-fitting in comparison.

"Satya!" Niran said, his voice different than she remembered.

REBUILDING RUINS

"It has been far too long, my friend. What a surprise to see you here."

"Did Vishkar not announce I was coming?"

"They announced *someone* was coming. They neglected to mention it was you."

"An oversight, I'm sure."

"I'm sure."

For a long moment, they watched each other, as if taking in every detail of what had changed and remained the same over the last eleven years. Niran was no longer the lanky teenager she'd seen last. His shoulders had broadened, and his hair had grown nearly as long as her own. It suited him: that combination of strength and warmth, not to mention the confidence with which he held himself.

He looked good. Satya almost wished he didn't. It would have made her mission easier to see him unhappy, regretting his choices rather than thriving in them.

Niran's gaze lingered on her hair, perhaps noticing a strand still out of place. It stung her. Back at the Academy, she'd always been the one to point out when *his* hair was out of place, and he'd have tucked it back with a long-suffering sigh and crooked smile. What did he think of seeing her like this now? What did he think of *her*, after so long?

Satya discarded the thought as quickly as it came to her. Irrelevant.

"Interesting choice of vehicle," Niran finally said, nodding at the empty helipad behind her. "We have a highly efficient transportation hub, as I'm sure you're aware."

"Vishkar's matter was urgent," she said simply, although that was only part of the truth. The other part was that Vishkar had wanted her to make an entrance. For an important discussion such as this, they would not send a delegate in a *train*, to arrive with the rest of the masses.

"A helijet seems rather wasteful."

"Do you plan to chastise me for much longer, Niran?"

That seemed to give him pause. Perhaps it was the sound of his name: *Niran*. In the past, she'd always called him by his nickname: *Bua*.

Or perhaps she'd simply been too familiar to tease him, letting her feelings get in the way of a proper negotiation. Sloppy.

Satya forced a polite smile. "I'd simply like to get to the purpose of my visit. As I stated, my business is urgent."

"After said visit," Niran said, "are you meant to summon the helijet again for your return trip?"

"Yes." Under normal circumstances, it would've remained here until she finished. After yesterday's Null Sector attack in Paris, however, the world was on alert. Vishkar needed every vehicle on hand, and for all they knew, these negotiations could take the better part of the day.

REBUILDING RUINS

"In that case, you can call Vishkar right now. I'm afraid your visit is over."

So, Niran was going to toy with her. Wonderful.

"Unless?" Satya said, refusing to be intimidated.

His lips curled into a slight smile. "Unless you agree to take a train back to the mainland, afterward."

Vishkar wouldn't like it. Neither would Satya, in truth. Trains were crowded and busy and draining. A helijet, for all its noise, at least allowed her some personal space.

Still. The mission was more important. If this was required for the negotiations to take place, so be it.

"I'd be glad to see for myself just how efficient these trains of yours are," she said.

Niran raised an eyebrow. "I hadn't even finished my pitch. I was about to praise the comfort, sound isolation, and privacy of the personal cabin we'd offer you."

Oh.

Niran knew her too well.

"Generous," Satya said, recovering quickly. "And also, appreciated."

"Naturally." He gestured for her to precede him. "After you, Satya."

Satya strode ahead along the walkway, entering the main spire into an enormous plaza. It was *busy*—too busy for her, but also filled with fascinating people and structures and

devices. Her eagerness won out over her discomfort.

"Tell me," she said, without thinking, "is it true that all the technology and labor that built this was offered freely? You had no outside funding at all?"

"Indeed." Niran guided her to take an escalator up, leading to a mezzanine. "That is one of our fundamental tenets, Satya. Every member of the Collective contributes in whatever way they can. Everyone shares in the fruits of those labors."

Satya found this mind-boggling, frankly. "Then everything must be taken on trust. That sounds difficult."

Another pause. Satya was so focused on the pod of whales swimming contentedly below the great glass structure that it took her a while to notice Niran was watching her with an odd expression. His silence dragged on too long for comfort.

Finally, he said, "I know trust doesn't come easily to you."

For good reason. Trust tended to go poorly.

You left me, she wanted to say. *And I wish I was here to repair our friendship.*

She still didn't understand why that friendship had worked as well as it did. Satya, the daughter from the slums of Hyderabad; Niran, the son of a wealthy Chiang Mai family. Satya, structured and focused and precise; Niran, sociable and rebellious and quick-witted.

At the same time, they'd both been outsiders, both been brilliant, both taken Vishkar's teachings and applied them in

REBUILDING RUINS

their own ways. Their friendship *had* worked: all those shared, quickly stifled smiles across the Academy classrooms; striding through the halls side by side, him talking animatedly about his latest trip abroad with his family while she listened in silent fascination. How often had she interrupted him because he'd gotten so caught up in his personal projects that he'd forgotten they still had class that day? How often had he kept her company as she practiced her dancing, repeating the same movement for hours on end until she was finally satisfied she'd perfected it?

It felt like a lifetime ago. They had changed, both of them.

But that had nothing to do with her mission today. She kept her tone neutral: "I would like to discuss the Null Sector attack that occurred in Paris yesterday. The city needs help to heal its people and rebuild." She offered a polite, inviting smile, the kind she so often struggled with, working for Vishkar. "We think the biolight technology you started at Vishkar years ago could be of great use to them."

Niran's gaze didn't waver. "In your experience, is Vishkar among those I should trust, Satya?"

She'd left that particular sore spot wide open for him. At least she managed to maintain her forced smile.

Her pride and trust in Vishkar had taken a hit recently. She'd spent a long time as Vishkar's trusted closer—the talented architech the company turned to for high-profile projects. But

over the last few years it seemed all Satya did was clean up corporate's messes. It had pulled back the curtain on the unsavory side of their business: from gentrification and slumification to large-scale environmental destruction—floods, famines, ashy and desolate landscapes where there had once been rich rainforest and wildlife. While Niran had cut ties with them long ago over rumors of this kind of damage, she'd stayed and trusted that the ends must justify the means.

She wasn't so sure anymore.

And the last thing she wanted was for Niran, of all people, to pick up on that.

"Let us stay on topic, please," she said calmly. It had taken her too long to reply. Niran must know he'd rattled her. She tugged at the hem of her uniform, which felt uncomfortably tight.

To her surprise, he laughed. "Satya! All work, as usual. What kind of host would I be if I didn't give you a proper tour before we get down to business? Come."

Niran escorted her to a balcony, which detached smoothly from the wall and began to ascend slowly up the spire. The open interior bustled with activity, as though an entire city were contained within. Niran showed her one of the many overlooks for marine study, a gallery and art institute where residents' work was displayed and sold, and restaurants that served food from all over the world. He highlighted the hydroponic gardens that

REBUILDING RUINS

grew residents' produce and told her about his own garden in which he cultivated and crossbred several rare species. The spire, he explained, made the most of the talents and contributions of all its inhabitants. Working together, they had equipped it with cutting-edge technology that automated essential services and harnessed clean, renewable energy to power those services.

Satya folded her arms behind her back as she walked, wrapping her fingers together to keep her hands still. She'd endured many drawn-out tours, arrogant managers showing her around terminally dull buildings; this tour, at least, was genuinely fascinating. None of the interest she showed had to be feigned.

Finally, the balcony slowed to a stop near a set of durovidro doors. With a wave of Niran's hand, they slid open to reveal an intriguing space. The glossy main structures were similar to the rest of the Arcology, but the lines here were especially clean and aesthetically pleasing. The furniture, also clean and minimal, was built for both comfort and function. The personal possessions tidily stored away in open, easily accessible shelves suggested it was living quarters.

"What is this?" she asked, wondering why—with all the marvels the Arcology had to offer—Niran had chosen to show her a residential space.

"Too many countries are either silent on or outright hostile to the issue of omnic equality. We're seeing more and more omnic refugees flee to the Arcology."

CORINNE DUYVIS · SANGU MANDANNA

"This is their space, then?"

"Yes. It's one of my contributions to the Arcology—a bit outside my usual work. I aided a group of omnics who developed a plan for a residential section." He pointed to a set of doors at the far end of the large, welcoming space. "We've completed the personal quarters past those doors; roughly three dozen omnics have moved in so far. This area here is a little minimal because we haven't quite finished it yet. It will be split up into several sections, primarily as living and leisure spaces. Like other living spaces in the Arcology, it'll prioritize entertainment, comfort, and personal development, but this particular space will do so in a way that caters to its omnic residents specifically."

Satya nodded. "Understandable."

Her time spent with Zenyatta and the other omnics in Suravasa had taught her a lot—including about omnics and ways their experiences and perceptions might differ from those of humans. Even when buildings included spaces meant for omnics, they might not be tailored to them, or merely hastily retrofitted. A place like this, built from the ground up with omnic needs in mind, was a rarity. Having people consider omnic needs to begin with was unusual at best.

While it was hardly the same as her autism, Satya could relate to that particular element. Now in a high position at Vishkar, she had some amount of control over her living space and

REBUILDING RUINS

personal routine, but it had been different at the Academy.

She remembered vividly how proud the school management had been of the food quality and diversity they offered their students, surprising them with every meal; Satya, for her part, had felt nothing but anxious every time she dragged herself to the dining hall without knowing what to expect. The high-pitched whine from the lights that no one heard but her, the ever-changing and unpredictable curriculum, the way the paintings in the hallways weren't hung *quite* at even distances from each other, the teachers demanding Satya make eye contact while answering questions . . . Even when the Academy had honored her during the graduation ceremony, allowing her to sit on stage while Vishkar's CEO spoke about its founder, Dr. Bhatt, it had all been for *Vishkar's* sake, not hers. They could show off their prize student, plucked from post-Crisis poverty and molded into perfection; for her part, Satya had been unable to hear a single word of the CEO's speech, too wrapped up in following the instructions she'd been given. *Keep your legs demurely crossed. Don't tap your feet. Look into the audience, make sure to smile, pretend you can see them even though the lights will be blinding. Keep your hands in your lap, and keep them* still—*you don't want to look immature, or distracted, or rude, or strange, or . . .*

Afterward, Satya's own speech had been flawless, but it had taken her a week of curling up in bed to recover from the ordeal.

CORINNE DUYVIS · SANGU MANDANNA

She hadn't even had Niran to cover for her, claiming illness and keeping people at a distance as he'd done in the past.

He'd left long before graduation.

She tried to shake the memories. Here and now, she had a mission to focus on.

Niran went on: "Omnic-oriented architecture and design is still in its infancy. Overhauling thousands of years of human-centric knowledge will take some time. But it's an honor to be invited to work on this project. In particular for omnic refugees, who have already been through so much pain, it's essential they have a place to feel . . ."

"Welcome?" Satya prompted.

"Mmm, not quite. *Welcome* implies they're still a guest. This should feel like *home*. Their needs come first here, rather than having them feel obliged to adapt and adjust to an environment where they're merely an afterthought." Niran looked out at the hall. As incomplete and imperfect as the space was in its current state, it didn't seem to bother him. Satya detected something else entirely: pride.

She'd never been particularly good at recognizing emotions, but pride—that one, she knew well by now.

This was a different flavor of pride than the one she saw in Sanjay and the other Vishkar leaders, though. This was not pride in oneself; this was pride in one's work. Pride in what one could contribute.

REBUILDING RUINS

"There are ways to make some of these hard-light structures more efficient," Satya said thoughtfully.

"Perhaps," Niran acknowledged. "Your expertise would be appreciated, if you care to offer it."

Satya's mind was already spinning with possibilities. She had no place offering the Arcology anything, though. She changed the subject. "Shall we move on?"

"By all means."

The balcony floated higher, passing a garden full of merry, industrious children working and giggling under the watchful eye of a teacher. Satya tried to remember the last time she had seen anyone, of any age, having so much fun. It distressed her that she couldn't trace such a memory in recent years. She had to go further back, all the way to her childhood at the Academy. For all its flaws, there had been times there that she'd enjoyed. She'd had fun. Usually with the person standing next to her.

"Everyone looks content," she remarked, eager to get her mind off their shared history. "People are moving with purpose, but they're not in a rush. They stop to converse. They appear relaxed."

"Most people come to the Arcology seeking refuge," Niran reminded her. "There is nothing for us to fear here. No one we need pretend for."

What a luxury that must be.

She didn't reply, too preoccupied with burying her bitterness.

CORINNE DUYVIS · SANGU MANDANNA

Niran stepped closer. "Satya? I can't help but notice that you seem troubled. If there's something bothering you, you know you can talk to me."

Could she, though? That wasn't what she was here for.

Maybe she hadn't done as good a job hiding her thoughts as she'd hoped, or maybe Niran just knew her that well, even after all this time, but he seemed to realize the effect his words had had on her.

"If Vishkar's making you do something you're not comfortable with . . ." He hesitated. "You don't owe them anything. You don't have to stay with them. It doesn't matter how much time has passed. If you need help, I'm here for you."

The words, an echo of the dear, dear friend she'd once had, cracked something inside her.

"Why?"

Niran's brow furrowed in confusion.

"Why did you leave?" Satya asked, the words tumbling out along with years of hurt. "We were friends. We grew up at the Academy together. You were the person I trusted more than anyone. And you knew the company would forbid me from contacting you and that I would have no choice but to stay! Why did you take Vishkar's technology and flee?"

"*My* technology. I created it."

"Using the education and resources *they provided you*, with the understanding that they would have exclusive rights to

REBUILDING RUINS

it," she pointed out. It was one of Vishkar's lines, one she'd memorized before leaving for the Arcology.

"Vishkar taught me much that I'm grateful for, but I moved on. They don't own me, nor my mind, nor my technology."

"You plan to profit off it yourself."

For the first time of the meeting, Niran looked genuinely surprised. *"Profit?* Is that what they told you?" He swept an arm wide, gesturing at the Arcology around them. "You know how the Collective works, Satya. Surely you can see that nothing I did here has been for *profit*. Can Vishkar say the same?"

Satya had known she was wrong as soon as she said the words. In truth, she'd never fully believed what Sanjay told her about Niran's departure. It would've been easier if she had.

None of that impacted the reason she was here. "Vishkar is helping people. They could've helped *more* people if you'd stayed. The resources they could provide—"

"I do not deny they've done good work, but you must know that they also cause catastrophic damage in their quest for profit and influence."

"I came here to ask for your help. Not to listen to you criticize me."

"Not *you*, Satya. *Them.*"

"I'm *part* of them!"

Niran folded his arms, giving her a look that was both firm and kind. "I've known you for too long to believe that."

Satya stepped back, furious with herself for becoming so emotional. Until just now, she'd been doing well—she'd kept her true thoughts to herself, she'd fixated on her mission, she'd done exactly as Sanjay had instructed.

Maintaining the image of Vishkar's perfect employee always took its toll on her, but today, with Niran right in front of her, it was harder than ever.

She didn't want to convince him, to defend herself, to argue, to pretend.

She just wanted to go back to the way they used to be.

"It's been a long time, Niran," Satya said, but her words sounded flat, exhausted. "People change."

"They do, but I don't believe you're really on Vishkar's side in all this."

On *their* side. Part of *them*. *Was* she? She kept telling Niran as much, but Satya no longer felt the same conviction she once did.

One day, she would have to make a decision. She would need to weigh the bad she'd seen Vishkar do against the good it accomplished. She believed in the greater good, and yes, there had to be a line *somewhere*, but . . .

Satya wasn't ready to draw that line yet.

Niran, though, seemed to have drawn it a long time ago. She could not read his expression, nor did she need to. "You don't intend to return to Vishkar, do you?"

REBUILDING RUINS

"No," Niran said simply.

She smiled wryly. "We spent all this time on pleasantries and diversion, when you were never planning to entertain my plea." She was so tired all of a sudden. She didn't want to keep going. She had to, though. This mission was about more than her versus Niran, about more than Vishkar versus the Collective. "I'm here because there are people, vulnerable humans and omnics alike, who could benefit greatly from your work."

"I understand that," Niran said. "Believe me, I do. But if I gave my technology to Vishkar now, would it still be accessible to those who need it? Or would it stay locked away behind proprietary laws and licensing fees? Vishkar's communities cater to the wealthy and leave the rest behind, Satya. You know that. It stands to reason they'd use my technology the same way." He shook his head, firm in his opinion. "I am doing what I can to help those who need it, in Paris and elsewhere, but I will help in my own way. Not theirs."

"Then why not tell me that as soon as I arrived?"

"I would have, had Vishkar sent anyone but you." Niran did not look apologetic. "I intended to dismiss their emissary immediately. But when I saw you . . . It's been *years*, Satya, years without a word from you—my dearest friend. How could I simply send you away? I wanted to show you the place I have made my home."

"You wasted my time."

"Only if you feel that your time has been wasted." He cocked his head, still a bit of the boy he once was. "Has it?"

Satya could not bring herself to say it had. It would have been a lie.

The floating balcony came to a silent halt. They'd entered a sleek, busy transportation hub.

"You're seeing me to my train," she said.

"I am. I don't want to waste more of your time." There was hurt in his voice, she thought, but she saw no trace of it on his face.

What Satya might have said next, she would never know. They were interrupted by an unexpected sound.

A scream.

She whirled to see where the voice came from. Across the station, passengers spilled en masse from a train that'd just arrived from London—some falling, others stumbling onto the platform.

"What . . . ?" Niran's eyes went wide.

The passengers' screams blended into one another as they fled from the train. Panic and chaos washed over the hub.

"What's happening?" Satya didn't wait for an answer, already running for the train. Whatever was going on, one thing was clear: people needed help.

She would do what she could to offer it.

Extending her gauntlet, she threw up a hard-light shield over those who'd fallen from the train, guarding them from the hail

REBUILDING RUINS

of energy projectiles behind them. Several of the passengers looked badly hurt.

"Get them out of here," she yelled at Niran, but her voice was lost in the noise. She chanced a look over her shoulder, but she didn't see him.

He ran to get help, perhaps. Didn't matter. She needed to focus.

As she reached the train, a new shape stood in the nearest doorway. Gleaming metal, angular edges. An omnic passenger, Satya thought first, but no. Too calm. Nothing behind its eyes. No soul. And the arms . . . rather than tapering into hands, they widened into sleek energy weapons, the likes of which she recognized from recent news reports.

This wasn't a passenger. This was what the passengers were running *from*.

"Null Sector," she whispered. There was no mistaking it. Yesterday's attack in Paris had been a preamble to further chaos, just as Sanjay had said it might be.

The sharp wail of an alarm blared through the screams.

The Arcology is under attack. The voice came from speakers mounted throughout the station. *All residents and visitors, please follow emergency action plan A and seek shelter in your designated living quarters. Security, report to the transportation hub.*

The Null Sector unit emerged from the train. Two nearby passengers were instantly knocked back.

More units exited from further down the train, cutting through anyone in their path. Satya moved to throw up more shields, barely protecting an older couple and giving an injured omnic the chance to limp out of the way. The crowd had opened up around the train doors, desperate to escape the emerging forces and leaving behind only those injured—and those aiding them.

Like Niran.

A glimpse of white hair and the glow of his biolight told her what she needed to know. Niran hadn't gone to get help. He *was* helping.

The realization caught her by surprise, although it shouldn't have. This wasn't one of her Vishkar colleagues; this was *Niran*. He must've gone to tend to the wounded long before she'd shouted for him to do so.

A massive leaf unfurled by two children hunching over an unconscious adult, their faces red and tear-streaked. No, not a leaf: a petal. A lotus petal, one of several. The biolight flower gave off a soft pink glow as it scooped up the family and whisked them to safety.

For a moment, the sight of Niran's abilities mesmerized her. She'd seen his biolight in action before, but they'd been children then. It had only been the seed of what it could become: His shapes still unformed, his light dimmer and prone to an unsteady flickering. A hint of a leaf shape. A glimmer of a

REBUILDING RUINS

branch.

This was nothing like that. He was an adult now, and this was Niran at his most powerful.

The sight was glorious.

Satya's attention snapped back to the robots. If Niran was protecting the injured, she could go on the offense.

Satya was a creature of dance, not war. Fighting was not in her nature. But that didn't mean she couldn't do it. She'd spent her youth powerless and afraid. As an adult, Vishkar's combat training had offered a solution. With the limitless potential of hard-light at her disposal, learning to fight had been an easy task compared to her studies as an architech.

Destruction was always easier than creation.

Icily, she turned to the massive robot in front of her, using her gauntlet to materialize a photon projector. "You are not welcome here."

The enemy unit paid her no mind. It stalked past her. In the gleaming metal of its skull, she saw the reflection of a frightened omnic behind her, cowering against a pillar.

Her photon projector took care of the Null Sector unit, burning a clean hole in its torso.

"Run," she told the omnic behind her. They scrambled out of the way.

The unit had been easier to get rid of than she'd expected. She and Niran might stand a chance.

CORINNE DUYVIS · SANGU MANDANNA

The sound of a train screeching on the tracks grabbed her attention. She whirled toward the noise. The train rolled into the station—dented, windows shattered. All across its hull, enemy units clung to the metal like swarming insects, some working their way into the passenger cars, others leaping away from the train and toward the panicking crowd in the station.

The next several minutes were a whirlwind of photon blasts and lasers and the smell of fried electronics, a tumult of screams and blood and fear. Satya locked it all out, focusing only on her next target and the most efficient way to dispose of it.

An otherworldly metallic groan cut through her concentration. She flinched, watching one of the cargo compartments on the newly arrived train bulge—the metal hull distorting and shifting, as though something massive inside was pressing up against the walls and ceiling. In some places, the metal tore from pressure. In other places, it split in straight lines, aided by the weapons of the enemy forces now scattered around the platform.

The roof of the compartment pulled loose and was flung back, crumpling against a wall. Inside the train, the rhino-like unit that'd been straining to get out finally unfolded itself to its full height, easily the size of the helijet she'd flown in on.

It moved one leg. The walls of the train folded like aluminum foil under its weight.

"Satya! Get to cover!" Niran's voice came from farther into

REBUILDING RUINS

the station. He had his hands extended. Biolight vines snaked through the air to aid a group of omnics fleeing the violence.

Satya fixed her eyes back on the mechanical beast, observing the massive unit as it lumbered onto the platform toward Niran and the evacuating crowd. The weapons of the Arcology security forces pinged harmlessly off its outer shell. Its movements, the mechanics pushing it forward . . . in all its size, there had to be a weakness for her to exploit.

Or perhaps she needed something of a similar size. She'd have to move fast, while the space around the giant was still empty. A swift movement of her arm, a step to the side to avoid an incoming attack, a precise twist of her fingers as though she were holding a pen and signing her name . . .

Several feet above the unit, a teleporter spawned and unfolded. As its metal legs dug into the stone of the ceiling, its portal flared wide. The cool blue glow stretched at least a dozen feet across.

Satya flung the other teleporter unit at the train tracks beside her, directly underneath the damaged front carriage of the first train to carry in the fighter bots.

The carriage shifted, groaned. Its front sagged down into the portal. Above the massive enemy unit, the underside of the carriage could be glimpsed through the other portal.

For a moment, it seemed like the carriage might stabilize there, might not go through—

Then, with a metallic shriek, it shuddered back into movement. Right on time. A fraction of a second before the portal snapped shut, the carriage crashed through and landed atop the rhino unit. The noise thundered through the station—rivets snapping off, metal twisting and tearing open like wet cardboard. The unit slammed flat to the ground, splintering the stone platform.

Whether it was enough to take it out fully, she couldn't say, but she wouldn't take any risks. As Satya switched to her photon projector and took aim at the metallic skull—or what remained of it, misshapen and barely distinguishable from the twisted, crumpled train carriage that had landed on top of it—the Arcology's security forces swarmed the unit. They were well trained. Some fired precision shots in between layered armor plates; others planted explosives and promptly took distance.

The giant twitched once, twice, but stayed down.

Satya surveyed the scene. Her breathing still came heavy. Most of the civilians had been evacuated from the station. The security forces were working on taking out the remaining Null Sector robots. Niran sat in a crouch near several of the injured, his hands hovering over their wounds while his eyes were fixed on Satya.

Around them all, bodies lay unmoving. Some human. Many omnic.

Strange. On most of those omnic bodies, the external damage

REBUILDING RUINS

was minimal. Even stranger: a spiked device sat attached to their skulls, covering their faces.

What in the world . . . ?

And that wasn't the only thing Satya noticed. The bodies of the victims outnumbered those of the aggressors.

Satya whirled in place, her eyes flitting from body to body. She counted less than thirty destroyed warbots in total, scattered across the transportation hub. Far fewer than had arrived on the trains.

"Where . . . ?" she murmured.

She knew, though.

The first unit she'd fought had prioritized the omnic behind Satya over Satya herself. Add that to the devices clinging to the heads of the downed omnics, and it was clear that whatever Null Sector wanted, it had to do with them.

And the majority of the omnics in the Arcology weren't here, high in the transportation hub. They would be below, sheltering in their living quarters, as the evacuation broadcast had instructed them to do.

Her first thought was to shout orders at the security forces, but there was still too much chaos, too much noise.

She sought out Niran's eyes across the room, but there was no time. She had to move.

All she could do was trust that he saw her and would understand.

Satya ran back the same route she and Niran had taken earlier, finding shortcuts where she could. In one place, she could avoid the evacuees by leaping down to a ledge and sprinting across; in another, she could bypass the entrance hall, creating a simple teleporter to send her instantaneously across the massive space.

Here, too, security forces were fighting Null Sector units, and here, too, bodies were scattered over the ground. Most of them omnic, with the same strange device as before attached to their skulls. Satya hissed through her teeth. As much as she wanted to help, she knew there had to be more enemy units ahead.

The chaos in the station, the massive rhino unit . . . All of it had been a distraction from their real goal. How could she not have seen it earlier?

Satya tapped her gauntlet as she ran, crafting another set of teleporters to bring her from the hall directly to the omnic living quarters that Niran had shown her. Adrenaline fueled her, sending her leaping into the portal without hesitation, but she could feel herself growing tired. Her abilities were an art, not a sprint. Rushing them took a lot out of her.

The world flew past. Just like that, she tumbled out of the other teleporter, landing in a crouch.

At least a dozen warbots were barraging the durovidro doors two meters ahead. Rapid-fire blasts slammed into the glass,

REBUILDING RUINS

which trembled from the impact. The doors themselves would hold; the walls keeping them in place, though, were showing large cracks.

At least Null Sector hadn't made it inside yet, let alone into the personal quarters beyond, where dozens of omnics had to be taking shelter.

If it was up to Satya, this was as far as the enemy went. She extended both hands, tugging at the air with nimble fingers. A barrier flared to life, its blue glow blocking the hail of their fire and protecting the damaged walls.

Satya inhaled deeply, steeling herself for what was to come. The combined force of all the units around her would take out her barrier within seconds if her focus faltered for even a moment.

There was an easier way to deal with the situation, she knew. The robots themselves weren't tough. If she focused on attacking them directly, she might take them out before they reached a single omnic, but that meant dropping her barrier, and that would destroy . . .

No, she couldn't risk that. She only had to hold on a couple more moments.

So she did. She mended cracks in the wall, even as new cracks formed alongside them. She reinforced the most vulnerable sections, filled in each gap, and scanned the barrier for any weakness that needed strengthening.

Some of the units got wise and turned to attack her. She spun a quick shield around herself. Barely in time. It caught the worst of the attacks, but it was too fragile to stop all of it. A blast seared the side of her leg.

She couldn't falter. The wall needed her full attention. Just a few moments more—

"*Satya!*"

There he was.

Niran's voice—no, Bua, *Bua's* voice—was the most welcome sound she'd heard in a long time. A biolight lotus floated down, appearing where the elevator normally would, carrying Bua on its surface.

"You're late," she said, her words strained.

Bua stepped onto the floor, the lotus dissolving behind him. "You know me too well for that to be a surprise."

Despite her focus, despite her pain, she smiled.

After that, the time for talk was over.

Bua moved forward with a whirl—throwing out his gauntleted hand and sending a flurry of biolight spikes through the air. He came to a stop by Satya's side right as the spikes—thorns, almost—slammed into their targets. Metal tore. Sparks flew.

The units' focus shifted from Satya's barrier to Bua and Satya themselves. She didn't dare release the shield, didn't dare lose concentration, but it provided enough relief to allow her to multi-task. Within moments, she'd crafted a teleporter behind two

REBUILDING RUINS

nearby units. Bua understood. He flung a set of thorns at the warbots, pushing them through the portal. Outside, a few dozen meters beyond the spire, the units came tumbling through the other side of the portal, into the sea.

Satya wouldn't be able to repeat that trick. The teleporters she'd used to get here and the massive one she'd built in the transportation hub had taken too much from her gauntlet.

Satya tossed a few sentry turrets onto the ceiling, which instantly damaged a unit that'd been approaching Bua from behind. She evaded an attack to her right and spun to take it out with her photon projector. More of Bua's thorns whizzed through the air behind her, stirring her hair but never once clipping her. Satya whirled through the space, blending dance and fight, elegance and grit, seemingly unfazed by the sight of more drones arriving from below.

Every now and then, a few of the units renewed their assault on Satya's shield, eager to reach the omnics beyond; Satya would pause her attacks, dedicating herself fully to maintaining the wall, while Bua stepped in to guard her back.

Only when the final unit collapsed to the floor—a sparking, metallic mess—did she dare release the shield. It snapped into nothingness, like the quiet *pop* of a soap bubble.

Her legs buckled. She nearly collapsed, but caught herself on the nearest wall and remained upright. She chanced a look up at the main hall, several floors above. A haze hung in the

air from the fight, but she couldn't see any more flashes from weapons firing. It didn't look as though new Null Sector units would be arriving.

"Satya, you're bleeding." Bua approached with a concerned look on his face. "Let me look at that."

"It's nothing," she said, but when she took even a small step forward, her leg suggested otherwise. "Ah. Perhaps it is something. Very well, then. The threat is gone?"

Bua summoned a hard-light earpiece, listening in to the security channels, then nodded. "All scans point that way. Our airspace is clear. The warbots must have come from other cities under attack. Security forces and medics are taking care of the situation and have closed the transportation hub while they assess. Sit, sit." He helped her move away from the scene of the fight, sitting her down instead amidst the partially constructed leisure space she'd been guarding.

"The omnics. Null Sector was planting devices . . ."

Bua's face was grave. "They're neural suppressors of a sort. I fear for those affected . . . but the Arcology has its top researchers looking into it. We'll have to wait to hear more." Gently, he moved away a flap of her uniform to reveal a deep scorch wound on her calf. "You can rest for a minute, Satya. You *should*. This will not be an easy fix. It's a nasty wound."

"Nastier than I expected," she admitted.

He steadied her leg with one hand. His other moved around

REBUILDING RUINS

the air, the movements slow; she was so focused on the gestures of his fingers that she almost missed the thin biolight shape growing from the ground underneath. A sapling, she realized. It sprouted branches as it weaved its way up through the air, a dreamy glow at its core.

"Beautiful."

"Thank you," Bua said.

She hadn't even realized she'd said the word aloud.

"Satya . . .," Bua started, still crafting the tree. "Why?"

"What do you mean?"

"Why didn't you simply attack the bots instead of maintaining that barrier? From what I saw down in the transportation hub, you could've taken them."

"The refugees . . ."

"There were at least two more barriers between the drones and the omnic refugees sheltering in place. Even if the doors fell, you would've had time to take the drones down."

"Perhaps. But if I'd done that, the fight would've spilled into this section." She glanced around. While still under construction, the space was full of promise, and she could see the endless amounts of work and love that had already gone into it. The precision, the care, the *warmth*. A home for those who had already lost a home before, or who'd never had one at all. Bua was right to be proud of his work. "What this place stands for . . . it's too important to be collateral damage."

"You put yourself at risk."

"Only briefly. I knew you'd be coming."

He was silent for a moment. "You put a lot of faith in me, then."

"It worked out, didn't it?"

"Thank you. For your trust, and for what you did here." Bua nodded at the space around them.

She couldn't meet his eyes. She watched him work instead. The tree had grown to the ceiling. The gentle glow suddenly brightened, pulsing once, and then a wave of warmth washed over her skin. She studied her leg in quiet awe. Raw, damaged flesh grew into fresh skin.

Satya had known from the start that Bua's biolight technique might go far, but this . . . The sheer artistry was a magnificent sight, but the practical potential was endless. Even his gauntleted hand, black and gold and so different from Vishkar's equipment, seemed to work like a seamless extension of him, each ripple of its surface a small powerhouse of light.

The fact that Bua had channeled his technology into healing applications said a lot about him. Others might not have been so noble.

What about Vishkar? She was certain that with technology like Bua's, they could do a lot of good.

She was also certain they would not stop there. Not when there was money to be made.

REBUILDING RUINS

"The reason I was late to welcome you after your arrival," Bua said, talking slowly, "is because when I saw Vishkar had sent you, I needed a moment to steel myself."

"You saw me as I got off the helijet?"

"Yes."

"With my hair in *that* state?"

"I've never seen a more charming bird's nest, Satya," he assured her.

"Lovely," she said.

No doubt it was in a similarly disheveled state after the fight. The rest of her certainly was. It felt wrong, but if anyone had to see her like this—it helped, just a bit, for that person to be Bua.

"Your arrival simply caught me by surprise. I'd often hoped to see you visit the Arcology. Just not by means of a Vishkar-branded helijet, wearing that stiff Vishkar uniform."

Satya glanced down at herself. Where the hydraulic fluid from the Null Sector bots had splashed her, the white-purple Vishkar uniform stuck uncomfortably to her skin, but what was worse was the fabric; the seams were always itchy, and now they were joined by the ragged edges of where the uniform had been torn in the battle.

"As much as I dislike this uniform," she said, "it does help, in a way."

"Oh?" By now, the tree had faded. Cautiously, Bua shifted

his hand to hover over the newly healing skin on her calf. She tensed in anticipation of pain as a small lotus flower blossomed onto her skin, but the biolight felt warm and comforting, much like Bua himself.

"I prefer my dresses," she said. "I won't lie. They're custom-made by a tailor from my old neighborhood, before Vishkar. They let me do my best work, whether I'm dancing, creating, fighting. They're *Satya*, in a way that no uniform could ever be."

"But?"

"But sometimes," Satya said, choosing her words carefully, "all that discomfort—the chafing, the itching, the restrictive-ness—helps me remember what I'm doing. It makes it easier to keep my face on. To do my job."

Perhaps she was not phrasing that correctly, but Bua's thoughtful nod showed her he understood.

The uniform was not *Satya*, but neither was her work with Vishkar. It was a means to an end. Scripting, rehearsing. Faking smiles, forcing pleasantries. Vishkar forever pushed the boundaries of her discomfort, whether physical or mental or moral, but in the end . . .

"I can do *good* with this uniform." Satya tugged at a frayed edge of her sleeve. "It is exhausting and difficult and far from perfect, but for now, when I look at the people I've helped, the wonders I've built . . . It's worth it."

REBUILDING RUINS

"A conscious compromise," Bua said.

"Yes."

"I'm glad to hear that. I worried you might be accepting discomfort only for the comfort of others. Working to create change in yourself where none is necessary. Those who stand out are too often pressured to fit in instead."

A smile hovered on her lips. "I am not so easily pressured."

"I'm learning that," he said. "And I'm glad. I'm quite fond of you, precisely as you are."

Could she tell him the truth? Having trusted him in the heat of battle, she knew, logically, that there was no reason not to trust him now. And Satya was nothing if not logical.

"I have had concerns about the way Vishkar goes about achieving their ends," she admitted. "And I know that I have been lied to. *But*," she added, before he could interrupt her, "if I leave, if I try to stop them, what do I become? An enemy in their path. I would waste my energy fighting them, rather than helping others. Vishkar allows me to do things and reach people I never could by myself; those resources are invaluable. From the inside, I can help direct those resources to better ends."

Bua considered that, then nodded. "I hope, for everyone's sake, that Vishkar will accept your guidance."

Satya reached for his hand and squeezed it briefly. "It has been wonderful to see you again, my friend."

"I am glad you count me as your friend still." He paused.

"Also, you may need to arrange that helijet for your way back after all. The transportation hub will be out of commission for a little while."

"Certainly. I am not in a rush for Vishkar to arrive, however. Are you?"

A smile grew on Bua's face. "The Arcology could certainly use another pair of hands right now."

The next hours were hard work, but with her friend by her side, it didn't feel like it. Satya helped manage the crowded med bays while Bua healed the worst of the injuries; after, they went around to repair what they could of the destruction the enemy bots had left in their wake. One of the Collective's security coordinators tagged along, partly to survey the damage, partly to pick their brains on the Arcology's security protocols and what they might know of the devices Null Sector had placed on the omnics.

Finally, the two of them found a secluded spot at one of the restaurants overlooking the Arcology's gardens and waited for Vishkar's helijet there—a few precious, fleeting moments of peace at the end of a long day. They made the most of them: talking about Bua's projects and Satya's time in Suravasa, catching up on the parts of each other's lives that they'd missed, and laughing nostalgically about their shared childhood.

One particular memory bubbled to the surface: Once, their Academy teachers had taken the class on a field trip to the old

REBUILDING RUINS

Ulsoor lake bed in Bangalore to practice manipulating hard-light outside of the strictly controlled Academy environment. Satya and Niran had been paired off as usual, his elegant and artistic flourishes complementing her precise and practical structures, and he'd been in such a playful mood that he'd made her laugh. Out loud. In front of her classmates. The surprised, pleased look on Bua's face had been worth the loss of control.

He leaned in. "You're thinking about that day at the lake bed, aren't you?"

"How did you know?"

"I keep telling you, Satya. I know how to read you."

That had bothered her when she'd first arrived. It didn't bother her anymore.

"You've always been a menace," she said.

Bua laughed, then remarked, "Your hands."

"Hm?" She'd had them raised above the table, she realized, thoughtlessly repeating the same movement: fingertips touching one by one, a flourish, a twist, fingertips touching again.

She lowered them abruptly. "Sorry." The response was automatic.

"What? No. Don't apologize. I only meant to say I liked it. I've missed seeing it, you know." His head cocked. "Like your hands are doing their own lovely little dance. It suits you."

Satya had learned long ago to keep her hands still around others. It distracted from her work.

CORINNE DUYVIS · SANGU MANDANNA

But she was not working now. She was simply talking to a friend. Determined, she raised her hands again. Touched her fingertips to each other.

It had been so long since she'd consciously done this where someone could see her that she expected it to feel wrong, even shameful, the same way she'd used to feel at the Architech Academy when a teacher had caught her. Instead, it felt good.

It felt safe.

"Remember when you returned from class," Satya mused, "and you couldn't get into our room anymore because I'd blocked the door by accident?"

Bua's eyes lit up. "Yes! You'd attempted a hard-light construct from that book you'd been reading. Even though it was from three grades above ours."

"And then—"

"When you tried to take it down—"

"The doorframe! I had used it to strengthen the construct while I was still crafting supports—"

"It completely collapsed! Poor Suraj had to rescue us."

Their words tumbled over each other, memory after memory, and by the time they spotted the dot of the helijet approaching the spire, it felt like no time at all had passed.

Minutes later, down on the landing pad with her hair whipping around her face, Satya offered Bua a small smile. "I hope to see you again soon."

REBUILDING RUINS

His smile, as always, was broader and brighter. "Let's not leave it another eleven years, hmm?"

She approached the open doors of the helijet.

"Satya."

She paused, glancing back.

"If you want more answers to the questions you have about Vishkar, look into its founder."

"Dr. Bhatt?" Satya held up one hand to keep her hair from her face. "Why?"

"The legacy of Vishwakarma Bhatt was the reason I stayed with Vishkar for so long, and ultimately why I left." Bua stepped in closer to be heard. "But his vision for his technology, for Vishkar . . . was very different from the path the company took."

"Do you already know what I'll find?"

"Not precisely. But I have my suspicions."

"And if those are correct?"

"Then the Arcology will be delighted to have you."

Satya laughed and strapped herself into the helijet seat. She felt an ache in her chest, the pain of a farewell she wished hadn't been necessary. But that was all right. Farewells weren't forever. She had answers to find, a world to improve—

And whenever she needed it, a friend to return to.

UNITY

TOBI OGUNDIRAN

UNITY

Efi couldn't believe she was in Toronto, next to Sojourn herself! If only her best friends, Hassana and Naade, could be here. But she had promised to video call so they could say hi to Sojourn. And she'd taken loads of photos—particularly of the military dropship Sojourn had sent to collect them. Efi had no idea what kind of calls Sojourn had made to get it to them, but then, there weren't many other options for an in-person meeting. Orisa didn't quite fit in first class, let alone coach.

They walked down Bloor West Street, Sojourn pointing out her favorite places to Efi; Orisa, fascinated by the swarming pigeons, trailed behind them. Sojourn had thanked them for coming, said she'd wanted to see Orisa with her own eyes—to meet this new kind of hero built by the next generation.

Finally, they sat down on a bench in High Park, and Efi asked the question that had been gnawing at her.

"Is there any hope?" she asked. "Of Overwatch coming back?"

Sojourn looked grim for a moment. "I don't think so. I can't even get on a plane without international oversight."

"But why . . . didn't you fight it? The UN's decision to shut you down. You guys are heroes! The world needed you." She frowned. "It still needs you."

A shadow passed over Sojourn's face, but she smiled in spite of it. "Kid, there are many reasons Overwatch went away. I'm not even sure I know them all myself, but . . ." She shook her head, then offered Efi a smile. "If we inspired you to do what you did for Numbani, then we did something right. You're our legacy, Efi, and your journey is just beginning. You are now a hero. Whether you like it or not, you've had a great responsibility dropped on you. Think long and hard about what it means to be a hero and about what your mission is. That includes you, Orisa."

"My mission is to defend Numbani," said Orisa from behind them. "No one can do it better than me."

Sojourn smiled. "Sure." And then she cocked her head, a twinkle in her eye. "Now. How about we get that ice cream you mentioned?"

Efi powered up the Junie on her worktable and stepped back.

UNITY

Her small, six-legged Junior Assistant—or Junie—robots were growing in popularity across Numbani. They could help with most day-to-day tasks, but Efi was hoping this latest experiment would take her creations to the next level.

"Activate protective barrier." An ephemeral blue shield shimmered into existence, humming slightly. Obviously the Junie had no gun or an arm cannon or the countless weapons an enemy might wield, but all the little bots had the hardware necessary to produce a simple energy shield. With this software upgrade, they could put their existing hardware to good use. The shields they produced were smaller than Orisa's protective barrier had been, but still enough to protect civilians, and they should hold up just fine under fire. Efi had managed to squeeze a simplified version of Orisa's battle protocols into the same software upgrade too, so the Junie could effectively evade fire and multitask in the field, alert the proper resources, and aid in evacuations. "Excellent," she said, satisfied.

"What are you doing?"

Efi wheeled around to find Orisa, her robotic friend and greatest invention, standing in the doorway, head cocked suspiciously. "Orisa!" she sputtered, hastily tapping her data pad to deactivate the shield. "Nothing! I was just—"

"Upgrading the Junies," said Orisa, walking slowly into the lab, "giving them defense capabilities."

As she approached the Junie, it turned in her direction and

settled into a combat stance. "You've recycled my old capabilities," said Orisa, incredulous, "and even given it some of my new ones."

Although Orisa did not have human facial expressions, Efi knew her well enough to read the hurt in her eyes.

"Are you . . . replacing me?"

"No—that's not what I—" Efi sighed. "We talked about this, Orisa. There are people outside the city who need our help. The Junies can defend Numbani, so we—"

"*My* mission is to defend Numbani." She picked up the little Junior Assistant bot by its leg. "How can I trust these little things to keep the city safe?"

"What about the rest of Nigeria? What about the rest of the world? They also need our help. Keeping them safe will also help us keep Numbani safe."

"The Idina robots once protected Numbani too, but they weren't strong enough to stop Doomfist."

"Of course, but we have to start somewhere . . . The Junies are already in half the city's homes—they far outnumber the Idina bots the city had before you."

"Why not make me stronger?"

"You can't be everywhere at once, Orisa."

"Then make me *faster*."

Efi sighed, glancing at the little bot on the table. "At least the Junies didn't inherit your stubbornness."

UNITY

Orisa's head cocked further at that.

"Ugh, Orisa, I didn't mean it like that! I'm not trying to . . . Um, the Junies are simply . . ."

Orisa was already walking away.

"Wait!"

Efi ran after her, but her friend had already bounded off the balcony and into the street below.

"Great." Efi sighed, chewing her lip. "Just great."

She was doing what was right. She knew it, but . . . that did not make her feel any less guilty, any less like she was betraying Orisa. At that moment her data pad pinged, and she glanced at it to see the reminder GET GROCERIES flashing across the screen.

"Ugh," Efi groaned. She had almost forgotten about that. Her mother needed some fresh veggies to make coleslaw for dinner tonight.

Minutes later she got off the #68 tram and started down Arroyo Street, the sun streaming overhead, the sounds of Numbani alive around her. Almost a year had passed since she first made Orisa, since they fought beside Lúcio to defeat Doomfist, and since she met Sojourn. They'd successfully kept other threats at bay in the meantime, but worry still ate away at Efi that Doomfist might one day return, and that he might do so when both Efi and Orisa were away. What would Numbani do without its defenders? They couldn't be everywhere at once; they certainly couldn't be in Numbani all the time. It was why

she had been programming the Junies' upgrades. She'd done it secretly because Orisa was a little touchy in that regard. Touchy, even though she'd upgraded Orisa's combat capabilities at her own request, made her even more mobile and imposing in the field.

Efi sighed, stepping aside as a couple of kids flying a kite raced past her. To think that just a year ago she had felt like a parent, watching Orisa's every step, teaching her not to crash through people's homes because that was the shortest route. Orisa learned fast, and Efi was proud of her. In the time since, they'd only grown closer, could even tell what the other was thinking. If she was being honest, Orisa had become Efi's best friend.

Even though we're disagreeing. But friends disagreed. She couldn't count the number of times she'd had an argument with Hassana and Naade. But they always found their way back to one another, even when the fight was over something big like this. She just hoped Orisa would—

A shadow fell over her.

Efi squinted at the sky, wondering if the rains had come again. One minute the sky could be clear with not a cloud in sight, the next . . .

Then she heard the screams.

A massive ship filled the sky, rings of fire sputtering from the gargantuan engines.

UNITY

"Null Sector," she breathed. Terror crawled down her spine.

Null Sector was here. *In* Numbani. She recognized the design of the ship and the warbots from the attack in Paris yesterday, but she had quickly turned off the broadcast in fear. She didn't think the fighting could spill this far. And why would it? Null Sector's creed was all about equality for omnics—and nowhere were omnics treated more fairly than in Numbani, the city of harmony. Yet here they were. Efi held no illusions that they had come peacefully, not when a command ship was hovering overhead, ready to wreak havoc on her home.

Even as she watched, a hatch yawned open with a pneumatic *hiss* and out came multiple drop pods, swooping down onto the city like birds of prey.

She ran.

The first pods crashed into the streets and out came the warbots, marching in formation, arm cannons primed to fire, their metal effigies promising violence. Efi weaved through screaming pedestrians, panicking shopkeepers, dodging their jostling limbs. She had to get home. She had to make it to her lab. And where was Orisa? She whipped out her data pad—

The first cannon blast went off, deafening in its loudness; the next minute she saw a building down the street erupt in flames. For a moment she was back in the airport, ducking from Doomfist's barrage of fire. Her blood roared in her ears as the stink of smoke and fire filled the air. But she saw shapes

running out of the burning building, and then she was racing toward them, helping them, herding them away from danger.

A vise grip clamped around Efi's arm, and she looked up to see Mr. Faruq, owner of the local Kọfi Aromo, tugging at her. He yanked her as though she weighed nothing, and they dived into the alley just as a trio of warbots came marching into sight. They scanned the area, then marched on.

"What were you thinking?" hissed Mr. Faruq, once the Null Sector troops had passed out of earshot. "Exposing yourself like that!"

"I was . . . I was trying to help them."

Mr. Faruq shook his head. "You're always trying to help everybody! Just look out for yourself!" He glanced around. "Where is Orisa?"

"I don't know," said Efi. She noticed then that he had a gash above his left eye, weeping bright red. "You're bleeding."

"I ran into one of those monsters," he muttered, wiping absently at the wound. "But I'm fine."

Efi unzipped her bag, reached for her data pad. "I—I'll contact Orisa."

At that moment the ground rocked, windows rattling as an explosion went off in the distance.

"Once we get to safety," hissed Mr. Faruq. "We have to get off the streets. Come on."

They navigated the labyrinthine streets of downtown Numbani,

UNITY

avoiding clusters of Null Sector forces, until they reached Kọfị Aromo, where several people were already huddled.

An elderly woman Efi recognized as Madam Coker was helped forward by her Junie. "Is it true?" she asked, her eyes wide with fear. "Is Null Sector here?"

"Yes," said Mr. Faruq. "We've seen them."

"They took my friend," one of the omnic patrons said. "Put something on him—a device—"

"But why? What do they want?"

"Who the hell knows?" one of the younger survivors shouted. "We shouldn't be talking. We should be barricading the doors! And the windows. Quick! Quick!"

The nearly two dozen customers sprang into action, pushing chairs and tables to block the doors and windows. Efi found a corner, rapping at her data pad as she desperately tried to contact Orisa, but for some reason she couldn't get through.

"Come on, come on," she muttered, rebooting her data pad and attempting to ping a nearby satellite. Something was blocking the signal.

Mr. Faruq gawked at the holoscreen where the destruction of Numbani was on full display. Even as Efi watched, a skyscraper in the business district went up in flames, billowing black smoke into the open sky. Several injured humans were scrambling away from the wreckage.

The warbots were tearing through the city with no regard

for life or property. At this rate, there was no telling how long Numbani had.

At that moment, the holoscreen in the café went out. A collective gasp ran through the shop. Then every screen in the cramped space, except Efi's data pad, came alive with a broadcast. The omnic in the message was a vision of terror: an R-7000, one of the models most feared during the Crisis. He wore a faceplate that looked like a skull, with synthetic hair waving in the air like snakes; a titanium exoskeleton covered a torso fashioned after human ribs. In one arm he held a staff.

"My fellow omnics," he said. *"Do not be afraid. This is not war. This is liberation. Since our creation, humans have oppressed us. You have lived in fear. That ends now. We will shatter the chains that have held you in servitude. This marks a new era, one of equality, of unity. Conflict and strife will be relics of the past. Together, working as one, we will lift our people. Together, of one mind and purpose, we will make this world a paradise. The humans will fight us. Change frightens them. We frighten them. They believe we are not their equals. Together, we will prove them wrong. Do not betray your fellow omnics by defending injustice. Join us. Take your place at our side. Only together will our strength manifest. Only as one will we ascend. We welcome you into the Iris."*

Silence descended upon the shop.

UNITY

A boy began to cry. "I'm scared, Mama!" he sobbed, tugging at the hem of his mother's skirt. She scooped him up, muttering in his ear as she tried to calm him.

"They've come for us," said an omnic wearing a green-and-blue patterned iro and buba. Of the twenty people clustered in the room, six of them were omnics.

"Any luck contacting Orisa?" asked Mr. Faruq.

"No," said Efi. "I can't get through to anyone. I think . . . I think Null Sector is jamming the signal."

Mr. Faruq looked grim. "They're isolating us. They think we will turn on each other—humans and omnics."

There was a heavy pause as his words settled into the tense air of the café.

"But that means Null Sector does not know Numbani."

An omnic patron jumped in. "We already have unity in Numbani. And it makes us strong."

"Stronger than Null Sector!"

Efi gritted her teeth. Their words were hopeful, in the friendly air of Mr. Faruq's coffee shop, but no one could say how the rest of the city was faring.

Null Sector *was* isolating them. It was a brilliant strategy, one she would have appreciated if the tables were turned. This was no haphazard attack like Doomfist's had been—intended to sow chaos and discord, to ensure the strongest rose to the

challenge. No, this was carefully plotted, the bombardment rolled out in stages with little chance for the people of Numbani to regroup or defend themselves.

Efi looked over at the Junie in Madam Coker's arms. Maybe the people didn't need to defend themselves. Wasn't this exactly what she had been preparing for? There were Junies in nearly every household, in every corner of the city, ready defenders of Numbani. All she needed to do was give them a new directive and bring their defense upgrades online.

She approached Madam Coker. "Hello, ma. Do you mind if I borrow your Junie?"

The woman looked at her, her glasses magnifying her cataract-milky eyes. "I know you," she said. "You're that girl—the one who makes the Junie bots! My grandson won't stop talking about you."

Efi gave her a quick smile. "I want to get you home to your grandson, but I need to borrow your Junie."

The woman put the bot down. She nodded at the Junie, and it marched over into Efi's waiting arms.

Efi quickly established a wired connection with the little bot and began to install the upgrades she'd been perfecting.

There came a burst of blinding light; the west wall exploded in a spray of concrete and glass. Efi dived, thrust by the force of the explosion. Her data pad flew out of her hand as she landed behind the counter. A large shard of glass came whistling through

UNITY

the air, shattering on the floor where her hand had been mere seconds ago.

Groaning, she pushed herself to her knees. The world spun. There was a loud ringing in her ears, and for a moment she couldn't hear anything. So she remained perfectly still, crouched behind the counter as she tried to regain her balance. The lights flickered on and off, and she could hardly make out anyone else through the cloud of dust and plaster that filled the shop. But she saw the warbots, red eyes winking through the smoke, blasters glowing, as they climbed through the hole in the wall and seized the nearest omnic.

"No!" he yelled, struggling. "No! Let me go—"

Two Null Sector units held his arms, pinning him to the wall, while a third one—a floating, jellyfish-like thing—produced a contraption that it fixed on the omnic's head.

The omnic went limp, as lifeless as a rag doll.

"What did you . . . what did you do to him?" cried another omnic, whom Efi recognized as Ishara. She ran a hairdressing salon not far from Efi's home.

The Null Sector jellyfish bot who had forced the contraption on the omnic's head stepped back, red eyes burning like coals. From the holoscreen came the spliced broadcast, repeating: *"My fellow omnics, do not be afraid. This is not war. This is liberation.*

"We welcome you into the Iris."

TOBI OGUNDIRAN

The dust was starting to settle, and Efi could make out the people in the shop, scattered about and lying in varying states of injury. Some were just now groaning back into consciousness.

Ishara turned to the rest of them. "Run," she said. "I'll hold them off—"

"I'll join you," said another omnic.

A tense moment passed; somewhere on the street, someone's scream was abruptly cut short—

"No," said Mr. Faruq, his voice firm. He stepped forward, brandishing a coffee maker at the warbots. "You come into my city, my shop. You destroy everything. You're not welcome here. If you want to threaten my neighborhood," he growled, "you'll have to go through me."

Madam Coker stepped forward, waving her bag threateningly. "And me."

"And me." It echoed through the shop.

Within moments all the humans in the shop linked arms, forming a shield around the omnics.

The warbots raised their arms in unison, powering up their blasters.

"Upload complete," chirped the Junie. "Defense systems online."

Efi scrambled over to it and disconnected her data pad. "Neutralize the threats!" she screamed. *"The warbots!"*

UNITY

The Junie sprang into action. It leapt, cartwheeling through the air, and landed in front of the humans just as the warbots fired. A blue energy shield shimmered into existence, absorbing their fire. The crowd stood where they'd gathered, frozen in surprise.

"GO!" Efi yelled at them, scrambling over the counter. "GO! GO! *GO!*"

They poured out of the shop. Efi helped Madam Coker, who couldn't find her walking stick.

"I've got this," said Mr. Faruq, sweeping the woman into his arms. "Find Orisa."

Efi nodded, turned to sprint.

"And be careful!"

Efi raced down the street, dodging Null Sector units and pointing civilians to safety. Many people were opening their homes to those fleeing the violence, and it made Efi's heart swell to see people helping one another. This was why she loved this city. This was why she would do anything to protect its citizens, humans and omnics alike. She hadn't failed them yet, and she wasn't about to.

As she ran into the tram station, Efi realized that the tram lines were no longer running; the terminal was mostly empty. She would have to make it home to her lab on foot, and that was at least fifteen minutes of nonstop running. She wheeled about to exit the station, then stopped dead in her tracks.

Huddled in the departure lounge was an omnic and a young boy, not much older than Efi. They hugged each other as a warbot aimed its blaster.

"Please don't hurt him," the omnic was saying. "Leonel, run!"

No, they weren't hugging each other; the boy was *clinging* to the omnic, tears in his eyes. Efi realized he would not let his omnic friend sacrifice himself. With a jolt of horror, Efi saw how this was going to end.

"Hey!" she screamed, voice echoing in the deserted station. "Hey, you!"

The Null Sector warbot turned to her, and she flung a trash can at it. It bounced off its legs, skittering across the tiles before coming to rest next to the information desk. But it was enough of a distraction that the boy and the omnic took flight, dashing out of the station. The warbot fired after them, but it missed.

It turned to Efi, red eye glowing.

"Uh-oh—"

She fled as it let loose a barrage and hid behind a couple of benches. It didn't stop firing, and Efi could hear the telltale *clunk* of machinery as it marched toward her. Panicked, Efi covered her head, glancing at the exit as she contemplated making a run for it. Except . . . there was nothing but open space before her, and there would be no dodging the warbot's fire—

Silence. Had it stopped to reload? It didn't matter. This was

UNITY

her chance. Just as Efi stood up to bolt, something dropped in front of her with a *clang*: the warbot, a gaping hole blown into the back of its head.

She looked up, confused, to find Orisa striding toward her.

"These things are very dumb," said Orisa. "It did not see me coming."

"Orisa!" Efi cried, flooded with relief. She leapt to her feet and threw herself at Orisa, wrapping her in a hug. "I didn't know if I was going to make it out of here! Where have you been? I tried to reach you—"

"I have been exterminating these Null Sector insects," said Orisa. "But there are too many of them."

"Exactly! I tried bringing the Junies' defense systems online, and . . ." Efi realized that Orisa was likely still sensitive about the Junies and tried to backpedal. "You know, um, to help. I figured the more forces we have defending Numbani, the better. But Null Sector has control of every network in the city, and—"

"Right. What do we do next?"

Efi paused. "You're not—you're not mad . . . about the Junies?"

Orisa shrugged. "My mission is to defend Numbani. So far as I can do that, I don't mind the occasional . . . help."

Efi tried not to smile. It was not quite the same thing; if the Junies could defend Numbani, then Orisa would not be needed here, and she would be free to broaden their efforts. But it was

progress enough. Besides, they didn't have much time to go over the details. They had work to do, and little time in which to do it. They could argue later.

"We need to get back to the lab. From there, I should be able to remotely bypass whatever jamming program Null Sector is using and activate the defense systems simultaneously."

Orisa nodded. "Let's go."

Efi kept close to Orisa as they jogged through the city. The streets around the tram station were deserted, which meant the fighting was closer to the city center. Sure enough, they soon came upon Null Sector units firing at a group of omnics who huddled behind the ruin of a car.

Orisa charged, bounding at them in two great leaps. She landed smack in the middle of their formation and spun her energy javelin, pushing them back. Confusion spread through the Null Sector bots as they turned to face Orisa.

The omnics still remained behind the car, and Efi wondered why they weren't making a run for it now that Null Sector was otherwise occupied. The reason became apparent as she raced toward them: an omnic was lying half-buried beneath rubble. The rubble in question was a particularly large chunk of concrete with a metal bar sticking out of it.

"She's trapped," said another omnic, who looked to be her husband. "Please, help us!"

Together they grabbed the metal bar and began to pull, but

UNITY

the block was heavy, and all their straining didn't move it even an inch.

A shadow fell over them as Orisa appeared. She peeled away the bar as though it were nothing but paper, and the omnic crawled into the arms of her husband.

"Get home!" Efi told them. "And stay indoors."

They continued through the city, Efi directing civilians to safety, Orisa laying waste to the Null Sector forces they encountered. Their progress was painfully slow. Twenty minutes, forty minutes, an hour ticked by. They came across groups of civic defense locked in battle with Null Sector, who hailed down Orisa for help. Their forces were engaged all over the city, but they were spread too thin. Efi assured them that more help was on the way. She needed to get back to her lab, to execute an instant citywide upgrade of the Junies, but Orisa couldn't turn away from those who needed her help.

And many, many people needed their help.

Efi still hadn't heard from her parents, her cousins, her friends. In every desperate face they passed she thought of those she loved, was hit with a fresh wave of urgency to get home.

She was trying to be strong, to focus on the task at hand, but in truth she was worried. Her parents should be home, hopefully, safely tucked away. Today was their day off, after all; that was why her mom had sent her to get groceries. Naade and Hassana were meant to join her family for dinner tonight—

"Oh no," Efi breathed as they turned onto Satellite Boulevard. "No, no, no, no, no."

The remains of a collapsed building lay smoldering in the street, blocking the way. Hundreds, perhaps thousands of citizens milled about, pulling people out of the wreckage. Many were horribly injured, with more able-bodied citizens carting them away to safety. Efi was discouraged to see very few omnics among the crowd. On the massive, ruined holoscreen to her left, Null Sector's message flickered on and off, the gravelly voice stuttering through the air as the mystery omnic delivered his propaganda speech.

"We can go through Ikeja," said Orisa.

"That will take an hour. We won't get there fast enough."

"What if I carry you? I can run faster; I have four feet."

"We don't have time!" Efi yelled, giving in to a sudden burst of anger. "You'll still have to fight through hundreds of warbots to get home . . . there's just too many of them for us. At this rate, the city will be overrun in an hour, maybe less . . . Every second we're not in the lab is one where more omnics are captured, where more humans die . . . The city is coming to a tipping point—I *know* you can hear the civic defense channels, Orisa. And we met some of them. You know they're overwhelmed . . . *I'm* overwhelmed."

Efi sank to her knees, taking in the carnage before her. And

UNITY

for the first time in a long time, she felt utterly helpless. Tears stung her eyes. She saw in the chaos a reflection of Doomfist's attack on the Numbani airport. She had felt energized then, even in her terror. She could fix it. She knew she could. But looking around now . . . overhead, multiple command ships cast swaths of darkness across the city. A titan in the distance swiped at a building with its massive robotic arm. And closer, just yards away, was a child covered in concrete dust, weeping and alone. The desperation in her voice sent a knife of anguish through Efi's heart. Why was Null Sector here? *Why?* The omnics here were happy, were equal. There was no fight for Null Sector in Numbani, no wrongs to right. They were setting the city on its side . . . for what? They had coordinated this attack with precision, outwitted even her. What could their goal be?

Orisa placed a hand on her shoulder. "Efi," she said. "What do we do?"

An explosion rocked the street as a car went up in flames.

"I don't know." It was an admission of defeat.

"You are Efi Oladele," said Orisa. "The Hero of Numbani. Our mission is to protect this city. No one can do it better than us."

Efi gave a singular bark of dry laughter. "No, Orisa. I *built* a hero to protect Numbani. Without my lab, my technology, I can't stop villains, killers. Useless. Totally useless."

"No," said Orisa, gently but firmly. "You are the furthest thing

from useless. You are smart. You made me. You defeated Doomfist. I have not seen a problem too big for you to tackle. So think, Efi. *Think.*"

Efi looked into Orisa's eyes, managing a sad smile. If this was the end of their road, she was glad to have her friend by her side. She thought back to how she had made Orisa, the endless months of programming and debugging to make her so wonderful. Strong, smart, curious, tough, resistant to hacking, unlike the—

"Junies!" she cried, leaping to her feet. "A virus! I can make a virus to infect the Junies!"

Orisa cocked her head. "I am . . . not sure I understand."

"You remember when the Junies contracted malware, a couple weeks after Unity Day? And I had to recall the orders to debug them? I can reconfigure the defense upgrades to act as viruses, so every upgraded Junie that comes close with another Junie automatically overrides the firmware and spreads the upgrade!" She frowned. "But . . . they would have to be on the same network."

Efi groaned. She had built that fail-safe after the Junies contracted the first virus, to prevent such a thing from happening in the future. Even if a Junie got infected, it couldn't pass the infection on to other Junies unless they were sharing the same network. Now that very fail-safe was going to hamper her.

"Of course it's not that easy," she muttered.

UNITY

"What?" said Orisa as she laid waste to another warbot; it went flying, parts scattering in the wind.

"Nothing," said Efi, rubbing her hands together. "I know what to do."

She went to work, extracting the old virus the Junies had contracted and splicing useful bits of code with the defensive upgrades, simultaneously running several processes to turn her data pad into a temporary network provider.

"Are you going to be long?" asked Orisa after she engaged her fusion driver and decimated an approaching flank of warbots. "We can't stay here—"

"Done!" said Efi.

There were nearly three hundred Junies in range now, marked as red dots on her screen. As she clicked Activate, the Junie nearest her got infected. It had been herding its owner out of the line of fire, but now it froze, then dropped into combat stance as it produced an energy shield.

"James Junior?" the owner asked.

"Everyone!" yelled Efi, climbing onto the hood of a car. "Hey!"

"It's her!" someone shouted.

"It's Efi Oladele!"

"Everyone who has a Junie! Bring them close!" said Efi. "I've upgraded them so they can fight, so they can defend you, defend us!"

A ripple of excitement, no—*hope*—passed through the crowd.

TOBI OGUNDIRAN

As more Junies connected to the network, the upgrades spread faster and faster like, well, a virus. And when Efi glanced down at her screen a second time, it burned green.

She smiled.

"GIVE THE ORDER," she screamed. "TELL YOUR JUNIES TO FIGHT! FIGHT FOR NUMBANI!"

All around her, the citizens of Numbani gave a chorus of orders, and then the Junies were charging at Null Sector, attacking the warbots in overwhelming numbers. It reminded Efi of the time she forgot her sandwich on the kitchen counter, returning later to see an army of ants swarming it, breaking it into little pieces. Orisa gave a whoop of joy as she seized a warbot by the feet and then proceeded to use it as a bludgeon, sweeping the streets of other warbots and sending them flying. Efi ducked as an errant blast of energy whistled past her ear, and when she turned, she saw a Junie launch itself at the offending warbot, arms a blur as it dismantled it to bits.

A great cheer went up, and Efi turned to see civic defense pouring into the street. Satellite Boulevard had become the crux of the invasion. Energized, she returned to evacuating as many civilians as she could.

The battle wore on and on, but eventually the warbots had been cleared, dismantled into so much machinery. Orisa led the Junies as they worked with civic defense forces to expand their perimeter as well as the number of Junies fighting for the city.

UNITY

"Numbani!" someone cried. "NUMBANI!"

One by one, the survivors took up the chant. Efi, sweaty, exhausted, but thrilled, joined in, screaming at the top of her lungs until her voice grew hoarse. Then she settled on a large piece of rubble, watching the crowd.

Orisa returned to her sometime later. "What?" she asked, seeing the look on Efi's face.

"Nothing," she said. "It's just—there are no . . . reinforcements? Have we really defeated Null Sector?"

Orisa moved her huge shoulders as she shrugged. "Do you want reinforcements?"

"I don't. No, of course I don't."

"I mean, I don't mind." Orisa was still clutching the severed arm of a warbot. "I was made to protect, and I will. But this is a victory, Efi. We won. Numbani won. Don't look a gift machine in the mouth."

"I think you mean a gift *horse*, Orisa."

Efi plumped up her pillows for the umpteenth time, then collapsed back onto them. She tossed, searching for a comfortable position. She pulled up the covers, then threw them off, sitting up in frustration. There would be no sleep for her this night, so why fight it?

TOBI OGUNDIRAN

She had tried helping with the cleanup, putting the wounded in ambulances, but her parents had bundled her home—she was nearly thirteen now, yet they still treated her like a child. But she knew it was because they cared. Her mother had fought tears as she crushed her in a hug, and Efi knew that they had thought the worst.

Efi reached for the remote on her nightstand and flicked on the TV.

The headline OVERWATCH SAVES RIO scrolled at the bottom of the screen, a flaming Rio in the background. The next clip panned to a crew of familiar faces she recognized from the old cartoons, and one new face: Lúcio!

She screamed, leaping out of bed. *"They're back!"*

Her excitement was soon marred by an undercurrent of worry. The news could only mean one thing: the attack on Numbani hadn't been an isolated event. Null Sector posed a serious threat to the world—maybe the biggest one since the Omnic Crisis.

That would explain why there had been no reinforcements here in Numbani. Overwatch was keeping Null Sector distracted elsewhere.

"I should have known," said Efi, climbing out her window and onto the roof. "Couldn't sleep either?"

UNITY

Orisa stood, gazing out at the city. "I don't sleep. You know this."

"I can update your programing. Grant you the ability to sleep."

"The only upgrades I want from you, Efi Oladele, are more weapons of destruction. So I can eat Null Sector for breakfast, lunch, and dinner."

Efi chuckled, lowering herself next to Orisa.

They settled into companionable silence, taking in the city below, filled with smoke and the wail of sirens. Civic defenses were on high alert, but now that the Junies had their upgrades, the people would rest safer. Most of the fires were out, but the morning would reveal the extent of the destruction and how much work would need to be done to put their city back in order.

"Look what they've done to our home," Efi said. "You know we can't stay here."

Orisa remained mute, her thoughts unreadable.

Efi sighed, rubbed her eyes. "Overwatch is back. They saved Rio. I feel . . . we should join them."

"They don't need our help."

Efi groaned. Why was she being so stubborn? "Do you remember when we went to visit Sojourn? After we defeated Doomfist? Do you remember what she told us?"

"'Know your mission and never lose sight of it,'" said Orisa. "And our mission is to defend Numbani. No one can do it better than us."

"And we've done that," said Efi. They'd had this argument so many times she was tired of it. But it was a matter they needed to settle once and for all. "We've protected Numbani wonderfully. But this is much bigger than you or me or even Numbani. The whole world is in danger. Null Sector is back, and they're stronger than before. Today was a very close call. And this . . . new leader of theirs is terrifying, and smart, and it would be selfish of us to hide here, to protect only our city."

Efi gestured at the giant holovid, where Cape Town and Istanbul were engulfed in flames, still under Null Sector attack. "They're helpless, and we have the ability to help. I think . . . maybe we've accomplished our mission here, for now."

"Perhaps you are right," said Orisa. She lifted her hands, struggling for words, then let them fall back to her side. "I just—"

Efi shuffled closer to her, placed a hand on her shoulder. "You're worried about Numbani, and I love that about you. But they will be safe. Every household has a Junie, and I built their defense systems out of information gleaned from your many battles. They are more than capable of defending the city in your absence."

"You mean those little clones of me?"

"You're incomparable, Orisa. You know that. Think of the Junies as your . . . soldiers, and you, their commander."

Orisa was silent a moment. "That I am," she said, amusement in her voice. "I am one of a kind."

UNITY

Efi glanced at her.

"Not to mention," said Orisa, "they do not have my blistering wit."

Efi laughed. "*Or* your shining personality."

Orisa preened.

In the distance, the first rays of light split the horizon into bands of gold as the sun rose on a city that had survived Null Sector. Many were wounded, and Efi's heart ached to think of those whom she had failed to save. But this was only the beginning, and as long as she had breath in her, she would not stop fighting. Efi closed her eyes and turned her face up to the sky, breathing deep of the familiar smells of her home. When she opened her eyes, Orisa was staring expectantly at her.

"Well," said Efi, rising to her feet, "let's go."

LUCK OF THE DRAW

LYNDSAY ELY

LUCK OF THE DRAW

If hell were a real place, Ashe bet it looked something like Las Vegas.

Broken glass crunched beneath her boots as she crept forward, inching her way onto the ballroom balcony. Or what remained of it. Tattered curtains, dyed vermillion by the vibrant dusk, swayed in the light breeze, which carried the pungent scent of smoke and explosives. But it had been quiet—well, *quieter*—in the last few hours. The occasional pop and rumble of explosions still sounded, along with the sharp staccato of gunfire, but less frequently now, and at a distance. Not that she was stupid enough to mistake that for safety, but it was enough to risk a peek outside. Using the remains of an ivy-clad trellis as cover, Ashe peered out at the Las Vegas Strip, stretching to either side of the towering Spectacle Resort & Casino.

LYNDSAY ELY

It was a *mess*.

Explosive craters, burnt-out husks of vehicles, a devastated marble fountain still spitting and bubbling pathetically . . . a far cry from the bustling, opulent scene that had greeted her and the other Deadlock Rebels earlier that day. Her hands tightened around the Viper—her antique-with-an-upgrade rifle—as she spotted movement near the ruined entrance of the casino across the Strip. But it was only a couple of tourists and an omnic showgirl, her plume of feathers singed and wilted, sequins winking in the setting sun. Apparently Ashe wasn't the only one who'd noted the quiet. She lifted the Viper, tracking them with its scope. They inched out from their hiding spot, heads swiveling back and forth like broken toys. There was activity to the north and south of the Strip, but here, even the heavy infestation of Null Sector units searching the area had thinned out. And these three were taking the opportunity to make a break for it.

A hundred feet. That's how far they made it before a pair of Null Sector warbots appeared. Unarmed, the terrified trio threw their hands up in surrender. But the warbots didn't advance, only kept them corralled until another unit appeared. This one was different, unlike any she'd seen during the earlier fray. One of the tourists screamed as it swept down on them, but the unit ignored them, heading straight to the omnic showgirl, who, at the last minute, tried to bolt. But it was too late; the

LUCK OF THE DRAW

bot affixed something to her head. One moment the omnic was trying to get away; the next, she went still as the grave, slumped forward, tattered feathers hanging pathetically.

Ashe bit the inside of her lip. She didn't like the look of that. Not one bit. Her blood began to pump harder, rushing in her ears . . . so loud that she missed the low buzz of the search drone until it was right on top of her. Swallowing a curse, Ashe leapt backward as it slipped through a hole in the trellis, cutting her off from the door back inside. She raised the Viper, knowing she should take the shot, knowing at the same time that the noise would give away her position and bring others, but there was no time to think, no time to—

The drone *crunched* as two huge metal hands clamped down on it from either side.

"B.O.B.!" Ashe exhaled, shoulders dropping in relief before she frowned. "I told you to stay inside with the others."

B.O.B. blinked at her, then peered down at the ruined drone in his hands.

"Don't look at me like that. I had it handled." She nodded toward the group on the street. The humans were gone—run off, taken away, or killed—but the omnic showgirl remained. She hadn't moved one metal muscle. A cold shiver ran down Ashe's spine. "You catch the show down there, big guy?"

Slowly, uneasily, her omnic companion blinked again, which was all the confirmation she needed.

LYNDSAY ELY

"B.O.B.," Ashe said, a sour taste in her mouth, "we never should've come to this godforsaken town."

EIGHTEEN HOURS AGO

Las Vegas was one of the last places in creation that Ashe was interested in setting foot in. Too loud, too flashy, too full of people making damn fools of themselves on every curb and corner. It was not, as folks said, her cup of tea.

But, as they also liked to say, business was business.

An omnic server shoved yet another platter under her nose, this one bedecked with tiny pieces of toast swirled with pink mousse.

"Try it," insisted one of the young women on the overstuffed couch across from her. She twirled a braid woven with electric-pink ribbons around one finger, eyes twinkling as Ashe slipped one of the offerings into her mouth. "Amazing, right? I bet you don't have anything like that back in your neck of the desert."

Ashe swallowed a snort. B.O.B. had left better things forgotten in the back of the fridge. From her left, the omnic discreetly passed her a napkin. She considered spitting the mouthful out but reluctantly chewed and swallowed instead. "Not bad."

LUCK OF THE DRAW

"They're my *favorite*." The other young woman on the couch—a near copy of the first, save for a bit younger, and with purple ribbons instead of pink—snatched two of the toasts as the server passed. "Everyone knows if you want the best food in town, you come to the Spectacle."

"*Everyone* knows," her sister echoed.

"Hm," Ashe said, eyeing the pair.

Lark and Folly. Co-leaders of the Jackpot Gang.

Like everything else in Vegas—including the Spectacle Resort & Casino, where the Jackpot leaders had insisted on meeting—they were more flash than class. All brash colors and glittering frivolity, they looked more like they belonged in the stage show being performed below the private mezzanine where they were meeting than in the most feared gang in the area. The musical number mingled jarringly with the endless ringing of the gaming floor's slot machines, a grating cacophony. But Ashe knew the whole thing was a show of its own sort—designed, focus-tested, and executed by corporate minions to draw in the suckers who flocked to Las Vegas with dreams of making their fortune through the least amount of work possible.

And unsurprisingly, it worked like a charm. Velvet and marble. Filigree and gold. Lark and Folly seemed to be under the impression that this was what *rich* looked like, but Ashe knew better, and real wealth didn't look like this place. *This* place looked like a bordello crossed with a birthday cake.

"You don't say much, do you?" Lark quirked one eyebrow at B.O.B. "Almost as little as your big pal there."

Ashe gave her a thin-lipped smile. "You might say I'm not one to waste words." More like there wasn't much worth saying to these two.

Folly leaned forward eagerly. "You want anything else? Another drink? We can get anything you want here, just name it."

The only thing Ashe wanted right now was to finish their business and get out of there.

Be nice. Bez's voice in her head. *Give them a chance to make their case.*

Ashe had been skeptical to meet with the Jackpot Gang, but Bez—whose endless patience made him far better suited to managing the Deadlocks' "public relations" than Ashe—had insisted that they were the best way into the local smuggling game. As over the top as they were, they had a lot of pull, mostly owing, of course, to their ties to the corporate outfit that ran the Spectacle. The casinos in this town might present themselves as squeaky clean, but Ashe knew better. In Vegas, crime and greedy corporate grandeur had always gone hand in hand. They might not let the gangs into the boardroom, but someone had to do the dirty work. And there was *always* dirty work.

"Hey!" One of the Deadlock triplets—P.T.—waved over an

LUCK OF THE DRAW

omnic server to where he leaned against the mezzanine's balustrade. "My glass is empty." The other two, Zeke and Terran, didn't even bother taking their eyes off the stage show as they held their drinks out for a refill too.

At least those three were having fun. Standing nearby with her arms crossed and head bowed contemplatively, Bars, the gang's unparalleled omnic sniper, was harder to read. A crate lay at her feet, full of the business Ashe was eager to get to.

"What about some dessert?" Folly was still chattering away. "You wouldn't believe how good the—"

"I'm fine," Ashe interjected. "As tasty as the victuals might be here, we've got other things to discuss."

Lark and Folly traded a look, then smiled and turned their gazes back on her.

"Right," said Lark.

"Of course," said Folly.

"You know, we've heard all about the Deadlock Rebels." Lark lounged back onto the couch, one hand resting absent-mindedly on the stock of the handgun holstered on her waist. "All about your exploits. Impressive stories—"

"Very impressive," Folly slipped in.

"—and we know what an honor it would be to work with you, Ashe."

Ashe pressed her lips tighter at the tone, which didn't quite match Lark's words.

"It's only that around here, folks have . . . well, *particular* tastes. They aren't looking for just *any* weapon to fulfil their armament needs." Lark cocked her head to one side. "Y'know what I mean?"

Folly lowered her voice conspiratorially. "Around here, they only want the *good* stuff."

It took all of Ashe's restraint not to laugh in their faces. Oh, Bez was going to get an earful when she got back. Not that she was surprised. Nothing seemed to have gone smoothly as of late, not since the reappearance of a certain someone during their disastrous train heist a few months back. Ashe felt her trigger finger itch just thinking about that scoundrel Cassidy, his brazen theft, and the bike—*her damn bike!*—he'd ridden off on, happy as could be. And now Overwatch had reappeared in Paris, spooking Deadlock's clients so much that, within a day, half of them had frozen their shipments. *Cowards.* This nonsense was just the cherry on top of the sundae. She took a deep breath, ready to get to her feet, put an end to the meeting, and get the heck out of—

A hand fell on her arm. A big metal one.

B.O.B.

Ashe exhaled. *Fine*, she told him with a look, then turned back to the sisters and grinned, teeth bared. "Now, I know you ain't saying what it sounds like you're saying. Because if you know our reputation, then you know that the Deadlock Rebels

LUCK OF THE DRAW

don't deal in anything *but* the good stuff." Ashe gave a little nod in Bars's direction, a signal for her to make her way over. Bars grabbed hold of the crate, dragging it in front of Lark and Folly. "Show 'em."

"Right, Ashe." Bars opened the crate, revealing the sniper rifle nestled inside. Its gray metal coating and sleek curves drank in the colorful lights of the casino and swallowed them whole.

"Latest model that Arbalest has in production—and we got our hands on the whole first run." It never ceased to tickle Ashe, dealing in what was very nearly her personal inheritance. "Bars, tell the ladies why this rifle will make their oh-so-discerning customers turn their wallets inside out."

As Bars ran through the features—carefully and in detail, the way she always did when they had a really choice piece of merchandise—Ashe watched the sisters. They moved closer, gazes sliding over the gun like children's over the hottest new toy. Ashe leaned back, arms spread over the plush rests of her seat, watching the eager greed grow in their eyes.

But when Bars finished, Lark and Folly didn't say anything at first. They just shared another one of those weighted, chatty looks.

"Nice," Folly said finally, treating the word as if it were a concession. "Definitely nice."

"We certainly aren't saying it isn't," Lark picked up. "Anyone can see that this is a quality piece of weaponry."

Ashe narrowed her eyes. "But?"

Folly simpered. "But we simply aren't sure this deal is right for us, and for our customers."

Lark shot Ashe a smile that was all sharp edges. "We just want to make sure that this is the right deal, done in the right way, for the Jackpot Gang."

Ashe's fingers clawed into the arms of her chair, the stuffed velvet giving beneath her nails. "All right. I've had more than enough of this." She stood. "Bars, grab the merch. B.O.B., go get the bikes." She let out a high whistle. From their perch at the edge of the balcony, the triplets spun, at attention in an instant. "Time to go, boys."

Still on the couch, Lark and Folly gaped at her.

"Now, hold on—" Lark started.

"I said we're done," Ashe cut in. "Deadlock, we are out of here."

She spun on her heel, making it three steps toward the exit before an explosion rocked the casino.

NOW

My fellow omnics, do not be afraid. This is not war. This is liberation.

Ashe was getting real tired of that message.

LUCK OF THE DRAW

Since our creation, humans have oppressed us. You have lived in fear. That ends now. We will shatter the chains that have held you in servitude. This marks a new era, one of equality, of unity. Conflict and strife will be relics of the past. Together, working as one, we will lift our people. Together, of one mind and purpose, we will make this world a paradise. The humans will fight us. Change frightens them. We frighten them. They believe we are not their equals. Together, we will prove them wrong. Do not betray your fellow omnics by defending injustice. Join us. Take your place at our side. Only together will our strength manifest. Only as one will we ascend. We welcome you into the Iris.

It had been on repeat now for hours, broadcast on speakers around the city and on every communication channel they could raise, over and over and over until Ashe felt like ripping open the nearest sequined throw pillow and filling her ears with the stuffing.

"Any luck, Zeke?" Ashe anticipated the reply—the same as the hundred other times she'd asked over the last twenty-two hours—before the triplet shook his head.

"Nothin'," said Zeke. "Nothin' but that message over and over again. If Frankie were here, maybe she'd be able to get through, but me . . . ?" He shrugged, discouraged.

"Keep trying." There was no knowing whether the communications blackout was affecting just the city, or everywhere.

LYNDSAY ELY

Same for the attack—was it happening in other cities, other places? Bez was back at the hideout, but Frankie was who knew where, off on other business right now. It was frustrating, not being able to do a damn thing other than *hope* they were safe.

Or, at least, safer than Ashe and the rest of the gang were.

The attack had immediately plunged the casino into pure panic. Explosions sounded all around. Gunfire came from the streets. Then, suddenly, the power went out, leaving only the red, wet light of emergency lamps. The gory illumination seeped into the carpet and walls, turning the casino into some sort of carnival fun house, minus the fun. That was when the screams really started, followed by the stampede of footsteps and the crashing thumps of furniture being knocked over. The panic had carried most of the patrons out onto the Strip.

Which, as it turned out, was just about the worst place to go.

Ashe and the others had kept cooler heads. They'd formed up around her, weapons ready as they headed for the exit, only to find that the streets swarmed with Null Sector forces. They'd held their own, but try as they might, the underground garage where their bikes were parked might as well have been on the moon. They'd been forced to fall back through the casino—where they found the Jackpot Gang in similar straits—and then into a tucked-away ballroom that was clearly being used for temporary storage. There, they'd barricaded the doors and windows as best they could with tables and boxes and storage

LUCK OF THE DRAW

crates, and they'd kept quiet as whatever was happening outside continued to play out.

That had been nearly a day ago. Now Ashe scanned the ballroom yet again, taking stock because there was nothing else to be done. The triplets were manning a barricade of tables near the ballroom entrance, with Bars set up a little way back to pick off anything that might get past them. The Jackpot Gang were clustered in one corner, Lark and Folly looking increasingly anxious and whispering to each other more often than Ashe liked. And then there was the really scared lot, the half dozen casino-goers and omnic workers who had been too smart or too afraid to flee, cowering in the very back of the room.

Ashe let out a frustrated sigh. Twenty-two hours since the attack had begun. Eight hours since she'd seen how Null Sector "liberated" the omnics. They were low on ammo and patience, and when it came to how to get out of there, Ashe had nothing.

"B.O.B."—the omnic was keeping as close as a shadow—"if you got any ideas, now's the time."

B.O.B. looked down at her and shrugged.

"Yeah, didn't think so."

Lark, who'd been watching their exchange, stalked over. "This is ridiculous. We can't stay here forever!"

"No," Ashe agreed calmly, "we can't."

Lark blinked at her, eyes a little too wide, bright with a sheen of fear. "So, what are we going to do?"

"If I knew that, do you think we'd be hanging around?"

Lark's mouth opened once and then closed. Folly approached from behind her, a more hopeful but equally lost look on her face.

"Ashe!" Terran called before either of them could speak again. "We got movement coming up on us."

Ashe let out a curse and ran for the barricade, readying the Viper. Behind her, the Jackpot Gang was making for cover too, but in a much noisier way, and one of the civilians let out a wet sob. "Everyone hush up!" she hissed.

By now they were all smart enough to obey. Silence fell, broken only by whatever was beyond the doors, a heavy sound like something being dragged. It got closer and closer, until it finally stopped outside the ballroom.

Ashe raised the Viper and took aim.

"Hello?" The voice was barely a whisper, tight with hope and fear. "Is anyone in there?"

Ashe swallowed hard. "No one move a muscle," she said quietly.

A trap. That's what this was—a search drone playing some recording, trying to flush them out.

"Please!" Another voice this time. "Our friend needs help!"

There was movement at the edge of Ashe's vision: Folly, who'd crept closer.

"Should we help them?" she whimpered.

"Do we look like heroes to you?" Ashe snapped. But slowly

LUCK OF THE DRAW

she stood, keeping the Viper on the door. Maybe it was a trap. But maybe it wasn't, and if someone had made it all the way in here, maybe the path they'd taken was clear enough to follow out. "B.O.B., be ready. Bars, keep us covered. Everyone else—you fire before I do, I guarantee that's the last bad decision you make, got it?"

Slowly, senses straining for any hint of danger, Ashe made her way around the barricade. B.O.B. was right behind her, his arm cannons at the ready. They reached the door. Ashe could hear some faint noises outside, nothing that said drone or warbot, but who knew what other tricks Null Sector had up their sleeves. Ashe held up three fingers to B.O.B., who nodded. Then two. On one, she kicked the door open and plunged through it, ready to fire.

Someone let out a scream. Hands flew into the air—human hands. Ashe lowered the Viper. Standing outside the ballroom were two humans and an omnic lying on the floor between them. All three wore the garish server uniform of the Spectacle. The omnic wasn't moving, and one of the devices Ashe had seen from the balcony earlier was affixed to her head.

"Please don't shoot," begged a young, freckled man whose name tag read DIETRICH.

"I ain't gonna shoot you." Ashe peered beyond the trio. "You followed?"

They shook their heads.

"Get inside. B.O.B., give 'em a hand."

Back in the ballroom, with the doors closed up again, they gathered around the subdued omnic.

Ashe stared at the Null Sector device, a cold feeling growing in the pit of her stomach. But whatever it was, it probably wouldn't help them escape. "Where you came from, any chance we can go back that way?"

Dietrich shook his head. "We barely got by the drones. And more are coming—a lot more. They're making their way up the Strip, clearing the casinos and hotels as they go."

His companion, a woman named Nisha, nodded. "Warbots flushed a bunch of us from the other side of the resort. Rounded us up at first, but then they started taking the omnics, putting those *things* on them. We didn't know if it was killing them, or just . . ." She paused, trembling. "Everyone panicked, made a run for it . . . they mostly went after the omnics, so we were able to get away and hide until it was clear."

"They went for the omnics?" Lark interjected.

"Yeah." Nisha's gaze dropped to the omnic server, whom B.O.B. was gently turning face up. Up close, the Null Sector device had a threatening air, its cylindrical appendages lit up with an ominous purple light. But its purpose was impossible to glean. In fact, the omnic appeared entirely unharmed. If not for the lack of response, Ashe wouldn't have known anything was even wrong with her. It was like the lights were on, but

LUCK OF THE DRAW

no one was home. "We went back for Birdie—she's our friend. We . . . we don't know what the attackers did to her—what that thing is—"

"I saw a warbot attach one of those things to an omnic outside." Ashe waved Bars over. "Any ideas?"

The omnic sniper leaned over the device for a few moments, then straightened and took a step back. "I've never seen anything like it. Given the message they're playing, maybe it's some sort of . . . passive restraint?"

"There's one way to find out." Before anyone could react, Lark lifted one booted foot and brought her heel down hard, a blow that snapped off several of the cylindrical appendages.

"No!" Ashe barked, but it was too late. A crackle of energy arced across the device's surface, triggering its release. The moment it fell from Birdie, the omnic seized once, cranial lights surging before going dark.

Nisha let out a cry and fell to her side. "Birdie!" She shook her friend once, then again. When she looked up, her eyes were filled with tears. "She's—she's dead."

Dietrich's hands flew to his mouth, smothering the horrified noise that escaped him.

Bars went stiff with surprise.

"Son of a—" Ashe charged Lark, getting in her face. "Are you nuts? Why did you do that?"

Lark, to her credit, didn't retreat. She stared Ashe down,

then shrugged. "We know what they do now, don't we?"

They sure did. And it was becoming clear that Null Sector had a strange idea of "liberation" for the omnics.

"Yes," said Bars, in a cold, flat way Ashe didn't like. "And you just killed an innocent omnic to figure that out." She looked to Ashe, who shook her head despite the outrage burning in her gut. *Not now.*

Bars wasn't pleased with the order; Ashe could read that in her face. But Bars could read Ashe too, and she understood that, if not for needing every good shot they had at the moment, Lark wouldn't be getting away with what she'd done. Without another word, the sniper led the crying Dietrich and Nisha deeper into the ballroom to where the other civilians were hiding.

Ashe waited until they were out of earshot. "You do anything like that again, and I'll—"

"You'll *what*?" Lark took another step forward, so that only a few inches separated them. "This give you any big ideas for escape, Ashe? No? Well, I was listening to what they said even if you weren't."

Folly put a hand on her sister's shoulder, trying to pull her back. "Lark, hey, maybe don't—"

Lark shook her off. "They're targeting the omnics. That's what those two said."

Ashe narrowed her eyes. "I heard them."

LUCK OF THE DRAW

"Well, then what are we waiting for?" Lark's eyes were bright as newly minted coins now, brimming with energetic hope. Her voice dropped low, almost to a whisper. "We use the omnics as bait, and then we make a run for it. Got it?"

Ashe glared at Lark, jaw tightening. "Not a chance." The words ground their way out through her gritted teeth. "Deadlock Rebels don't use each other for bait."

Confused furrows appeared in Lark's brow. "So, what? You'd doom us all for a few tin cans who are gonna get snatched up anyway?"

Blood rose in Ashe's cheeks as B.O.B. moved protectively closer to her. "They ain't tin cans, and that ain't happening. Let it go."

"Or what?" Lark's voice jumped higher. "All these stories I heard about how smart, how daring you are, Ashe. Well, I'm starting to think they're exaggerations. Because we don't exactly have many options. This is it. This is our chance to get away!"

"I'm not leaving Bars or B.O.B. behind!"

Lark laughed, a short, derisive snort. "Okay, the sniper I can understand, but this one?" She nodded her chin at B.O.B. "How much of a loss would that be? It doesn't even talk! Heck, this is your chance to upgrade and get a new model that actually works right."

Ashe went cold as ice. She had the Viper cocked and halfway raised before she caught herself. *"What did you say?"*

B.O.B. put one hand on her shoulder, a heavy, calming gesture that seemed to say, *It's all right.*

Except it wasn't.

Ashe pulled free of him, fingers digging into the Viper's stock. "No one talks to a member of the Deadlock Rebels like that." Then, lower, in a near growl, "No one talks to *B.O.B.* like that. There is nothing—NOTHING—wrong with him. You got it?"

Lark laughed again. Not an amused sound; one that was tinged with desperation. Folly tried to step between them, but Lark shoved her sister away. "You know what, Ashe? No. No I don't. Because I've had enough of taking orders from you. And the rest of the Jackpot Gang, they're done listening too. Because it's clear you aren't half as tough as you let on." Lark's hand, hanging near the handgun strapped to her belt, twitched.

Ashe shook her head slowly. "Don't you do it."

It didn't come as a surprise that Lark didn't take that good advice. She drew the gun and leveled it at Ashe. "Move aside. Or you won't have to worry about any of those warbots out there."

To hell with needing every shot. Ashe swung the Viper, using it to strike like its namesake, knocking the handgun from Lark's hand. The young woman let out a noise of pained surprise as it went flying. Then she glared at Ashe, teeth bared.

Ashe tossed the Viper to B.O.B., then called out, "Bars?"

"Anyone moves," the omnic sniper said calmly, raising her

LUCK OF THE DRAW

rifle in the direction of the encroaching Jackpot members, "and—well, really just best not to move."

Everyone obeyed. Except for Lark, who let out an angry howl and swung at Ashe. Ashe dodged the blow, and then another, moving smoothly away from the attacks.

"Lark, don't!" Folly pleaded, eyes flickering from the fight to Bars and then back. "Please."

Lark raised her fists again. "Don't tell me to stop! Come help me, you cowards." Her eyes were fully wild now, cheeks flush with exertion. "Or are you all going to die here over a few stupid omnics?"

Ashe swung. Her uppercut cracked against Lark's jaw, sending her flying backward into a pile of boxes. They exploded like a piñata, bits of paper and packing material filling the air, then fluttering like snow onto Lark's prone form. Not that she noticed; the gang leader was out cold.

Ashe spun back toward Folly and the other Jackpot members. "Anyone else have anything to say about that?"

Silence filled the ballroom.

"Didn't think so." Ashe retrieved the Viper from B.O.B. "And just to make it extra clear, we are not using anyone as bait."

"Then . . ." The word came as a squeak, from Folly, who was leaning over her injured sister. "Then how are we supposed to get out of here?"

Bars tipped her head. "Fair question, boss."

LYNDSAY ELY

"I know," snapped Ashe. And they were running out of time. If what the servers had said was true, it was only a matter of time before Null Sector's sweeping forces reached the Spectacle. Already the distant sounds of gunfire and the occasional stray explosion were drawing closer. If they didn't make a move soon, they were going to be making their stand right here. And Ashe didn't doubt in the least that it would be a *last* stand.

She looked over to where the dead omnic lay, now covered by a tablecloth that P.T. had pulled from one of the tables. A cold pit grew in her stomach, eyes moving away from the grim scene to Bars, and then to B.O.B. The image of him with one of those devices flashed in her head, a device that seemed less a tool of liberation than a death sentence. Bile rose in her throat. She swallowed, then strode off a few paces. She needed a minute, needed to *think*. Needed to figure a way to—

A bit of debris on the floor caught her eye—a brochure from the boxes Lark had fallen into. Ashe picked it up and read it, and then read it again. "Hey, you!" She waved over one of the Spectacle servers. Nisha crept reluctantly over, stopping well out of arm's reach. Ashe waved the brochure at her. "Y'all still do this?"

Nisha blinked at the bit of paper, eyes widening. Then she nodded.

"And how far to the nearest stairs?"

Nisha pointed. "Not far. Just down the hall and past the casino floor."

LUCK OF THE DRAW

"Good," Ashe said. "Then I've found our way out of this ridiculous place." She held up the brochure, a tract advertising tourist sightseeing flights over the Las Vegas Strip and surrounding attractions, taking off from the roof of the Spectacle Resort & Casino.

Folly's mouth dropped. "That's crazy."

"It's what we've got." Ashe dropped the pamphlet onto a table. "Listen up, Deadlock Rebels. Even if we fought our way out of here, there's no way we're going to make it to the bikes and then out of the city. There're too many bots out there, and we don't have the ammo-. But they're focused on sweeping the streets, not the skies. And if we're quick and sneaky—and I happen to know for a fact we excel at both—we can steal the sightseeing ships and be gone before they even realize we were here."

Nisha, now at the head of the pack of civilians and omnics, wrung her hands. "Um, what about us?"

Folly had the same question in her eyes, as did the rest of the Jackpot Gang.

Ashe sighed. "Anyone who keeps up doesn't get left behind. But get ready, because if we're doing this, we're doing it *now*."

Minutes later, they were back at the doors of the ballroom, listening for any movement outside or any sign of the Null Sector bots. But there was nothing, only the recording again, and the now familiar sounds of conflict, closer than ever. But not in the hall, and that's what mattered.

"B.O.B." The omnic was standing over Birdie, staring down at her still, sheeted form. He looked up when Ashe called. "Time to go, big guy."

He gave Birdie one final glance, then stomped over to where the unconscious Lark still lay. Picking her up, he threw her over his shoulder like a sack of laundry, then made his way to Ashe's side.

Ashe snorted. "You're too nice, you know that, B.O.B.?"

He looked down at her, shrugged, then raised his free arm, cannon ready.

"Fine, but she'd make a good projectile if we encounter any of those warbots." Ashe gestured at the gathered company behind her. "Everyone ready? Because here we go."

She moved first, slipping into the hall, eyes peeled and the Viper ready for any signs of threat. But there was only the eerie, scarlet-soaked emptiness, something the Spectacle had probably never seen so much of in all its days. With Ashe leading and Bars and the triplets taking up the rear, their motley party moved slowly through the hall of the casino, following Nisha's directions. Every second that ticked by, every door or hallway they passed, Ashe expected the sudden hum of a search drone, or worse. But there was only the ruin left by the initial attack, in the form of overturned tables, spilled drinks, and slot machines gone dark. The stairs were tucked away in a remote corner. Ashe pushed the door open and gazed up. It was even

LUCK OF THE DRAW

darker here, the stairwell the color of spilled blood, which wasn't particularly inviting. But their best chance at escape was on the roof of the Spectacle. The only way out was *up*.

"Everybody keep quiet," Ashe hissed. "Just because we didn't see anything doesn't mean nothing has seen us."

They were a slow, somber procession as they trekked up stairway after stairway, silent save for the shuffle of footsteps and increasingly labored breathing. Even Ashe was getting winded by the time they made it to the twentieth floor, where the final stairway spilled them onto a landing with a door that read ROOF ACCESS. Ashe kept them still for a moment, letting the humans catch their breath. And not, she'd ever admit, because she wasn't sure what was going to be on the other side of that door. Because if the roof was empty, she was fresh out of ideas.

Ashe took a deep breath and cracked the door open. Then she let it out in relief. A hundred paces away sat two ships, cozy as a pair of nesting birds. They were smallish affairs, meant to carry a dozen or so tourists, with big windows they could press their faces into as they flew over the Strip. A ridiculous indulgence, but in that moment, they were the prettiest things Ashe had ever seen.

She turned back to the stairs. "Bars, boys, get up here."

The Deadlock Rebels made their way to the front of the pack.

"What's the play, Ashe?" said Bars.

LYNDSAY ELY

"P.T. can fly the first ship. Zeke and Terran, you two cover the escape. Load in the civilians and go. B.O.B., Bars, and I will take the Jackpot Gang in the other ship." Ashe leaned in close. "You don't wait for us, you hear? You get that ship up and running and you get to Deadlock Gorge. No looking back."

P.T. nodded. "You got it, boss."

"Okay. The rest of the plan is this: quick and quiet. Everyone hear that?" Ashe called down the stairwell. Their silent, hopeful faces were answer enough. "Then let's go."

Ashe stepped onto the roof. At this height, a brisk breeze whipped at her hair and clothing, whistling in her ears. She did one quick sweep of the roof—empty save for some kitschy, vintage-style metal signs advertising highlights of the sightseeing tour—and headed for the ships. Smoke tickled her nostrils as they moved; there were at least two big fires to the north that she could see, and some smaller ones to the south. But no Null Sector bots, and that's what mattered.

They reached the first ship. It was as gussied up as the inside of the casino, with rows of leather seats in the rear and a velvet curtain separating the cockpit up front.

"P.T.!" Ashe hissed.

"On it!" he replied quietly, jumping into the vehicle and pulling aside the curtain. He plopped down into the pilot's seat and began tapping at the displays. Suddenly, the engines hummed to life. P.T. grinned and signaled they were ready to go.

LUCK OF THE DRAW

"Okay, start loading in the civilians." Ashe turned to the others. "C'mon, the other ship is ours."

Folly shifted nervously. "I—I can fly it."

"B.O.B. can fly," Ashe spat back. "I trust him."

"But—"

"We do this my way or you're staying here. Got it?"

Folly blinked at her once and then nodded.

"Good."

As they reached the second ship, the first began to rise off the roof, slowly, then faster. As ordered, P.T. didn't wait. The first ship turned away from the Strip and flew off.

"Move it," called Ashe. She and B.O.B. jumped into the back of the other ship, followed by the Jackpot Gang. B.O.B. gently buckled the unconscious Lark into one of the seats, then headed toward the cockpit. "Get us moving, B.O.B. If they haven't noticed us yet, someone is gonna spot the first ship at any moment." Bars, covering them, was last on the roof. Ashe grabbed her hand and helped her into the ship. "If we're lucky—"

But they weren't.

Over Bars's shoulder, Ashe spotted movement. Search drones, cresting over the far side of the roof. And not a few—a whole mess of them, plus several warbots and a pair of the units with the control devices.

Ashe swore. "B.O.B., we need to get out of here NOW!"

But even as she spoke, Ashe knew it was too late to avoid

a fight. The Null Sector forces had them in their sights. Worse, it wouldn't take more than a few well-placed hits to ground a civilian ship like this. Ashe fired in their direction, picking off a couple of the drones as she felt the ship shudder to life and begin to lift off.

Good, she thought, knowing it wasn't. It didn't matter; the bots were too close, locked on and ready to fire. Still, she turned toward the cockpit, ready to tell B.O.B. to hold them steady as he could and give them a chance to shoot their way clear of the fray—

But B.O.B. wasn't in the cockpit. Folly was, and B.O.B. was moving toward Ashe with focused determination.

"B.O.B., what in the world are you—"

He reached Ashe, pausing only a moment to give her forearm a quick, gentle squeeze.

Then he pushed her into Bars and leapt out of the ship.

After that, everything happened at once.

B.O.B., running across the roof, firing as he charged the Null Sector forces.

The bots, turning their attention from the ship to him.

And Ashe, understanding what he'd done.

"No!" She lurched for the open door, but Bars held tight, pulling her back. "B.O.B.! Don't you dare—B.O.B., you get back here!"

More resistance. More hands holding her back, keeping her

LUCK OF THE DRAW

inside the ship as B.O.B.'s name tore from her lips again and again. But he didn't listen. He was giving them a chance to escape.

And all Ashe could do was yell as the ship lifted away from the Spectacle.

TWENTY-EIGHT YEARS EARLIER

B.O.B. slid a plate of food into her view. All of Ashe's favorites—macaroni and cheese, spicy black bean salad, fluffy biscuits dripping with honey butter. She stared down at the plate, then pushed it aside. Undeterred, B.O.B. nudged it back again.

"I'm not hungry!" she snapped, loud enough that the words practically echoed through the deserted mansion. Her parents were gone—*again*—off to work. Gone even after they were supposed to be home for a while, had promised that—

Ashe let out a huff. It didn't matter what they'd promised. It *never* did.

Somehow that didn't stop the anger, though. She seethed quietly, putting her head down on her arms, staring out across the vacant plane of the dining room table as B.O.B. hovered beside her. "I just wanna be left alone," she muttered, closing her eyes.

The omnic's hulking presence remained.

Ashe gritted her teeth. "I said LEAVE ME ALONE!"

A moment passed. Then came the sound of B.O.B.'s heavy tread, obediently leaving the room. Whatever. She knew he would come back later, once she'd cooled off. Usually with a fresh plate of food or some other offering proposed by his programming. But until then . . .

Ashe remained stubbornly slumped over the table as the afternoon turned to dusk, and then to dark. Still, the omnic didn't return.

She felt a tickle of guilt. Had she really yelled that loud this time?

"B.O.B.?" He always came when she called. But no footsteps answered her, only the viscous, suffocating silence of the empty mansion. "B.O.B.?"

Ashe checked the kitchen. And the bedroom wing. And the library and the garage. She wandered the grounds for hours, calling his name.

But B.O.B. had listened.

He had left her all alone.

NOW

"B.O.B.!"

Ashe gave one last, great wrench of effort. Felt the hands

LUCK OF THE DRAW

fall away. Then she was free—free—and running. Leaping. And then—

The casino roof rushed up from below, too fast. She hit hard, white-hot pain shooting through her ankle as she toppled to one side. As her shoulder hit the cement, she rolled, fingers tightening around the Viper as she righted herself and fired. One of the drones ringing B.O.B. exploded. Then another. She pushed her way up, ignoring the rushing in her ears, the heat in her cheeks, the pain as she hobbled forward—nothing existed except for B.O.B. and the Null Sector bots swarming him. The omnic had quit firing on them—*out of ammo!*—and his metal plate was beginning to show damage. Glancing shots, only meant to subdue him. To give the units carrying the disabling devices their chance.

Well, she wasn't going to let that happen. Wasn't going to lose B.O.B. to Null Sector, or another Crisis, or whatever this was.

Not again.

Suddenly, B.O.B. took a hit to the knee. He crumpled.

"B.O.B.!"

If he hadn't heard her screams before, he heard them now, head swiveling in her direction. His whole body went stiff. Then, with visible effort, the omnic pushed himself back onto his feet and lunged for the nearest object. He tore a metal sign free, swinging it like a weapon. One warbot went flying. Another

dodged the swing, but Ashe picked it off before it had a chance to fire on B.O.B. again. Using the sign to shield himself from the remaining attackers, B.O.B. limped toward her as she did the same toward him.

"B.O.B., you big piece of—" Her voice broke as they met in the center of the roof.

But there wasn't time for words anyway. The bots had recovered, gathering themselves again. Ashe picked off two more, but others took their place in an instant. One of the units with a control device made a move toward B.O.B. She aimed and fired.

Click.

Empty. Letting out a scream, Ashe ducked under the sign and swung the Viper like a club, smashing the device. B.O.B. followed her attack with one of his own, sending the bot flying over the side of the hotel roof.

Then . . .

Then nothing. Ashe's gut dropped to the bottom of her boots. They were out of ammo. Surrounded. And it was clear the Null Sector forces knew it. They'd stopped firing, forming a circle around them. Ashe turned so that her back was to B.O.B.'s, leaning into the heavy familiarity of him. She held her breath, gaze sliding from drone to drone, a crushing feeling growing in her chest. Any moment they would fire; any moment it would be over. Then, finally, she saw what they were waiting for:

LUCK OF THE DRAW

another unit brandishing a control device had appeared, hovering just beyond the ring of drones.

Ashe let out a long, measured exhale. "Ain't looking too good, B.O.B." She felt him turn. One hand fell on her shoulder, gently pushing her aside.

Ashe didn't move an inch. "I don't think so. I'm not living without you again. Whatever those devices are, there's no way anyone is putting one on you. Not as long as I'm drawing breath." She reached up, placing her hand into B.O.B.'s as the drones parted, moving aside for the device-bearing unit.

B.O.B.'s hand tightened.

Ashe stood a little straighter. "Beginning to end, B.O.B. You and me."

The bot started forward.

Then it exploded. A nearby drone met a similar fate, and then another.

More gunfire sounded from above. Ashe looked up. The ship! The windows were broken and Bars was hanging out of one of them, firing in a way that would have seemed reckless if it had been anyone but her. With every shot, a drone exploded, not a single bullet wasted. When the ship was close enough, the Jackpot Gang appeared as well, letting loose with what ammo they had left. Around Ashe and B.O.B., the drones popped and dropped, enough to open a path.

"Ashe, run!"

LYNDSAY ELY

She'd moved before Bars yelled the order, keeping ahold of B.O.B. as she surged forward, ignoring the searing pain in her ankle, focused entirely on the ship. More shots, more explosions. Projectiles pinged off B.O.B.'s makeshift shield, but someone must have been on their side, because they reached the open door of the ship and tumbled in. One of the Jackpot Gang tossed Ashe a rifle. She caught the weapon with one hand and threw the Viper back with the other, twisting in time to pick off two drones that had nearly caught up with them.

"Hold on!" cried Folly.

There was a sharp lurch as the ship lifted off again. Ashe and the others kept firing as the Null Sector forces rose off the roof in pursuit. But their numbers were far fewer than only moments ago, and they wouldn't be able to keep up for long. Ashe smirked, taking out the closest—

No. Behind her latest target was another unit with an open aperture, out of which a small missile had appeared. It fired before Ashe had a chance to cry out a warning.

But the shot was off, doing little damage as it clipped the ship's back end. Still, the impact sent the ship reeling to one side. Not enough to turn it off course, but enough to throw Ashe off her feet and toward its open door. As gravity sunk its unforgiving hooks into her, promising a fall that was going to result in a lot more than a busted ankle, the last thing Ashe

LUCK OF THE DRAW

saw was B.O.B., his metal form dented, singed, and outright destroyed in some spots.

It was, oddly enough, a sight that filled her with joyful, relieved warmth.

TWENTY-SIX YEARS EARLIER

It couldn't be.

No, Ashe's eyes were playing tricks on her, as they had a hundred times before during the last two gray, shapeless years. Ever since the Omnic Crisis began and then ended. Hope would swell, building itself up within her chest, only to get punctured and deflate as whatever wishful mirage she'd spied in the distance resolved itself into a vehicle or shadow or other disappointing reality.

And yet . . .

This time, the form stayed true, a shimmering spot growing larger at the far end of Leadrose's lengthy driveway. Ashe descended the steps of the front entranceway without looking, so distracted that she barely caught herself when she stumbled on the last one. For a moment, icy fear stabbed as she lost view of it, sure it would be gone when she looked again. But it wasn't. And she knew that shape—the towering height, the slope of the shoulders, the metallic sheen.

LYNDSAY ELY

Ashe was running before she fully realized it, legs pumping, boots knocking against the pavement with a sharp staccato. Her eyes burned, soon followed by her lungs, but she barely felt either as the distant figure grew in her sight, real and true and *alive*.

B.O.B.

Ashe slowed a few paces from the omnic, who'd come to a stop.

It was definitely B.O.B. But there was something different about him. And not only his exterior, riddled with the sort of damage that made Ashe's stomach ache. She held her breath, eyes sore with tears that wouldn't come, as the omnic remained rooted where he was, staring at her with an unfamiliar intensity. Moments ticked by, increasingly thick.

Then Ashe lurched forward, throwing her arms around the stout, unyielding form she'd known so well, for so long. At first, he was still. Then—slowly, tentatively—his arms rose too, circling her in an embrace. She pressed her cheek to him, fingers curling into the tattered garment he wore, devoid of understanding. She had questions, so many questions. What had happened to him? Where had he gone?

But as B.O.B. hugged her closer, all Ashe could do was sob.

LUCK OF THE DRAW

NOW

B.O.B. lunged forward, reaching for her. His metal hand closed around Ashe's, arresting the falling sensation and pulling her back into the safety of the rising ship. For a moment, all Ashe could do was gasp for breath, wind still whipping at her hair as she stared up at the omnic towering over her. Around them, the gunfire petered out, and when Ashe finally found the composure to glance behind her, the pursuing drones were as small as ants, the Spectacle Casino a distant dark form silhouetted by the light of the setting sun. She turned back to B.O.B., the edge of her mouth tweaking up into a weak smile. He nodded thoughtfully, releasing her hand only now that she was safe and steady. Shaking off the last of the close call, Ashe stood up straight and took a step forward.

A cry escaped her. Her damn ankle; she'd momentarily forgotten about it.

"Everybody okay back there?" Folly called from the front of the ship.

"Okay enough." Ashe hobbled over to the cockpit. "Didn't mark you as someone who'd come back for stragglers."

Folly tossed a grin her way, then glanced at the unconscious Lark. "Figured we owed you one. And that your sniper there might put a bullet in me if I didn't."

Bars shrugged. "I was considering it." Then she cocked her

head behind her. "Don't see any signs of continued pursuit, boss. I think we're home free."

"Good." Ashe sighed. "I've had enough of Las Vegas to last me a lifetime."

"I think maybe I have too," muttered Folly.

With that, Ashe limped back to B.O.B., who had set himself down along a line of seats in the very back of the tourist ship.

Letting out a long, relieved breath, Ashe squeezed in next to him. "You okay, big guy?"

He didn't look it. The first thing they were going to do back at Deadlock Gorge was get B.O.B. some serious maintenance. Still, he gave her a contented thumbs-up.

"Don't you dare pull anything like that again, you hear me?"

Peering down at her, B.O.B.'s head tipped to one side, his eyes narrowing.

"And don't you give me that look either. I said what I said and I meant it. Beginning to end, B.O.B., you and me . . ." Ashe leaned into him, as she had so many times before, and closed her eyes. "You and me."

A FRIENDLY RIVALRY

JUSTIN GROOT
GAVIN JURGENS-FYHRIE
MIRANDA MOYER

A FRIENDLY RIVALRY

"So, I know this looks bad," Junkrat said, struggling against the chains to scratch his nose.

Mako Rutledge, aka Roadhog, his much larger, much more heavily shackled partner, said nothing. Through a high, barred window in the wall, there was a metallic *crunch* and a scream as someone in the arena lost an important bit.

Junkrat wasn't listening. He had a strong suspicion his best mate was nervous. "Relax!" he said. "I'll do *all* the talking. And if things get too heated, I can always tell Queenie where the secret treasure is."[1]

Roadhog said nothing.

[1] Junkrat's knowledge of a secret treasure hidden below Junkertown was the worst-kept secret on the Australian continent. Even if you traveled a hundred miles into the irradiated Outback, the hermit you found out there would say, "Junkrat? I've heard of him. Got a secret treasure, doesn't he? Never shuts up about it."

GAVIN JURGENS-FYHRIE · JUSTIN GROOT · MIRANDA MOYER

"Come on," Junkrat said. "You know me and the Queen! We're tight as marbles! Not like you and me," he added hastily. "But like . . ."

He prodded the chipped floor tiles with a dirty toe.

"A friendly rivalry!" he said. "Sometimes not *that* friendly, but there's respect there, right? *Mutual* respect."

Roadhog grumbled. Junkrat took this as a positive sign.

"So yeah, maybe we'll get a stern talking-to." Junkrat shrugged. "Then, we offer a statement of sincerest regrets, some shovel time at the Sludge Pit, and then? Back to the bar for some boba and cricket crisps!"

Roadhog did not look relieved. He looked, Junkrat judged, a trifle *more* worried.

"All right," Junkrat admitted. "Maybe we'll spend a few days in the clink. Week at the most. Is that what you're worried about?"

Silence.

Junkrat snapped his fingers. "You think we should escape now! You're right. Waiting around for our sentence? That's not worthy of master criminals like Junkrat and Roadhog! We should already be down the sewer and halfway up the trench! *Let's do this thing!*"

Roadhog did not leap to his feet and rip the chains from the wall. Junkrat was losing patience with him.

"What is it, then? What are you waiting for?"

A FRIENDLY RIVALRY

The door to their cell slammed open.

"All right, gents!" said the guard. "It's time to get executed!"

For the first time in a long while, Junkrat was speechless.

Roadhog sighed.

"Finally."

The Scrapyard was a huge ring of rusted steel, its floor a sandy landscape of stains and debris. At its center was a metal spire, hung with robot parts and other bits.

Above the walls were the seats, packed to bursting with people Junkrat had known his entire life. Touched, he gave them a cheery wave, and someone threw an egg at him.

"I saw that, Scumbo Wigley!" Junkrat shouted. "You should be ashamed! Here in Junkertown, our wise and compassionate Queen demands we treat prisoners with *respect*."

Roadhog tapped him on the shoulder.

High above, on a vantage jutting over the ring, stood the Junker Queen, nearly seven feet of armor, scars, muscle, and one very large knife. Her axe, Carnage, loomed over her shoulder like the promise of painful death.

She was smiling. It wasn't a friendly smile.

"You two don't get respect," she said. "You've barely got my attention. I'm just here for the execution."

GAVIN JURGENS-FYHRIE · JUSTIN GROOT · MIRANDA MOYER

"This is outrageous!" gasped Junkrat. "Roadhog and I are loyal subjects. If there are allegations against us, we demand to hear them!"

The Junker Queen gave him a *look*.

"Fine," she said, holding up a finger. "Attempted demolition of Junkertown's main gate."

"We were testing your defenses!" Junkrat protested.

"Blasting Outback Bill's Premium Sausage Stand to chunks." A handful of charges now. "Along with a few of his favorite customers."

"We—" Junkrat paused and glanced at Roadhog, who nodded. "Right, we did that one. Sorry, mate!"

Outback Bill sagged in his seat, looking more hurt than angry.

"And worst of all," the Junker Queen said, leaning into the silence, closing her fist, "the Biscuit Incident."

Angry muttering rose like a tide, and Junkrat whirled on them.

"You look me in the eyes and tell me you wouldn't have done the same!"

"The sentence," the Junker Queen said from high above, "is death at the hands of my champion."

"Afraid to challenge us yourself?" Junkrat shouted.

"Nah. Giving you a chance because the biscuit thing was pretty funny. Catch." She kicked a crate over the edge. It shattered on the ground.

A FRIENDLY RIVALRY

"Unbelievable," Junkrat muttered, going through the wreckage. He grabbed the six grenades on a rather fetching bandolier, while Roadhog wound his chain hook around his meaty forearm.

The huge iron door at the far end of the arena rose. Behind it, a mouth of darkness.

"Isn't this wonderful?" Junkrat breathed. "Dying at the hands of the champ! What an honor!"

"You die," Roadhog said. "I'm living."

"Tinkers and Wreckers, Demolitionists and Scavengers..."[2] The Junker Queen hefted her axe. "Your champion and mine: Wrecking Ball!"

A grapple claw crunched into the top of the doorframe, and a huge ball-shaped mech swung into the air. Roadhog grabbed Junkrat by the bandolier and hurled him out of the way.

Above, two quad cannons unfolded from the ball and opened fire, shredding the sand where Junkrat had been. The crowd bellowed and whistled. Junkrat, who had landed on his head, wasn't as happy about the turn of events.

"Hasn't lost a single match and never leaves the mech!" said a voice in the crowd nearby. "No one's ever seen their face!"

"What you reckon? Too ugly?" another spectator said.

2. The Queen ran Junkertown, but the factions made the city work, more or less. Scavengers found parts for the Demolitionists and Tinkers to build delightful contraptions with. Wreckers, on the whole, wrecked things, but in a generally helpful fashion.

"Could be. But think about it: In this heat? *Never* leaves the mech?"

"Gotta smell fierce in there. Like a sewer made of cheese," Junkrat shouted, excited to join in.

"Keep moving, idiot," Roadhog said. Neither saw the mech bounce, rebound off the wall, and rocket at them like a murderous comet.

Junkrat raised a finger to retort, but Roadhog was already hurtling toward the far wall at unconscionable speed, wrapped around the bulk of the champ.

Stone crunched. The crowd groaned. The Queen bellowed laughter from her high throne.

Junkrat yanked a grenade from his bandolier, pulled the pin because he worked better under pressure, and looked up.

Wrecking Ball's grapple was coming right at his head. Junkrat jerked out of the way, then grabbed the line as it retracted, whipping and hissing. The momentum pulled him off his feet and into the air, like a dust-colored bird. On his way over the mech, he dropped the grenade.

"Roadhog!" he shrieked as he shot toward the ground. "Catch me!"

Roadhog did not catch him. Roadhog lay at the far end of the arena, unmoving.

As Junkrat bounced along the ground, the grenade exploded. Checking his mouth for loose teeth, Junkrat staggered up,

A FRIENDLY RIVALRY

peering into the smoking crater where Wrecking Ball had been.

Where Wrecking Ball still *was*. The mech's armor was singed at best, and a little hatch at the top looked loose. But that was it.

"Wicker basket!" Junkrat swore, with feeling.

With a deep-bellied wheeze, a very much not-dead Roadhog surged forward, whirled his chain hook, and threw. The hook bit deep into the hatch. Muscle rippling beneath the meat, Roadhog pulled and—

An entire panel of the mech's armor tore away.

There, at the mech's controls, blinking in the brutal light, was a hamster. He was a smidge larger than the average, non-mech-piloting hamster. He had a mohawk.

The crowd went silent. Then, finally, someone spoke.

"*That's* the champion?" asked Outback Bill.

The hamster shook his fist and chittered angrily. Lights flashed on the front of the mech.

"He says, 'You'll suffer for that,'" the mech translated.

Leaping to their feet, the crowd *roared* in approval.

The hamster dropped into the mech's guts, and the quad cannons sprang out. Junkrat and Roadhog dove apart as bullets screamed past.

"It's all right, Roadhog!" Junkrat panted, ripping another grenade off his bandolier. "All we've gotta do . . . keep our distance . . ."

But the crowd was chanting.

"*Spin to win! Spin to win!*"

GAVIN JURGENS-FYHRIE · JUSTIN GROOT · MIRANDA MOYER

The mech ground to a halt on the sand. The hamster surfaced and nodded once. A grapple shot out from the mech and latched on to the spire at the center of the ring.

Slowly at first, then with greater and greater speed, the mech whirled around the center, letting out slack little by little. It was a blur of metal, an ever-widening circle of death.

Junkrat and Roadhog backed away.

"You're gonna be sorry!" Junkrat shouted up to the Queen.

She leaned over her balcony. "You're gonna be *paste*."

Junkrat bit the pin out of his grenade thoughtfully and eyeballed the hamster, whirling around the spire . . .

He threw the grenade.

The explosion hit its mark. Unmoored, Wrecking Ball hurtled in a straight line through the wall of the arena, and by the sound of it, the next three streets.

The crowd held their breath as the Junker Queen peered out over her city.

"He's fine," she said. "Looks like Bill's new shack broke his fall."

The entire crowd, Bill included, cheered as the Queen leapt down from her balcony.

"That's all right. Kind of wanted to kill you both myself anyway."

"B-but you don't have to," Junkrat said, his lip quivering. "And consider this: if I die here, you'll never know the location of my secret treasure!"

The Queen and the crowd groaned as one.

A FRIENDLY RIVALRY

"No one cares about your treasure," the Junker Queen said, making her way toward him.

"That's right, my infamous secret treasure!" Junkrat said, bearing the scorn with the injured dignity of a true hero. "For I alone know how to get through the *Final Door*!"

Silence, in which was heard the distant crunching of a giant round metal mech rolling furiously over sand in the direction of the arena.

"What's the Final Door?" someone asked.

"The last unopened door of the omnium,[3] nitwit."

"Oh, *that* door."

"The Final Door's impenetrable. We've hit it. Bombed it. Nothing made a scratch." The Queen scowled at Junkrat. "*You* never got in."

"Not only in, but *out*!" said Junkrat. The crunching of sand was getting louder.

"Yeah?" said the Queen. "And you did that how?"

"I fell through a series of increasingly minuscule holes in the roof! Found a control room and hooked it up to me own special key!" Junkrat gave the Queen a saucy wink. "You want through the Final Door, you're gonna need my eye."

The crowd considered this.

"Kill him and take his eye!"

3. Junkertown was built within the ruins of an omnium, a pre-Crisis factory that produced robotic servants for humans and mechanical soldiers for the rogue god program Anubis. Junkers, appropriately, had blown theirs up ages ago and used it for scrap.

GAVIN JURGENS-FYHRIE · JUSTIN GROOT · MIRANDA MOYER

Wrecking Ball popped back through the hole in the wall just as a wave of Junkertown muscle poured over the railings. The mech tumbled with them, like a cork in a storm. From the other side of the arena, blast-scorched Demolitionists lit fuses, while Tinkers hefted massive machines.

Down in the arena, Roadhog looked from one advancing army to the other and sighed.

"Junkrat," he said.

"Junkrat, you're a genius?" Junkrat said hopefully.

"Knife," Roadhog said.

"Oh, what a relief. I thought you were gonna say idiot."

"Knife," Roadhog said, because one of the Wreckers had thrown one.

The Junker Queen drew her axe and swatted the flying knife out of the air.

"Mako," she said, "is he lying?"

"Don't know," Roadhog said.

"Figures." She turned to the advancing army of Wreckers. "What makes you lot think you can claim treasure in *my* city?" Before anyone could answer, a hundred Demolitionist bombs went off at once. A cloud of dust descended, leaving Junkrat standing in the Junker Queen's growing shadow. All around them, the Wreckers fought a life-and-death battle against themselves to get to him.

"I was really looking forward to watching you die," she said.

A FRIENDLY RIVALRY

"Me too," Roadhog said. The Junker Queen patted him on the shoulder sympathetically, then turned as Wrecking Ball, at last, rolled up.

"Where've you been?" she said.

The hamster clawed his way out of the cockpit and snarled something.

"The mammal says he fell into a sewer," the mech translated.

"And that's why you stink, yeah?" the Junker Queen said, snorting. "Not because you never take a bath."

Junkrat clawed at the air, trying to understand.

"You knew?!"

She turned, and the smile dropped from her face like a guillotine.

"I don't remember saying you could speak, ratbag."

"*He's a wombat in a robot suit!*" said Junkrat.

The Junker Queen tilted her head. "And you're a rat, and your mate's got a pig face," she said. "I'm bored talking about this. You owe me treasure."

She slapped Wrecking Ball's plating and pointed through the crowd of Wreckers.

"Champ! Lay out the red carpet!"

Firing a grapple through the crowd, Wrecking Ball surged forward. Roadhog charged after, laying about with his hook to keep the path clear. Junkrat followed . . . with the Queen's knife at his back.

GAVIN JURGENS-FYHRIE · JUSTIN GROOT · MIRANDA MOYER

The four sprinted, staggered, and rolled down a crooked alley. On neighboring streets, gangs of hunting Wreckers called to one another like drunken wolves.

Without a pause in the pace, the rolling ball sprouted four legs, skittering ahead of the group as a Wrecker burst out of a side alley and pointed a rifle at them. The mech bounded into the air, spun, and came down on the Wrecker with a *crunch*.

Junkrat winced. When he saw the state of the Wrecker, he winced again and surged forward to Roadhog, jogging at the front of the pack.

"Roadhog," he whispered.

"No," Roadhog said.

"What do you mean, *no*?"

"No more plans."

Junkrat *almost* exploded. But he decided, rather cunningly he thought, to save his temper for later.

"Once Queenie gets the treasure, we're expendable. Right?"

Roadhog said nothing.

"So, once we get through the door, wait for my signal. All right?"

"What are you two whispering about up there?" the Junker Queen demanded.

"The treasure," Junkrat said, sticking to the truth.

"*My* treasure," the Junker Queen corrected. "And what is it, anyway?"

A FRIENDLY RIVALRY

"A surprise," Junkrat said. "But I'll tell you one thing. You'll never see it coming!"

He cackled a little while the rest of the group trekked on, picking off Junkers as they went. Together, they exploded into a courtyard at the top of a hill. At the very bottom, set in the rock foundation of a leaning building, was a polished steel door untouched by rust or time.

The Final Door.

Unfortunately, a crowd of Wreckers stood in front of it, waiting for them. Their leader was at the head of the group, with a fresh bandage and a large homemade cannon dangling from duct-taped handles. It was not clear what the cannon fired, or even if it *would* fire, but he looked awful pleased with himself, nonetheless.

The Junker Queen eyed them sourly, then slapped Junkrat upside the head.

"You never had much respect for my rules," she said. "But now I have you watching my back in this scrap. Do you know why I rule Junkertown? Why people follow me?"

Rubbing his cheek, Junkrat opened his mouth to respond.

"Don't interrupt," the Junker Queen said. "It's not because everyone's loyal to me, obviously. Take a look."

Junkrat *was* looking. The Wreckers had the cannon aimed now.

"It's not because I'm better than any of you," the Junker Queen continued, "though I *am*."

GAVIN JURGENS-FYHRIE · JUSTIN GROOT · MIRANDA MOYER

Vwoop. The cannon unleashed a white-hot beam of energy. A large section of the building above the Junker Queen's head evaporated.

"Pay attention," she said, while glowing embers fell around her like stars.

Junkrat's eyes instead went to the leader of the Wreckers, at the bottom of the hill. He was cursing and adjusting the angle of his cannon.

"I said *pay attention*," growled the Queen, grabbing Junkrat by the throat. "People follow me because when stuff goes wrong, when the mob is at the door and everything you've built is in flames, you need someone who'll do *this*."

She dropped Junkrat and drew her axe and knife.

"Who wants an axe in the face?" she roared.

Then she charged down the hill at the Wrecker mob. Alone.

Vwoop, went the cannon, but the Junker Queen was airborne, laughing, and the beam wasn't even close. Her axe carved an arc through the smoke and ash, and the cannon exploded. The Wrecker leader shrieked. As the rest of the Wreckers surged toward him, Junkrat considered his options. He counted the grenades on his bandolier (four), then looked at the crowd of Wreckers (more than four). Giggling, he pocketed a grenade, then sprinted down the hill into the melee.

Wrecking Ball swung through the crowd at full speed on his right, knocking great sweeping handfuls of Wreckers into the

A FRIENDLY RIVALRY

air. On his left, someone was making the funny bubbling sound people made when Roadhog got angry in their vicinity.

Junkrat broke into the center of the melee and saw the Junker Queen.

She stood with her back to the Final Door. Ten Wreckers with knives, clubs, hooks, and guns surrounded her. Another four lay in the mud at her feet, not looking at all well. Both her weapons were missing, and still no one dared get close.

"Took you long enough," she said. "Come here."

"Anything for the Junker Queen!" said Junkrat, aglow with sincerity.

The Junker Queen nodded and laid a hand on his scrawny chest. "Loyalty's a bastard. I avoid it, myself."

She lifted her hand, wearing the three pins from his remaining grenades like rings.

"Try not to blow up your eye, hey? Need it for the door and all."

Junkrat's heart filled with admiration as he and his now explosive bandolier hurtled into the crowd. It was a shame he had to betray her at the end of all this.

He scanned the battle for options and saw one swinging toward him. He leapt aboard Wrecking Ball and clung to the grapple line as the ground curved away. At the peak of the swing, he soared away from the ball and began hurling grenades at clusters of Wreckers.

GAVIN JURGENS-FYHRIE · JUSTIN GROOT · MIRANDA MOYER

Boom. He closed his eyes, smiling. Life was good.

Boom. Wreckers screamed. Junkrat stretched his arms out like a bird, feeling the heat of the explosions on his back.

Boom. Gravity was making several demands upon his attention. *Oh.*

Junkrat opened his eyes. The ground was approaching fast.

"Roadhog! Catch m—"

"Get him up," said the Queen.

Roadhog lifted Junkrat into the air and dangled him there. Junkrat's feet eventually found the ground and held it in place.

"Did we win?" he said blearily.

"You tell me, genius," said the Junker Queen, leaning against the wall beside the Final Door's optical scanner. All around her lay Wreckers in various states of unhealth. The champion had left his ball and was examining pieces of the Wreckers' cannon, chittering derisively to himself.

"We won!" Junkrat decided.

"That's right," she said patiently. "Now it's time for your bit."

"Of course, my queen!" he said, rubbing his hands together craftily. "Roadhog! Now!"

Roadhog stared at him blankly.

"I'm giving the signal!" Junkrat added desperately.

Roadhog scratched his elbow.

A proprietary hand, scarred and strong, closed around the back of Junkrat's neck.

A FRIENDLY RIVALRY

"Forgot to tell him the plan, didya?" said the Junker Queen, almost kindly. The hamster, now back in his mech, shook his little head in disgust. Junkrat thought about it.

"I suppose I did," he said sadly.

"Ah, well," she said. "There's always next time."

Then she lifted him by the neck and slammed his face against the optical scanner.

"ACCESS GRANTED," said the door.

"Hnghtbthh," said Junkrat.

The Final Door slid open with a warm hum, revealing rich, cool darkness. The Junker Queen stepped through, squinting as her eyes adjusted. Then she looked up. And farther up.

"Detecting astonishment," Wrecking Ball's mech said, breaking the silence.

Roadhog peered around them, his mask failing to hide his awe. Their collective wonder filled Junkrat with pride, though it was short-lived.

"You two," the Junker Queen said, gesturing to Junkrat and Roadhog, "have thirty seconds to get out of my sight. Just consider yourselves lucky I'm letting you live after the stunt you pulled."

Before Junkrat could protest, she turned back to the room, clapping Wrecking Ball's mech. "Reckon you can get it flying?"

THOUGHTLESS GODS

ANDREW ROBINSON

THOUGHTLESS GODS

The setting sun bathes the ruins of the makeshift settlement in pink and crimson. Smoke from burning wreckage and vehicles peppers an apocalyptic haze over the Australian outback.

The Junker Queen grins as she surveys the destruction. Armed Junkers scurry about, rooting out what remains of the band of omnics who had either the audacity or the ignorance—but definitely the misfortune—to come within a mere hundred kilometers of Junkertown. Hammond learned long ago that these omnics—that have terrorized the Outback since the aftermath of the Omnic Crisis—are different. They're not like the omnics the wider world is used to; something about the desert—the radiation, the heat . . . perhaps their extraordinary insularity—has twisted them into something else. They are bigger, wildly aggressive, and totally unpredictable except in

their unceasing hostility against the Junkers. They're ferocious in a fight too, and relentless in their pursuit of gear and weaponry to augment their destructive capabilities. The Queen snorts as she takes note of a downed omnic with five upper limbs: sometimes "arms race" is literal.

The damned thing wakes as she walks past. It grabs for her leg, crawling toward her like some hideous, wounded insect, hissing, "get you ... meatsack ..." She almost startles, but as it raises one flamethrower arm, she whips out her Scattergun and unloads into the metal monster's overbuilt skull. Twice, for good measure. It stops moving.

Hammond nods in approval and starts to move his mech, but another tortured scream of metal draws his attention. All heads turn as a large omnic, its limbs twisted and bedecked with razor-sharp blades, feet bolstered with small knobby tires for speed, bursts from a hidey-hole. Hammond realizes that this omnic—the size of a battle-mech, though corroded and dilapidated like so much of the Outback—is preparing to fire a Crisis-era shoulder-launched missile that it has incorporated into its body.

Hammond chatters; the Wrecking Ball mech announces, "Danger!"

He fires his grappling hook, which *clangs* into the omnic's knee, making it stumble just as the Junker Queen dashes at the monster, swinging her axe, Carnage. The omnic turns

THOUGHTLESS GODS

toward her, but its aim is off; Carnage cleaves its head from its massive shoulders, and the rocket fires into the sky and explodes harmlessly. The Junkers cheer the fireworks as the headless chassis topples to the ground with a crash. The head bounces once and settles on the hard-packed dirt. "All you . . . dead . . . soon . . .," it says as its lights go dark.

"No rubbernecking!" the Queen barks at her followers. "Show's over." She nods at Hammond in thanks for the assist.

Meri, the head of the Tinkers, looks over at him. Hammond and Meri now share responsibility for getting the Queen's pet project, which had recently been unearthed from the depths of Junkertown, online.

The Queen continues toward a mangled steel structure where Hammond is attempting to gain entry, raining shards of metal onto the Junkers nearby. She calls out, "Think maybe this is where they're hiding the good stuff, champ?"

Hammond looks over to her. They have been seeking a specific type of component for the massive anti-grav thrusters he and Meri have been rebuilding. He's privately skeptical that the omnics would have come across such a rare treasure in this region, but he wants to keep the Queen's spirits up, so he shrugs. He cringes a bit—his ears are sensitive—as the Queen whistles sharply at a team of scavengers nearby.

"Make a clean sweep, people! Let's find our pot of gold," she declares.

Hammond watches the various factions of Junkertown—Tinkers, Wreckers, Scavengers, etc.—getting into a rhythm now as they go about dismantling wreckage in the aftermath of the battle, breaking ramshackle vehicles, infrastructure, even omnic bodies into smaller parts for later repurposing. The Wreckers use everything from axes to backhoes to crowbars to tear things apart into manageable pieces. Scavengers sort through the scrap, searching for material, textiles, rare metals, and other electronics and treasures. They barter and haggle and fight over parts with the Tinkers, who triage for value and usability. "Keep it movin', you lot," Meri tells her people. "Thruster parts'll gain you extra pay."

Hammond turns his attention back to the reinforced door of the structure. Losing patience, he fires a burst of the mech's quad cannons, then bashes the mech into the door a few more times. The hatch of the mech rattles just a bit—a souvenir from his fight with Roadhog in the arena. Though the lock functions just fine, he is a perfectionist, and it's irritating. He will have to fix that.

"I've got explosives if you need 'em, champ," Meri calls helpfully.

Hammond grumbles. "Negative," the mech responds, managing to convey Hammond's annoyance. One last bashing and the door finally comes off its hinges.

Inside, Hammond finds a fair-sized room with several

THOUGHTLESS GODS

monitors showing various news feeds—a crude communication center, he assumes. The monitors display news about some sort of planetwide robot attack. The mech opens and Hammond emerges, blinking in surprise at the images. This is not what he was expecting.

The hamster wonders for a moment whether, as much as the Junkers hate the omnics, they have been underestimating them. Did they build this war room, or was it scavenged from some human settlement? And have they been monitoring the world? If so, why? What does it mean? He mulls this, then stores the thought for another time and reverses course to the doorway, chattering. "Breaking news," the mech translates. "Come see."

The Queen looks over at the rodent curiously, then strides through the entryway, unslinging her axe. "What's got your grappler in a twist?" She enters the room and reacts, surprised to see the various feeds. She clocks them in turn. "Los Angeles, London, Johannesburg . . . is this all over the world?"

Hammond nods.

"Null Sector, eh? Bloody omnics're always up to something." Junker Queen nods approvingly at Wrecking Ball. "Well done, whiskers." She pauses. "Gotta admit—tin cans they may be . . . but Null Sector may be onto something. The fights 'round these parts are starting to get old. Maybe . . . we go see the world a bit, once you and Meri finish fixing up our new ride."

ANDREW ROBINSON

Hammond turns his attention back to the news anchor on the lowest screen to the left: "The latest city to fall under attack by Null Sector, Lijiang is one of China's premier technology centers, home to Wancài Industries, Lucheng Interstellar, New Harvest Banking Consortium, and other corporations." The anchor pauses as the feed switches to grainy footage of a military squadron under heavy fire. "The government is devoting extraordinary resources to defending Lijiang, as the proprietary technology developed by Lucheng and its competitors could make Null Sector even more dangerous . . ."

Something catches his eye on one of the screens: a sign on a glittering skyscraper. Something unmistakable. A blue arrow on its side, a diagram of a lunar orbit encircling it. The logo of Lucheng Interstellar. The owners of the Horizon Lunar Colony, his former home.

His creators.

Thoughtless gods.

He is frozen, paralyzed by a seething surge of adrenaline and rage. In a blink, the past twelve years vanish, and he is catapulted into his earliest, most fractured memories—images, really.

Soft. Warm . . . Mother.

Rustling. Click click click—claws on plastic. Winding tubes go up and down. Squirming, snuggling in among his siblings: a dozen, and later, more. He is *happy*. A simple happy.

The scientists place him into mazes. He uses his sense of

THOUGHTLESS GODS

smell to find treats they put at the end. He learns to solve puzzles, and enjoys it—especially the reward, the blissful, salty *cronch-cronch* of his favorite sunflower seeds. Though he does not know that he is being pitted against his siblings, he finds treats more often and more quickly than they do. He grows to become the biggest in his family. Sometimes when he finds a treat very fast, the scientists make noises and bare their teeth, and then hand paper to each other. (Years from now, amid the roars of battle in the Scrapyard, he learns that this is called "betting." The scientists wager on him and his family to pass the time.)

He is alone and cold and afraid. The one scientist who is there more than all others, the one they call "Doctorchao," jabs him with shiny sharp sticks. It hurts horribly. He cannot fight or flee from her, so he expects death, but it does not come, as it does for some of his siblings. It lasts for months; each interaction is more than he can bear. He does not understand why he survives.

He wakes up one day to something new, a marking that appears over and over: a kind of loop. Doctorchao approaches as another examines him.

How's Specimen Eight this morning?

We're calling him Hammond, Dr. Chao. We've found that naming them helps with their development . . . Why a hamster, by the way?

ANDREW ROBINSON

They're less expensive than gorillas, and nobody cares how many hamsters we lose. So don't get too attached.

He undergoes more treatment. And more. He grows, in both body and mind. He wonders why he is being experimented on. That is the word the scientists use about him. There is a rush of exhilaration to his brain. He *understands* things, a flood of realization about himself. He is . . . smart, special, *powerful*. These are things he never was before. He prefers it this way.

The scientists do not return him to his home this time. They place him in his own larger cage, apart from his family. When he claws at the bars, the scientists speak in gentle tones; they are concerned he might crush the others. Though he was larger than his siblings before, he is now many times so. He has never been alone for this long. He searches for the eyes of his mother, but there is an unbridgeable chasm between them that encompasses more than distance. He watches his family play together from his separate cage. They pay him no mind. He is very lonely.

He is confused and frustrated. He tries to ask the scientists why more of his family are not with him . . . are not *like* him; he misses them terribly, but he has no language, no way to communicate this to them. They think he is simply doing antics and they laugh. They encourage him to do more antics. They give him treats.

Over time, more siblings are removed from the communal

THOUGHTLESS GODS

habitat (he has learned many words from the scientists now, even if he cannot speak). They are given the same injections that Hammond was given. Each time, he waits eagerly for them to join him. He is hopeful.

And then, each time, he is sad. Unspeakably sad. His brothers and sisters are dead. He has seen the scientist Dr. Nevsky consulting with the scientist Dr. Nguyen. They are confused. They realize their experiments are failing—except for him—but they do not agree on what causes the failures. Yet their faces convey no sorrow or remorse. He has learned how to read human faces. He has come to realize that his well-being depends on it. He wonders why they are not sad.

CLANK.

"Oi! Champ! What'd you do that for?" Startled out of his reverie, Hammond looks around to see the Queen gesturing at him with her knife. He realizes that his grappling hook has smashed through the monitor entirely. He stares for a moment, then retracts the grapple from the ruined screen.

Meri enters the room and notes the wreckage of the monitor. "Bad time?"

The Junker Queen sighs. "Good as any. What's up?"

Meri grimaces. "We've scouted this dump with a fine-tooth comb. It was a long shot they might have what we need—and unfortunately, it looks like we're out of luck."

The Queen's lip curls in irritation. "How are we supposed to

fix up our toy without those components, Meri?"

Meri takes an involuntary step back. "We'll keep looking."

Hammond glances at Meri. He's not concerned about her, but then he looks back at the ruined screen with the flickering image of Lijiang Tower. A realization occurs to him.

He chatters at them.

"The mammal has something to do," the mech declares as he rides it outside.

The Queen cocks her head, curious, and follows him out. "Hey. I give you a certain amount of leeway, but you can't just go AWOL. What's your play?"

Hammond utters a stream of barks and growls. "He knows where to find components," the mech proclaims.

That sets her on her heels. "Okay then. Let's saddle up!"

Hammond shakes his head no and trills softly, activating the rolling function and heading due west, into the evening sun. "He must go alone," the mech's voice carries back as it trundles away.

"Right, try not to die, then," the Queen shouts after him. "Batty rat." She turns to her chief engineer. "Looks like it's all you, Meri. Jump to it."

◆ ◆ ◆

The moon casts its pale light on the city of Lijiang, China.

THOUGHTLESS GODS

Hammond has to be very stealthy as he pilots the Wrecking Ball through the streets to avoid Null Sector troops. There has been some damage to the city, but frankly less than he expected, given what he has seen of the omnic troop transport ships and munitions. The fact that the city has been mostly evacuated makes his task somewhat easier, as does the fact that the omnic patrols are regularly timed and easy to hear coming.

The Night Market sits at the base of Lijiang Tower. It looks like it was once a bustling place, even at this late hour, but the invasion has left only a few hardy souls on the streets desperate enough to disregard the danger. Perhaps the human counter-offensive outside the city has drawn Null Sector's attention. It is oddly peaceful now. The Wrecking Ball rolls in at a swift clip, then Hammond pops the mech's legs and tilts up. He finds the reflections of holographic signs and lights on the wet streets to be strangely alluring. Not what he expected from a city of millions of people. He suspects it would be somewhat less alluring if they were all packed in here.

He emerges, sussing out a route into the tower, but he is surprised by the scent of food nearby. His stomach growls; though the Junkers are many things, "good cooks" is not one of them. He spies the Piggy Mama Hot Pot stand and zeroes in on the aromas coming from it. He can almost taste the marinated meats and salty vegetab—

No. That can wait. He wipes the drool from his puffy cheeks.

He needs the thruster components. But he also wants answers. And . . . maybe payback. He mutters to himself. He gazes up at the skyscraper, and for a moment he feels small and insignificant. A little afraid. This makes him angry, which is good and useful. He smiles grimly.

The entrance to the tower enjoys a large open courtyard. So much for stealth. Well-armed security agents patrol the perimeter in packs of five—safety in numbers. Smart. Heavy bunkers have been set up to defend the building. He snorts. This confirms his thoughts about Lucheng: they will protect themselves rather than helping push Null Sector out of the city. He has heard a human saying: the fish stinks from the head. *Apt*, he thinks. *Lucheng is a stinky fish.* Nonetheless, he has an idea.

Hammond pops back into the Wrecking Ball and fires its grappling claw to its full extension, latching on to a corner of the building nearest the tower. Swinging some meters above the ground, faster and faster, Hammond times his release precisely, then activates the mech's Pile Driver function. The Wrecking Ball becomes a speeding projectile that craters into the tower lobby like a meteorite, knocking the guards inside off their feet.

Hammond chatters. "Oh no." The mech drones: "Null Sector is attacking. Null Sector is so bad. Everyone flee." Hammond

THOUGHTLESS GODS

rolls the mech back out of the lobby before anyone can respond, but he knows that this attack will draw the bulk of the building's security. So he wastes no time, crossing to the large building map, which informs him that Lucheng Interstellar occupies the top ten floors; the parts he's looking for will be there. They must be . . . they had *better* be. Then he rushes around the side of the building, where he uses the grappling claw to scale the glass edifice, ten, twenty, thirty floors up.

He pauses for a moment to admire the tranquil gardens, where executives no doubt fling underlings into the deadly moat. The rodent chuckles to himself at that thought, then resumes his climb. Forty—swing—fifty floors up before he swerves out and fires the mech's quad cannons at the plate glass windows of the fifty-seventh floor. He remembers this move from an old Christmas film the scientists showed on the colony once, and with one last swing, the shatter-proof glass explodes beneath the force of his momentum.

There are no people in the offices. This is good for him but also good for them. Maneuvering the mech to an elevator bank, Hammond pries open the doors, climbs into the shaft, and ascends to the sixty-third floor, where Lucheng is located.

Exiting the elevators, Hammond notes that massive security doors have dropped into place. If he were here with the Junker Queen, she would ask him why scientists would need

doors like this. But he knows this is not just any office. There are secrets here. Ugly secrets.

He sighs. Getting to the control center through them will be difficult and will take more time than he has. As soon as Lucheng's security discovers the hole he put in the side of the building, they'll send more than just guards.

Hammond trundles the mech over to an air-duct register near the perimeter of the building. He pops out of the mech, checks to ensure that he has the tools he will need, opens the duct grate, and clambers in. Just before he closes the grate, he warbles at the mech.

"Autotarget mode engaged," the Wrecking Ball intones.

As he dashes through the air ducts, pausing here and there at each juncture for direction, he remembers other air ducts, where he used his keen sense of smell to sniff out treats—or tools. Now, he scents for particular electronic frequencies, the heat signatures of server towers, the dried sweat of security agents on duty for the last eight hours. He grins as he approaches his goal, remembering a long-ago triumph.

His first escape.

He is back in the lunar base, years ago. Seeing that he is alone, Hammond maneuvers a bobby pin out of his cheek, where he has held it for most of the day. It takes a few minutes to pick the padlock Dr. Zhang placed on his cage to keep him contained for the night. Climbing atop his enclosure, he

THOUGHTLESS GODS

launches himself to the ceiling, where his claws grasp the slats of the ceiling vent. He has hidden a screwdriver as well and quickly accesses the air ducts.

From that moment on, he is uncontainable. The ducts remind him comfortably of the Habitrail mazes he used to live in and even the mazes the scientists used to run him through to assess his intelligence. Then, as now, he uses his sense of smell to guide him to the commissary, where he binges on corn chips, yams, fruit, ice cream. He had *no idea* the variety of things that are edible. Later he discovers the garages, the fun to be had playing with tools, of fixing broken mechanisms and creating new ones from spare parts. It feeds his ego to put something over on the humans, just as it amuses him greatly to leave " presents" for Dr. Patel in his room. But more importantly, engineering, repurposing, or fixing things feeds his insatiable need for challenge. Soon enough, there is little he cannot fix or build.

Hammond will later appreciate these same qualities in the Junkers: how they take wasted, broken things and bring new purpose to them. They re-create and recycle. What's more, they don't think too deeply; they live for the moment. He appreciates that too.

In time, Hammond comes to memorize the network of ducts, and he realizes that there are other creatures that have been . . . He's not sure what to call what Doctorchao has done to him. "Changed" is insufficient. Augmented? Evolved? He has glimpsed

a few of these creatures through the slats of the grates, and some of them made every hair on his body stand up with their *wrongness*. He avoids those ducts now. But one night he is bringing some tools to work on his secret project—the one that will take him away from this place someday—when he hears a whimper, a squeak, almost, through the vent of a room below. He pauses. He sniffs. And though what he smells does not smell like him, it is not one of *those*.

He peers through the slats into the dim and can just make out a hairy form on a bed. It whimpers again. He hardly dares to hope: Did another hamster somehow survive the scientists' treatments? Will one of his siblings finally join him? His heart races; excitement and curiosity overrule caution. He quietly unscrews the grate and drops into the room. He pulls out a flashlight from the one-piece uniform that the scientists make him wear. (He would chew it to rags were it not for the pockets he carries tools in.) He turns on the flashlight and creeps toward the figure . . . which sits up and yelps in surprise. Hammond lets out an involuntary squeal and launches himself backward while the figure leaps to the ceiling, gibbering.

It takes them both a moment to regain their composure; the gorilla clings to the open grate, breathing heavily, looking panicked. Hammond realizes that the gorilla is wearing a uniform similar to his own, with the number twenty-eight on it. Hammond is struck by a sense of . . . sympathy? The ape

THOUGHTLESS GODS

has obviously survived what Hammond has. The gorilla looks at him suspiciously. The hamster shows his front paws to communicate that he means no harm, then remembers that he has a peanut butter bar in one pocket; he opens it and offers it to Twenty-Eight, who sniffs curiously and drops from the ceiling. Hammond tosses the bar to the gorilla, who takes a tentative bite and breaks into a broad, sunny smile.

Finishing the candy bar, the ape examines Hammond, and in his giddy curiosity about what Hammond even IS, he laughs. He bounces on his bed. Hammond notices the bed frame squeak and uses his screwdriver to tighten the offending bolt. Twenty-Eight's eyes go wide as he points at the tools. Neither can speak, but Twenty-Eight is well suited to charades. Hammond tries his best to answer back with gestures. Nonetheless, when Hammond leaves, the ape eagerly asks if he will come back, and Hammond agrees. He tosses the screwdriver to Twenty-Eight, who cradles it like something precious.

It is the start of Hammond's first friendship. Like him, Twenty-Eight is far more intelligent than the others realize. And like him, Twenty-Eight is alone, somewhat outcast from the other apes. There is something about him, an innocence, that inspires a sense of ... *protectiveness? Is that it?* in Hammond. Hammond remembers it in himself—an eagerness to test the world. It seems to irritate most of the other primates, who tend either to ignore Twenty-Eight or harass him. That, of course, leads

to his occasional isolation while the scientists recalibrate the social elements of their grand experiment.

 Hammond starts sneaking treats to his friend regularly. Peanut butter is Twenty-Eight's favorite thing. He even shows the gorilla how to fix things. And in return, Twenty-Eight shows Hammond how to . . . well, how to dream of something better. One night he points to a drawing—a blue circle with patches of green. In the unforgiving vacuum of space is a rocket; Twenty-Eight is in the viewport, a crudely drawn Hammond flopped over his shoulder.

◆ ◆ ◆

Back in the present, in the central control room of the Lucheng complex, two agents operate a dizzying array of camera feeds. The first agent cocks her head toward the ceiling. "Did you hear that?"

 The second, focused on a feed showing the massive hole where Hammond breached the building, grunts. "Hear what?"

 "A scraping noise in the ceiling ducts."

 The second guard snorts. "Probably just a rat."

 The first guard stares back. "A rat. On the *sixty-third* floor."

 The second guard scoffs, not returning her look. "What else would it be?"

 Just then the ceiling grate swings open, and Hammond

THOUGHTLESS GODS

drops into the room. The agents stand in shock; the first guard struggles to unclip her sidearm from her belt as she panics. "That's the biggest rat I've ever—!"

She does not get to finish, because Hammond has beaten them both to the draw with Tasers. They go down hard. He grins.

Hammond pulls a chair up to the console that the guards were operating and quickly sizes up what he needs. First things first: he activates a building-wide alarm and types in a message for the comm system to read. "Threat remains. Evacuate building," a calm voice urges repeatedly as the emergency lights shut off. He watches the camera feeds, seeing agents herding scientists and administrators to the exits. There is a joke Hammond once heard about sheep, but it doesn't appeal to his sense of humor; he prefers slapstick. Pratfalls, broken limbs—that kind of thing.

In short time he has unlocked the heavy security doors, and using his remote control, he summons the Wrecking Ball. But moments later, two more guards dash into the room.

"Don't move! H-hands . . .," the first guard stutters, seeing the three-foot-tall, heavily armed rodent facing him. "Up?"

A rumbling sound approaches. Hammond smirks as the guards turn just in time to get toppled by the Wrecking Ball. He uses the grappling hook to tow the now-unconscious guards out of the room, then returns inside, bringing the reinforced

doors back down to barricade the control center. No more time for antics; he has work to do.

He types into the console, flipping through various security feeds. Where would they store the components he needs, and how does he get there? A thought strikes him, and in it there is not just a realization but a frisson of fear: *he knows who would know*. He shoves his unease away and cycles through the security feeds impatiently, hoping to see some sort of lab or storage facility. He growls softly in frustration, then stops abruptly as another set of screens catches his eye. What he sees is not anything in or around the building.

It is a security feed of a place he never expected to see again. The place he once called home.

Horizon Lunar Colony.

He starts to cycle through camera feeds. The main hangar—bay twelve—where he taught himself mechanical skills, rovers and jump packs lying around, seemingly gutted for parts. A greenhouse filled with thriving crops. The commissary, deserted. The classroom where he and other genetically altered animals were educated and tested. A medical bay. The hydroponics lab. A waste-treatment plant.

Deep in thought, lost in memories, the hamster startles at a woman's voice. "Specimen Eight, I presume?"

He whirls around as the mech announces, "Intruder approaching."

THOUGHTLESS GODS

Hammond chitters angrily at the machine.

"New pilot profanity detected. Adding to database," the mech counters.

Whiskers twitching violently, Hammond snarls at the frail, aging Chinese woman who has seemingly materialized a meter away, seated in a hoverchair. She smiles gently at the threat. "I am no danger to you, Specimen Eight." The fact that she uses the identification number he was given, rather than his name, is not lost on him.

He growls; though it might sound comical and small to humans, the threat behind it is not.

"Address him as Hammond," the mech translates, leaving out the more colorful squeaks.

She nods in understanding, if not acquiescence. "'Specimen Eight' must be a bit . . . impersonal. Do you remember me?"

Hammond grumbles at her.

"He is not an idiot, Dr. Chao," the mech pronounces.

She nods again, impressed. "Well, it's been quite a while."

He grumbles again. "You left the colony early," the mech says.

"If by that you mean before the . . . rebellion, then yes. But as you can see, it feels like I spent more than enough time there. After years in and out of lunar gravity, my body atrophied beyond repair. I'm afraid at my age—even with years of physical therapy—it was too difficult to regain the muscle mass

I lost. I wasn't a great candidate for cybernetics either, so . . ." She gestures to the chair.

Hammond scoffs and the mech translates. "You should have evacuated the tower when Null Sector invaded. Foolish."

"You know as well as I do that there is information here that mustn't fall into the wrong hands. As CEO, I'm responsible for that." She sighs. "Besides, you don't get to my age without learning how to distinguish one danger from another. If you really wanted me dead . . ." She shrugs, almost challenging him.

He stares for a moment, then grunts. He adds a high-pitched but meaningful growl.

"Option remains viable. You will give the hamster information, or else," the mech voices. "Where are Huang-Unigwe activators kept? For antigravity thrusters."

Rather than reply, she gazes at him appraisingly. "I must say, I am surprised but pleased to see you, Specimen Eight. Where have you been for all these years?"

Hammond *hmphs*. The mech whirs. "None of your business."

"The company assumed you perished in the apes' rebellion. But I had my doubts about that; you were always so . . . *capable*."

Dr. Chao approaches the terminal; Hammond keeps the mech's quad cannons trained on her. She types in a command to shift the camera feed. A water treatment plant—still functioning, tended by robotic hands. She switches the feed to a

THOUGHTLESS GODS

fabrication station, where structural materials are produced for the moon base, and then to a particular room. Hammond startles and turns to her, head cocked demandingly. "Your old room. And the cage you so effortlessly escaped time after time." She grimaces wryly. "No matter how they changed or reinforced the locks."

Hammond growls again. The mech states, "He does not like being told what to do. Or what not to."

"Yes, you always thought outside the box. As I recall, Dr. Zhang and Dr. Flores had something of a running bet as to where you were going." She turns to another monitor and calls up old security footage from the lunar colony. In it, a younger Hammond is working on something mechanized, utilizing a gravity wrench and a laser cutter. "You taught yourself engineering and mechanics. Why, just look at this cunning little mech you cobbled together. Imagine the uses we could put it to."

Wrecking Ball takes a step closer to Hammond. The hatch rattles a bit as it does. Hammond grits his teeth; he's got to fix that.

Hammond grumbles a response.

"Everyone underestimates the small," says the mech.

She does not offer further response; instead, she pulls up a feed of a training facility, a large, multilevel gymnasium. On the feed, two apes spar in a ring. He recognizes a beefy orangutan

who used to bully him for the simple pleasure of it. Dyson is now older, thicker—and he has fashioned armor and weaponry for himself.

They gaze at the screen, where the apes trade fierce blows. Oscar pins his rival; the other ape gestures submission. Oscar delivers a painful mock kill anyway.

Hammond chitters at Chao. "What happened?" the mech asks.

"What do you mean?" Chao asks.

Hammond screws up his face, concentration fixed on the screens. He verbalizes lengthily.

The mech takes a moment, processing, then says: "Why did Lucheng never try to take back the lunar base from the apes? Trillions of dollars in resources lost. That is not like humans."

Chao looks sour. "Oh, we've tried. We sent three teams up over the last ten years to retake the colony. Each better trained and better armed than the last. What we didn't realize," she admits, "was how damned *clever* the apes are. Saw us coming. And while we were innovating, so were they."

Hammond is not sure what she means by that. She brings up a new feed. This one focuses on the exterior of the colony—specifically, a massive telescope that sweeps slowly, almost imperceptibly, from side to side, scanning space. He knows that Lucheng uses this site to perform astronomical observations;

THOUGHTLESS GODS

outside of the hazing effects of the earth's atmosphere, they enjoy incredible clarity of imagery.

Hammond recalls that he actually reached the telescope once and took the time to look through it. He did not enjoy it. Perhaps it is a species-level feeling. Having nothing but open space above his head causes a primal sense of unease; rodents are prey animals, and death nearly always comes from above.

Well, he thinks to himself, *most* rodents are prey animals. Not him. Not anymore and never again. He is a hunter, a destroyer.

He idly wonders whether the apes are maintaining the various systems, including the telescopes—once used to track asteroids that posed an existential threat to Earth. Whether Lucheng scientists are controlling it remotely, or whether it has sat untended for the last decade, degrading and leaving the planet vulnerable to an extinction-level event.

Hammond verbalizes.

"Does Lucheng still control the telescope?" the mech asks Chao.

She nods. "Although, at the moment we worry less about the unknown dangers coming from space than the dangers we know exist there."

"The apes," Hammond guesses.

"I find it ironic . . . you spent so much time trying to escape

cages, even to help the others escape theirs—oh yes, my friend, I know—and yet you've *chosen* to hide in the one you made for yourself. Survival tactic, I assume."

Hammond glares but stops himself from attacking her; he does not miss her smug expression, but he is forced to consider her words. He takes the controls and switches to Lijiang Tower's security feeds, resuming his search for the thruster components, and finally finds what he's looking for: a tech lab in the rocketry research center. He notes the lab number in the feed and pulls up a diagram of the component he has been seeking. It is not the same as he remembers, but it is close enough to what he'd designed so long ago.

◆◆◆

There is violence. There are screams. He does his best to avoid it. Though he bears the scientists no love for what they have done, he does not want to witness their demise. Some of the primates give him angry looks, but they are more bent on the destruction of their oppressors than on him. His small size benefits him, as occasionally it does.

Still, he knows the apes may soon decide they do not want him around. He realizes that he has a very limited amount of time to act on his own behalf. He takes to the ducting and swiftly makes his way to the spaceport.

THOUGHTLESS GODS

Hammond scuttles through the various bays only to see to his horror that the apes have disabled the shuttles that are used to transport astronauts, scientists, and workers to and from the moon base. He is trapped here.

He reacts to a noise from bay fourteen and stealthily makes his way there. He stops, seeing a figure—Twenty-Eight, Winston—working furiously on an escape craft, nearly ready to leave. It looks like it is based on the plans they dreamed up together, the rocket they would one day leave the colony on. The ape makes a final adjustment to a familiar rocket thruster, closes its compartment, and heads for the cockpit. Hammond is confused . . . and then hurt and angry. It seems Winston does not plan to bring Hammond with him, and this leads to another devastating realization: they are not friends after all.

Hammond now sees: Whatever else Lucheng made them, they are all, in the end, just animals. Animals who will do what it takes to survive.

◆◆◆

In the control room, Hammond suddenly realizes Dr. Chao is aiming a Taser at him; he barely dodges the wires as they shoot out, and he barks a command. The mech's grappling hook fires out, knocking the weapon from Chao's hands.

Chao breaks his reverie, "I must know, Specimen Eight: Was

Winston aware that you piggybacked on his escape?"

Hammond looks away, scowling.

She gazes at him appraisingly. "And you never let him know that you were okay. Never went to see your best friend. Perhaps to join Overwatch with him."

He glares at her and chatters emphatically, spitting on the floor for good measure.

The mech whirs. "He stole . . . untranslatable. Rodent profanity detected."

She raises her hands in mock surrender. "I see. A sensitive subject. But still, why wouldn't you find him? You both made it out, after all."

Hammond begins to snarl in response but stops. That has never occurred to him. He growls softly.

The mech translates: "He has new friends."

"And you've been hiding from the world in your little ball ever since. Just a frightened rodent."

He chitters flatly. "There was something to fear. But the hamster is no longer afraid."

To emphasize that he is done with this part of their conversation, Hammond changes to another feed. It shows Earth looming above, beyond a great glassine wall. It's a magnificent view, if you like such things; it was always Winston's favorite. Winston brought him there once. Hammond hated it. Too much space. Or too many memories.

THOUGHTLESS GODS

But there's something different about this view than he remembers. He can't put his paw on why.

Why? He has wondered this for the last decade and more, and he has never come to a conclusive answer. He must know. He almost forgot that it is one of the main reasons he is here. He verbalizes.

"Why?" the mech demands.

Chao glances over at him, confused.

"He demands to know why you did this to him, to all of the subjects."

She contemplates the rodent for a long moment, then sighs. "Initially, hubris, frankly. We did it because we could. And then for the accolades . . . and the funding."

This does not surprise Hammond. Nearly every human he's met has been arrogant and overconfident . . . apart from the Junker Queen, the only human who has bested the Wrecking Ball in combat. And to be sure, the Queen *is* arrogant, but she's at least earned it.

"Why *hamsters*, orangutans, gorillas?" So much could go wrong. So much *did* go wrong. "Toying with life. Playing God."

She shrugs. "We were curious as to the limits of our ability, to see what we could accomplish with genetic manipulation. You'd be surprised at what we tried. You barely saw a portion of it. And I admit, our failures were . . . horrific. That's why we could only do it up there. Can you imagine if any had escaped

down here? But our successes were wonderful. Just look at you!"

Hammond snorts and grumbles. "Your creations escaped their cages and killed your doctors," the mech intones. "New definition of 'success.'"

Then Chao surprises him. "You don't know what that work laid good ground for: the long-term effects of low gravity on animals, the viability of sustained life on the moon. We thought it was all about Earth, lunar ops, but then . . . the scope of our project changed. The apes—and you, if you lived long enough—would become part of a long-term space travel program."

"Big plans," the Wrecking Ball says. "The apes had different plans."

She chuckles bitterly. "You'd think they would be grateful for the gifts we bestowed on them."

Hammond is astonished; he chitters angrily.

The mech whirrs, processing: "None of the life-forms *asked* for what you did. Even if they became . . . better, they suffered for it. *You* are responsible. Thoughtless gods."

Hammond turns back to the feed that looks out at Earth and suddenly realizes what has thrown him off about the view. There is a structure outside that glassine wall that was not there all those years ago. It is only partially built, but it is not something the scientists made.

That is odd, he thinks.

THOUGHTLESS GODS

His train of thought is interrupted by the unmistakable pitch of a laser saw cutting through plate metal down a distant corridor: the sound of security forces breaching the defenses he locked into place. A glance at the building security cameras confirms it. He clambers down into the waiting Wrecking Ball. Foolish. She's been stalling him.

Chao sees the monitors as well and smiles victoriously. "Well, it's been nice catching up, Specimen Eight," she wheezes. "But you're surrounded. There are guards above, below, and around. You see"—she smiles—"Winston may not be Lucheng property anymore . . . but you never had your day in court. And now, you never will."

Enraged, Hammond steps forward, pulls out a multitool, and plunges it repeatedly into the control panel on the right arm of her chair, which drops to the floor with a *bang*. He looms over her now, hissing angrily.

The mech translates: "He belongs to no one."

"Kill me if you like; it won't make any difference," she says with a wince. "As I said, I am an old woman, and I have built Lucheng to last. I am not afraid to die."

Hammond snarls. "Testing statement," the mech offers as it spins up its quad cannons. Dr. Chao closes her eyes tightly and cringes, waiting for the barrage that does not come. The quad cannons spin down, and she opens her eyes, confused. Hammond grunts. "Liar," the mech declares. Hammond is glad

she did not tell him where the components were; she would certainly have led him into a trap.

Hammond fully deactivates his weapons systems. Off her smug look, he vocalizes a sequence of trills and chirps. "The mammal has decided not to kill you. He will make you watch ashe dismantles the empire you have built to last," the mech declares.

In a burst of fury, he leans over and punches a sequence into the control pads. A signal to the lunar colony: YOU ARE BEING WATCHED.

The mech broadcasts Chao's voice: *"Hubris, frankly. We did it because we could."*

Dr. Chao's eyes widen in alarm for a moment, then she grimaces. "Clever. But too late."

As her security forces burst into the room, Chao shouts, "Do not let it escape!"

The hamster growls and squeaks. "Escape is not the intent," voices the mech. "The hamster is finally going to get what he came for."

Hammond crouches into the Wrecking Ball, closes the hatch, and spins up his quad cannons, chattering as he does so. "Please try to stop him," the mech declares. "He will enjoy it." In response, the humans—each wearing antiballistic armor and wielding some type of rifle he's never seen—open fire.

"Surrender!" an officer commands. "You are outnumbered and surrounded."

THOUGHTLESS GODS

Hammond barks defiant laughter.

"Amusement!" the mech enunciates. "Just how he likes it!"

He fires the guns just to make the guards twitch; as they blast at him, the mech warns: "Taking damage. Activating adaptive shield." Hammond withdraws the mech's limbs and activates its rolling function, plowing through the knot of guards with ease. He chuckles as it launches those too slow to jump out of the way.

"I need reinforcements!" their commander howls into his comm.

"Arriving now!" comes the reply.

The commander smiles as a dozen more guards rush out from the corridor. "Let's put this thing down!"

Hammond—no, he is Wrecking Ball—looks back, beady eyes gleaming with disdain; Chao looks withered and helpless to him now. "Lucheng cannot stop Hammond. Never could. Never will." He warbles with glee and launches a dozen antipersonnel mines into the crowd. They hit the ground, blinking ominously, and the humans have only moments to react, diving away in panic with a variety of surprisingly creative curses.

Hammond nods in approval as he triggers the mines.

From the street, one corner of the sixty-third story of the glass tower that houses Lucheng Interstellar blows out. Shards of glass catch the light of the exploding mines, showering the streets below like deadly fireworks. Hammond uses the

security forces' moment of shock to dive the mech out the window. As he begins to fall, the grappling hook shoots out, latching on to a now-exposed I-beam, swinging him around the side just in time to avoid shots from guards who were savvy enough to evade the explosion. He swings back into the building three floors below, to the production lab he identified. There he soon finds what he needs: the crucial components for the antigravity thrusters the Queen has been seeking—next generation, no less. The guards try to regroup and chase him down.

The humans are too slow. Soon, Wrecking Ball has returned to street level. Sirens are approaching. Many, many sirens. As much as he loves a fight, now is a good time to retreat. He turns and rolls into the night.

Making his way through the abandoned streets of Lijiang, he ponders his experience. What started as a relatively straightforward supply mission turned into something . . . unexpected, but right. He has learned much, and what he has learned has raised questions. He thought it would be enough to get answers from Chao, *revenge* on Chao—to throw a monkey wrench (he can't help but smile) into her plans . . . but that's not enough.

He must make all of Lucheng pay for what they did. The apes may be stranded on the moon, but Hammond is not. He's got a shiny new toy and a powerful, maniacal friend who will do him a solid for the fun of it. He's not just going to survive

THOUGHTLESS GODS

Chao this time; he's going to finish what the apes started, tear it all down. Maybe he'll even let the apes help.

◆ ◆ ◆

As the morning sun lights up the Outback, the Junker Queen, enjoying the view from an ancient corrugated tin roof, downs a steaming mug of coffee and rises from a dilapidated lawn chair scavenged from a long-abandoned township. "Nothing more metal than a sunrise," the Queen muses. "It's like a promise—of all the fun we're going to have." She turns to Meri and Geiger, who stand nearby. "How's our project coming?"

"No worries," Meri assures her. "Should be ready soon." She hesitates, then adds: "Pending getting the antigrav thrusters up and running, a'course."

Something approaches in the distance, raising a trail of dust behind it. The Queen squints yet can't make it out, but she'll brook no threats. "Geiger?"

The scavenger—as much machine as man—snaps out a telescope from some bodily compartment and holds it to his remaining eye, which widens in surprise. He tosses the telescope to the Queen, who snatches it effortlessly from the air and looks through it. In the scope, Wrecking Ball speeds toward her. The hint of a smile reaches her lips.

The mech finally reaches Junkertown's walls. The hatch opens and Hammond slowly emerges, stretching mightily. The hatch rattles just a bit. He barely notices it anymore. He gazes around at the open morning sky and the pale, waning moon so far away . . . and for the first time, it's beautiful.

"Well, well, well," the Queen smirks from the top of the wall. "The prodigal rodent returns. Y'look knackered. Been nailing heads to the floorboards again?"

Hammond shrugs. "The hamster never tells," says the mech.

She cocks her head. "Didja at least get what you went out for? Can we get going soon?"

He gives her a languid thumbs-up. "Mission successful," the mech states.

The Queen offers a crooked grin and motions with her jaw to the settlement entrance—her blessing to return.

Meri pulls her comms out and keys the mic. "Open the gates. The champ's back."

WHERE HONOR LIVES

E. C. MYERS

WHERE HONOR LIVES

As a general rule, Hanzo avoided cities. He had grown up in the shadow of Tokyo, towering skyscrapers blotting out the horizon wherever he looked. Even as a youth he had preferred the quiet of Kanezaka, parts of which remained frozen in time. On the rare occasions he had ventured into the artificial heart of Tokyo, accompanying his father on business, he had found it too bright and busy.

It had gotten even worse since his last visit . . . or Hanzo had become even less tolerant. The streets seemed narrower, claustrophobic almost, with many blind corners, hidden doorways, open windows. The gaudy lights meant to chase away darkness only cast starker shadows. Tokyo was loud and crowded with people, though more so now amid the looming Null Sector invasion, with all the running and screaming.

As a general rule, Hanzo also avoided people.

But then, he had been avoiding many things, for many years. Haunted by regret for killing his brother, Genji, he had been no better than a ghost—passing through the world without being a part of it. Until two years ago, when Genji confronted him at Shimada Castle. Not dead at Hanzo's hand after all.

Like a coward, Hanzo had run again. He had been running for so long, he didn't know what else to do. He distracted himself with his work as a mercenary, ignoring the truths that weighed on him.

And now there was no ignoring the impossible voice that had called him home.

Hanzo had been training in Okinawa, watching news footage of the Null Sector invasions around the world with deepening concern, when he heard Sojiro Shimada's voice. *"After some time, the dragon journeyed home to recover what he had left behind. During his absence, a tiger had moved into his cave and was terrorizing the countryside. And so, the dragon disguised himself and walked among his people, the better to know his enemy."*

Hanzo had not heard his father speak in more than fourteen years, but the voice sounded so real, so close, that Hanzo had turned toward it. He had been both disappointed and relieved to find himself alone.

Of course no one was there. It might have just been a vivid memory, returning to him now. His father had often told his

WHERE HONOR LIVES

children stories to remind them of their duty, to protect those who served them. But it was easy to moralize and say empty words when you sat above everyone else, holding all the power.

When Hanzo left the clan, he felt his father was a fool. The Hashimoto had assassinated Sojiro, and his death pulled back the curtain on just how much the clan's dealings put the people at risk. Threats from rival clans, law enforcement, Overwatch—his father had a duty to protect the people because he was also the one who endangered them.

The age of honor and respect, the age that Sojiro's many teachings had come from, was gone. But those words were all his father had left him. In the face of the Shimada clan elders who wanted results, Hanzo was ill prepared and overwhelmed, a puppet through which they sought to achieve their ends. What Sojiro had built, had upheld for generations, didn't last, and the whole thing had come crashing down, with Hanzo found unworthy of his father's seat.

For the first time, he had fled the responsibility that he'd spent his entire life preparing for, but only after killing his brother, the only person who'd ever truly understood him. Since learning that Genji had in fact survived their final encounter, Hanzo had spent the years since trying—unsuccessfully—to run from his shame. But now, his father's voice had summoned him to Tokyo. Perhaps it was leading him back to where he needed to be. Time would tell.

E. C. MYERS

Although the massive Null Sector ship was still outside Tokyo, out of view here in the center of the city, people were in a panic. The streets were clogged with unmoving vehicles, people hiking around them on foot and loaded with backpacks and bags, desperately checking their phones for updates and looking upward.

Hanzo threaded through the chaos, gently pushing his way in the opposite direction. When Null Sector inevitably began their invasion, a lot of innocent people would be caught in the crossfire. Most of these people wouldn't make it out.

A shrill air raid warning looped in the distance, mingling with police and ambulance sirens. But where were the police? They should be out here directing the evacuation, offering protection and comfort. He looked around—and spotted a group of nine men in black suits and ties, several of them wearing oni masks. They walked like they owned the sidewalk, forcing pedestrians to move out of their way. Hashimoto.

Hanzo drew back into a shadowed doorway of a shuttered book shop and watched as the gangsters bumped into an old man, causing him to trip and drop a shopping bag stuffed with clothes and food.

"Watch where you're going, grandpa," said one of the clan, a man with his black hair styled in a topknot.

"Sorry! Sorry!" The old man scrabbled in the streets for his things as the clan members kicked them away from him and

WHERE HONOR LIVES

jeered. Hanzo clenched his jaw. The Hashimoto didn't take care of their people. They were disgraceful parasites.

Is this what you want me to see, Father? Hanzo thought. He already knew that the Hashimoto were bullies and brutes. There must be something more, a reason for him to be here, at this moment.

At a sharp word from Topknot, the group moved on. They seemed to be in a hurry, or no doubt they would be harassing more people fleeing the city. With so many of them traveling together, Hanzo assumed they had been recalled to the Hashimoto stronghold to prepare for the Null Sector attack. Perhaps they could lead him back to the tigers' den.

Casting a sympathetic look back at the old man, Hanzo trailed them at a distance.

After a few minutes, the Hashimoto stopped in front of an alleyway and looked around. Hanzo ducked out of sight until the nine men had slipped into the narrow side street. He counted sixty seconds before he followed them.

The alleyway was deserted, the walls lined with dumpsters. It figured that these low creatures would be found among the garbage, but where had they disappeared to? Hanzo drew his bow and advanced cautiously, eyes darting around looking for movement, anything out of place. Ahead, the alley came to a dead end.

"You must be lost." Topknot stepped out from behind a

dumpster at the same moment the other Hashimoto clan members reappeared, pulling out knives and guns. "But don't worry. We found you."

Hanzo counted only five of them. The crunch of broken glass behind told him where the other four were. He was surrounded.

Hanzo drew an arrow and nocked it, aiming at Topknot.

The coiffed man whistled. "Look at this guy! What, you going to fight all of us with a *bow*?"

Hanzo narrowed his eyes at the leader. "I don't expect much of a fight."

In a smooth, quick motion, he let his arrow fly. *Twang!* The arrow flew over Topknot's head, who guffawed at the apparent miss. "Nice shot!"

Hanzo gazed pointedly behind Topknot. The man turned, and his laughter died when he saw the arrow pinning his knot of hair to the brick wall.

Hanzo calmly drew another arrow. "That was a warning. And an improvement."

Topknot blew strands of loose hair away from his eyes and sputtered, "What are you idiots waiting for? Get him!"

Three men in front rushed him, brandishing knives. Hanzo managed to pick two of them off with rapid-fire arrows, but before he could loose another, the third goon was on him. Hanzo jerked his bow up and blocked his short blade with its riser, barely in time—the tip nicked his left cheek. He brought up a

WHERE HONOR LIVES

boot to his assailant's chest and shoved him away, then brought his bow around in a wide swing that connected, sending his opponent sprawling, knife clattering on concrete.

Hanzo wiped the blood from his face with the back of his hand. *Too close. Getting sloppy.*

He stepped back, moving in a quarter circle to maneuver the Hashimoto clan members behind him into view. It worked—he could see the remaining four enemies, each of them in a colorful oni mask. Topknot and his men targeted Hanzo with their handguns.

Bullets whizzed by and ricocheted off metal. Hanzo whirled around and ducked between two bins. As he peered around the edge of one, aiming an arrow, a bullet thunked into his left shoulder. Searing pain shot along his arm and side. Hanzo grunted and lowered his bow.

"That's what I'm talking about!" Topknot said. Smoke wisped from his own firearm. "Toss your bow over here and come out with your hands up, and we can talk about this." The others snickered.

He couldn't get a clear shot at any of the enemy from behind his cover. Hanzo gritted his teeth against his injury and fired an arrow into a trash can opposite him. The metal container toppled over, spilling waste into the alley.

"Pathetic," Topknot said.

The Sonic Arrow embedded in the fallen trash can emanated

high-frequency pulses, helping Hanzo pinpoint the locations of every opponent in the alley. He aimed carefully and quickly fired a storm of arrows, letting his training and intuition guide their flight. The arrows hit the walls and bins, bouncing back at sharp angles. He heard the enemy shout and dive out of the way. Two men cried out in pain—he had hit some of his targets.

Hanzo assessed his shoulder. There was an exit wound, so the bullet had passed through. Even so, he was losing blood at an alarming rate. His head swam, and darkness crept into the edges of his vision. He took several sharp breaths and tried to shake it off.

"We don't have time for this. Bring out the big swords and take this guy down already!" Topknot shouted.

Hanzo sighed and raised his bow.

Suddenly, the bins on either side of Hanzo were dragged away, metal scraping against pavement, leaving him wide open to attack. Two Hashimoto pressed in on his right and left, wearing matching black and white oni masks and leveling tachi swords at him. Hanzo began to smirk—until he saw that their blades glowed with ethereal blue energy, not unlike his Storm Bow when he employed its more unique capabilities.

The weapons sparked and flickered as if trying to manifest some greater power. There was something wrong with them, making their energy fields unstable. They must have tried to copy the design of the Shimada family's blades, the only ones

WHERE HONOR LIVES

to use such technology. And it seemed they weren't comfortable using them.

The one in the black mask struck—he could use the sword well enough. Hanzo clumsily parried it with his bow, while the one in the white mask laid a hand on his right arm. Hanzo grabbed the man's forearm and yanked him closer, smashing their foreheads together. Pinpricks of light flashed and danced in Hanzo's eyes, and he staggered back from the blow. His dazed opponent let go of both Hanzo and the sword, which fell to the ground and sputtered out. Hanzo kicked it away, turning his attention to the first swordsman, who was soon joined by another—this one sporting a red oni mask.

Hanzo drew and fired several arrows at them, but blood loss was beginning to affect his strength; they were able to knock each one out of the air with swipes of their swords as they advanced. Electricity arced and sizzled along the blades. Meanwhile, the other Hashimoto had regrouped and were converging on him, penning him in.

They were well organized; he would give them that. And there were a lot of them. More than he had arrows. *Twang! Twang! Twang!* Black Mask fell. Hanzo reached back for another arrow and his hand closed on air. He tightened his empty hand into a fist and punched his nearest attacker, shattering his red mask and laying the man out on the ground.

Tired of waiting for them to come to him and increasingly

desperate, Hanzo stepped into the fray. He was fighting to get out of this alleyway. He was fighting for his life.

He would not fall to the Hashimoto like his father before him. He would not give them that satisfaction.

It became a kind of dance as Hanzo moved about the cramped battlefield, punching, swinging his bow, darting, dodging. He managed to retrieve several of his fallen arrows. But they were wearing Hanzo down. What the Hashimoto lacked in discipline and skill, they made up for in sheer numbers; at least, they did here in Tokyo, near their stronghold. And there was just one of him. It was only a matter of time before they overwhelmed him. He'd lost a lot of blood, and he was down to his last arrow.

Better make it count.

He charged his Storm Bow and fired the arrow, swirling with incandescent energy in the form of two intertwined dragons. They cut through the alleyway in a straight line, his enemies crumpling in their wake.

Only Topknot and a couple of his henchman had survived the devastating attack. Hanzo faced off against them, gripping his bow tight and swaying slightly on his feet. Much of the spilled blood on the ground was his own.

The enemy seemed taken aback for a moment, casting uncertain glances at each other. One of the men whispered to Topknot. The leader stared hard at Hanzo, at the bow in his

WHERE HONOR LIVES

hands, and mumbled, "Shimada."

Hanzo tried to get into a defensive stance, but he swayed and fell, slipping in and out of consciousness. Someone snatched his dropped bow and grabbed his hair, pulling his head up so they could get a closer look at his face. Topknot loomed over him, bleeding, but smug. "Who the hell are you?"

"I am no one." Hanzo spit in his eyes. The man recoiled. He swiped an arm against his face and then smacked Hanzo with his own bow. Hanzo's head snapped to the left, and his right cheek throbbed.

"Bring him," Topknot said.

Hands grabbed Hanzo's arms behind his back and looped a zip tie around his wrists, pulling the plastic more tightly than necessary. Hanzo had trouble focusing. He stared at graffiti that had been painted on the brick wall behind a dumpster, trying to make sense of the blood-red letters. Someone had unsuccessfully tried to scrub out the words, but he could just make them out: "If you do not enter the tiger's cave, you will not catch its cub."

Hanzo grinned. And then he blacked out.

—— ——

Hanzo came to in a small concrete cell, bare except for the rough slab he was lying on and a plastic bucket in the corner.

Opposite him, an amber wall of hard-light shimmered. Beyond it, a humanoid robot stood sentry. The omnic's metal body was the same silver and gunmetal gray as the armored door it guarded.

Hanzo yawned. His jaw popped, and he gently massaged the swollen side of his face. One of his molars felt loose. His shoulder wound had been cleaned and dressed in bandages. He was genuinely surprised that they had bothered fixing him up, but he also had a number of bruises and scrapes he didn't remember getting in the battle, which suggested they hadn't been too careful getting him here, wherever *here* was. Had they brought him back to the Hashimoto stronghold? Why had they decided to take him prisoner rather than leaving him to die in the alleyway, or simply killing him?

"How long have I been out?" Hanzo asked the omnic.

No answer.

He tried again. "Where are we?" He couldn't even be certain they were still in Tokyo.

The guard shifted his weight but didn't respond.

"Can I have a drink of water?" Hanzo asked.

That finally got a reaction from the guard. "Really, man?"

"I'm parched," Hanzo said.

The omnic knocked once on the door, and a moment later it opened. He left, and the door was closed and locked behind him.

WHERE HONOR LIVES

Hanzo lost track of the time, drifting in and out of consciousness, but it felt like several hours had passed before he heard the tumblers turn in the door's lock again. He was instantly wide awake, muscles tensed for another fight. But he kept his eyes closed while his visitor shuffled into the room softly on slippered feet.

"Greetings, young master," the man said.

Hanzo's eyes shot open at another familiar voice from his past. He bolted upright and stared. Toshiro Yamagami stood on the other side of the barrier. He was older and thinner than Hanzo remembered, yet somehow without seeming frail or weak.

The talented swordsmith had once demonstrated the forging of a blade, how it was heated and hammered over and over again until it was razor sharp. Yet despite its incredible thinness, the sword was stronger than untempered steel—and deadlier, even before his unique technology was fully integrated.

The impression that Toshiro Yamagami left was that, like one of his famous blades, whatever pressures he had been under in recent years had only made him stronger.

"Toshiro-sensei," Hanzo said in wonder. "What are you doing here?"

"Surviving," Toshiro said.

Hanzo drew in a sharp breath. The blades he had seen earlier weren't bad copies of Shimada weapons. The former

E. C. MYERS

Shimada swordsmith was now making weapons for the Hashimoto.

"By arming parasites like the Hashimoto?" Hanzo asked.

Toshiro's expression changed, some of his old fire dancing behind his eyes. His voice hardened as well. "I do not expect you to understand the difficult choices my family has been called to make during your long absence."

Hanzo winced. Until this moment, he had not given any thought to the fates of Toshiro and his family—his wife, Asa, and their daughter, Kiriko. After he'd left, the clan elders cannibalized Kanezaka and tore the Shimada legacy to shreds; Overwatch had ended what remained shortly after. He had assumed that Toshiro and Asa would go on as they always had, but he realized now that this was at best a naïve assumption, the better to salve his conscience. Of course things had changed for everyone. Each year, when Hanzo returned to Shimada Castle to pay tribute to his brother, he had seen the tainting of his home by the Hashimoto. He knew they had moved in when Overwatch moved on.

"Your work is shoddier than it used to be," Hanzo said lightly.

The fire went out. "I am forced to produce more . . . to work with inadequate materials."

Hanzo considered. Toshiro and Hanzo's father were of the same generation, and their similarities in manner and speech often led some to mistake them for family. There had never

WHERE HONOR LIVES

been any question of who held the power, but there also had been mutual respect between them.

And like Hanzo's father, Toshiro always chose his words deliberately, as though they had a hidden meaning. Hanzo wondered if Toshiro's materials were so poor, or if he was making his blades poorly to blunt the damage the Hashimoto could inflict.

If so, it must cost the man dearly, for he'd always taken such pride in his craftsmanship.

"It is unsettling, seeing Yamagami steel used to terrorize the people," Hanzo said. Not to mention, his artisan blades were being wasted on low-level grunts who didn't even know how to handle them properly.

Toshiro raised an eyebrow. "Life is not black-and-white. Who are the heroes? Who are the villains? It all depends on the actions you choose to take." The gray-haired man's eyes studied Hanzo, as if assessing raw steel. "Producing blades for the Hashimoto has helped keep *my* people safe these last eight years. Where have your choices led you?"

"Your words cut sharper than your blades, old man."

"Dull swords for dull men." Toshiro bowed his head. "My weapons can only be mastered by those who are worthy." He gave Hanzo a long look. "I forge them in the hope they will be wielded not only with skill but also with honor."

Hanzo was ashamed. Toshiro was the husband of Asa

Yamagami, who had trained Hanzo and Genji in the ways of the sword, alongside Kiriko. But she had been more than the Shimada clan's greatest ninja; Asa had been the closest thing the boys had to a mother after Rumiko Shimada had abandoned her family.

And yet, like an entitled prince, Hanzo had looked down on the Yamagamis as mere servants. He felt low standing before Toshiro now, knowing his family had shown more honor than he ever did. Hanzo ran from his responsibility, judging himself unworthy. But the Yamagamis stayed and took on a heavy burden—the burden that should have been his. He had changed since then, but that did not change his complicity in their current predicament.

"I am . . ." Hanzo swallowed. "You're right. I have been away too long. How is Asa-sensei?"

"She is still in Kanezaka, maintaining order."

Anyone who could keep the unruly Shimada boys on task during sword training would be good at keeping people in line. He suspected she was managing the Hashimoto rather than the reverse.

Despite his words, Toshiro's eyes still held some warmth. Hanzo remembered that he had always been quick with a smile for him, even when it seemed there was nothing to be happy about. As if they were the only ones in on the joke.

WHERE HONOR LIVES

Asa had once told him that it was just as important for one to know how to disarm an opponent without lifting a weapon. Often you could do it by saying just the right thing, smiling in just the right way. It was a skill that must have served her and her husband well under the Hashimoto.

Although, had it really been so different when the two of them worked for Hanzo's father?

"Hanzo, it is good to see you again. But whatever it is you seek, coming here was a mistake."

"My mistake was in getting caught," Hanzo said gruffly.

"Yes." Toshiro suppressed a chuckle. "The Hashimoto clan elders recognized your Storm Bow as a weapon that only could have been made by me." He held out his rough, calloused hands, palms up, as if in supplication. "They sent me to confirm your identity. Now that they have the Shimada scion, they will execute you to break the people. One stone, two birds."

"If it is an heir to the Shimada they want, you can tell them there is none. The clan died a long time ago—with my father. He left behind no one worthy of carrying the name. All that's left of my family are their lies, their failures, and their misdeeds."

Toshiro clicked his tongue the way he did when he found a nearly imperceptible flaw in a blade.

"Your father was a businessman. A criminal, certainly. But he always served the best interests of his people and, especially,

his family. He kept the tigers—and worse—at bay. Sometimes protecting what we love is all any of us can hope for our legacy."

They considered each other for a while. For Hanzo it was like gazing into a mirror that reflected his painful past, but also a glimmer of possibility.

Toshiro seemed to speak Hanzo's mind: "You remind me of how things were, but I also see what I have always seen in you, and in my daughter: the future we were trying to build. As long as our children live, so do our hopes for them and our dreams for the world they inherit."

Toshiro strode to the door. "I will report that the son of the dragon is so broken it would be a mercy to strike a killing blow. That you have destroyed the last vestiges of the Shimada more effectively than they ever could."

Hanzo gasped as if he had been struck.

"Your actions will determine the truth behind those words." Toshiro rapped his knuckles on the door behind him.

Honor resides in one's actions. Those were among Genji's last words to him. *You still have a purpose in this life, brother.*

Hanzo bowed to Toshiro, and the man returned the gesture. In a more conspiratorial voice, he said, "Should you somehow make it out of here, please find Kiriko. Tell her I wish I could have written more, been there for her. Tell her . . . I'm proud of what she has been doing to keep the Hashimoto in check."

Hanzo nodded.

WHERE HONOR LIVES

"Sojiro would be proud of you too, for coming back here," Toshiro said.

Hanzo folded his arms. "It would be the first time."

The older man smiled wistfully. "Oh, not at all, Hanzo."

The door opened and Toshiro turned to face the Hashimoto guards. As they escorted him out, Hanzo now saw that, indeed, they were in charge of the old swordsmith, not the other way around. But by making the choice to stay, under their rule, it was Toshiro who had seized control over his situation.

The door closed, and Hanzo eased himself down to the floor, folding his legs beneath him. He had much to think upon.

— —

When the door opened the next time, Hanzo knew it wasn't going to be a social call. Two Hashimoto clan members stepped in: a man with a drawn katana and his old friend Topknot. The latter held up a zip tie.

"Turn around," he barked. "Hands behind your back."

"If you're going to kill me, just do it here," Hanzo said.

"The bosses want to see you die. *Before* the evacuation."

Hanzo grunted. "By all means, then." He turned and held his arms behind his back, ignoring the twinge in his shoulder as Topknot roughly bound him. Of course his captors didn't know that when Hanzo was younger and bolder and more

arrogant, he had bragged that he could beat his brother, Genji, *blindfolded with his hands tied behind his back.* Asa-sensei had overheard and used it as a teaching moment.

And these fools weren't even going to blindfold him.

Hanzo had been outnumbered in the alleyway, but he could handle these two even without his bow—or his hands. And then what? Escape? He was done running. He wanted to see the Hashimoto elders with his own eyes, to understand how they could sit protected in their stronghold while the people outside suffered.

One of Asa-sensei's lessons had stuck with Hanzo because it seemed so counterintuitive: "You must learn when to strike and when not to strike. Sometimes you are better off waiting for the right opportunity to make your move."

So Hanzo waited, and he allowed these idiots to lead him through the labyrinthine corridors of the complex.

An itch at the back of his neck told him he was being watched. He slowed, casting his eyes about as they walked. He spotted a security camera positioned at the far end of the hall. Of course there were cameras, but that didn't shake the nagging feeling. There was someone or something else—

"Keep walking," Topknot said.

Hanzo took a steadying breath and continued on. The men ushered Hanzo into a gated elevator. Topknot slid the accordion gates closed and pressed the button for the third floor, then he

WHERE HONOR LIVES

turned the crank and the elevator rumbled to life. It slowly rose past two floors before stuttering to a stop. He turned the crank again and slid open the gate to reveal a spacious conference room. Five Hashimoto elders sat at a raised table on the far end, flanked by four guards in black suits. Topknot shoved Hanzo forward, and he walked toward the council.

Hanzo wondered which of them was the leader of the Hashimoto. The shrewd platinum-haired woman in the center of the lineup was the first to speak. "Hanzo Shimada."

"I no longer bear my father's name," he said.

A sleepy-eyed man on her far right steepled his fingers. "You might abandon the name, but it does not abandon you. Dragons are dragons."

"Until they are dead," joked the heavily made-up woman on the far left. The others chuckled.

"You are the last of your family, of our enemy," the first woman spoke. "And today we end the Shimada for good, and for all to see." Hanzo noticed a drone camera hovering above the guards, recording the proceeding.

Hanzo's eyes fell on his Storm Bow, resting on the table with his empty quiver.

"Which of you will fight me first?" Hanzo asked.

The elders glanced at one another, all smiles. "Shooting you will suffice."

Hanzo tensed as Topknot pressed the tip of his gun into his

back. The camera crept closer, its lens whirring and a bright light shining in Hanzo's face. He was going to be assassinated like his father before him, without even the distinction of facing his murderer in combat. All to send a message to the frightened people.

The gun's hammer clicked as it was cocked back. This was Hanzo's moment to act.

"Kill him."

Before Topknot could pull the trigger, the lights flickered. There was that feeling again: of eyes in the darkness. A glowing blue kitsune burst into the room, bounded past the astonished clan elders, and circled Hanzo and Topknot.

In the confusion, Hanzo twisted around and slammed into Topknot with his good shoulder, knocking the gun out of his hands and sending it skittering across the floor.

Metal flashed and a kunai flew toward Hanzo, slicing the plastic zip tie binding his wrists without even scratching him. His eyes flicked upward, tracing the welcome assist to an open ceiling panel. A figure dropped from it a split second later, landing lightly: a woman in white and scarlet miko clothing and red sneakers, the lower half of her face obscured by a red cowl. Someone shouted an alarm, and the elders scrambled for shelter behind the desk.

Hanzo whirled around and kicked high at Topknot, deflecting a punch. The man roared and swung at him again, but Hanzo

WHERE HONOR LIVES

was already launching himself into the air. He somersaulted forward, pinned the man's head between his legs, and twisted. He pulled Topknot down with him and rolled, flipping and spinning him around to slam down hard on his back. He did not get up.

Hanzo pushed himself to his feet and saw the newcomer watching him. The fox ears and stylized kanji on her headband suggested she was the one who had unleashed the kitsune attack.

Hanzo didn't have time to speculate on that, because a Hashimoto omnic was now swinging at him with his katana, sparking with glitching blue energy. Hanzo dodged his blows, knowing that contact with the enhanced weapon would deal a lot of damage. He needed something to fight with.

The fox ninja rushed forward and blocked the omnic's blade with crossed kunai. She followed up with a kick that made him double over, but he recovered quickly, sword flashing as he traded blows with her.

The fox ninja was lightning fast and nimble, keeping the omnic on the defensive as she zipped around him, jabbing with her smaller blades. The omnic retreated, no longer able to hold up his sword arm.

Without a word, Hanzo and the fox ninja pressed back to back and faced their remaining opponents. Hanzo stretched and flexed his aching arms. Fighting beside this ninja and her

glowing kitsune—he felt like he was in one of the fables his father used to tell.

Another wave of Hashimoto swarmed them with their glitching swords. Hanzo and the masked stranger worked in tandem, as if they had been fighting together their whole lives. They kept moving, rotating in the center of the room so that she could disarm the enemy with her kunai and Hanzo could finish them off in hand-to-hand combat. She was skilled, but her labored breathing indicated she was reaching her limits. Hanzo was nearly there himself, acquiring fresh bruises over his old injuries. The gunshot wound in his shoulder reopened, causing agony each time he moved his arm.

As soon as the last Hashimoto fell, the fox ninja turned to him. "Come on! We can't let them get away." In her voice was the echo of a girl he had known long ago.

Hanzo saw an open door at the front of the room. The elders were gone. He stepped carelessly over and on the fallen Hashimoto to collect his bow and quiver, noting that someone had restocked it with arrows.

The hallway outside the boardroom was eerily empty and silent. Hanzo glanced out the window, and what he saw drew him up short. Beside him, the fox ninja gasped.

The Null Sector command ship now hovered above Tokyo Tower with dark specks streaming from it, drop pods pummeling

the city in an apocalyptic hail. The sky flashed with weapon blasts, but Tokyo's police and Japanese militia were badly outnumbered and losing ground by the second. The city was under siege.

They raced downstairs, unchallenged, and got outside just as the Hashimoto's armored convoy was pulling away.

"We can still catch them!" Hanzo said.

She put a hand on his arm. "No." She took a deep breath. "We're needed here."

The streets around them were already swarming with warbots. People screamed and fled in terror. Hanzo was struck by the smell pervading the air. Of ozone, ash, and brimstone. Devastation and death.

Hanzo had seen the Null Sector attack in Paris on a broadcast, but in person, while it was happening, the level of destruction Null Sector wrought was a complete shock.

This assault was very real, and it was very personal. He knew the flame-tinged clouds and the smoke would be visible from nearby Kanezaka. And when Null Sector was done here, their drone ships would expand to sweep the less populated districts around Tokyo, corralling those who had fled the city. Most of the small towns in the outlying prefectures were defenseless; if Tokyo fell and Null Sector got a foothold in the region, it would have a domino effect and plunge the rest of the country into chaos.

E. C. MYERS

He nodded. The fox ninja drew her kunai as Hanzo nocked an arrow in his bow. Together, they picked off the closest warbots zipping overhead, sending them crashing to the ground. The cluster of people that the warbots were targeting bowed their thanks before fleeing.

"In there." Hanzo pointed the civilians toward the Hashimoto stronghold, its doors still wide open. "Plenty of room to hide until this dies down." He figured they would be as safe as possible there, at least until the Hashimoto came back to reclaim their base. *If* they returned.

The block around them temporarily clear, Hanzo turned to his masked benefactor.

"I know you," he said.

"About as well as I know you, Shimada. Probably less."

He raised a hand toward her but then pulled back. She tucked away her blades and loosened the cowl herself, lowering it beneath her chin. Her face sent memories spiraling through his mind. A young girl tagging along after him and Genji. He saw her sitting on the side of an arcade game cabinet while Genji chased another high score. He watched fireworks with her from the balcony of Shimada Castle. She brought dinner to Genji and Hanzo after their father died, his plate piled with an absurd amount of mochi—a small sign that she cared.

"The brat," Hanzo said.

WHERE HONOR LIVES

Kiriko smiled. "You're as insufferable as ever. I should have let you save yourself."

"I *did* save myself."

He would never have said he was close to her when they were younger. How could he have been? He'd had a duty before him, a role to prepare for. But he'd been untethered from any connection to his home for so long that her words—barbed as they were—reminded him of that time. Of all that he'd lost.

Even though he had turned his back on Kiriko, treated her like the nuisance daughter of the parents who served his family, she had been here for him when he needed someone, anyone, to care.

"However . . . you provided an opportune distraction," Hanzo grudgingly admitted. "You have my thanks, Kiriko."

"I missed you too, you big dope." She held up a hand, forefinger and thumb close together. "Like, *this* much."

He looked back at the abandoned stronghold. "You couldn't have been here for me. *I* didn't even know I was going to be here."

"You're right. I wasn't here to rescue you." She sighed.

"Your father."

"The Hashimoto kidnapped him years ago. He's allowed to communicate with us sometimes, but I haven't heard from him

in months. I thought I could use the Null Sector invasion as cover and get him out before it was too late. But the fox spirit led me to you instead."

Kiriko rubbed the back of her hand against her eyes, although they were dry. "Perhaps he wasn't even here."

"He was. I saw him," Hanzo said.

"When?"

"When they brought me in. He asked me to give you a message . . . He's proud of you, for keeping the Hashimoto in check."

Kiriko turned from him for a moment, staring at the place the convoy had been before it disappeared into the chaos.

Her family had followed their call to duty with honor, each in their own ways. Toshiro working from within, sacrificing his freedom so that his family could remain free, and feeding information about the Hashimoto back home. Asa, holding Kanezaka together and keeping them safe under Hashimoto rule. Kiriko fighting back against their oppressors, weakening their hold over the people and keeping hope alive.

Hanzo felt small beside their sacrifice.

There was a fine line between honor and cowardice. Hanzo had ended up on the wrong side of it, using honor as the excuse for not doing the right thing, the hard thing.

Kiriko squinted up at the smoky sky.

"Do you think Overwatch will come?" She turned to him

WHERE HONOR LIVES

then, glancing at Hanzo curiously.

He knew that Genji was back with Overwatch in Paris, and her expression told him she knew it too. But did she know what had happened between Hanzo and Genji before that? It was clear she would be happy to see his brother again, but Hanzo wasn't ready for that yet. And he certainly didn't want to talk about it.

She waited another moment for a response and then sighed. "There's no one to protect Kanezaka. Not the Hashimoto, that's for sure. I have friends back there, we've been doing what we can to fight back without making things worse, but they can't handle . . ." She looked over at the Null Sector ship. "Mom will be furious when she finds out where I've been, but it's done. Hey, you and I weren't a bad team!"

Hanzo nodded. "You aren't as useless as I remembered."

The voice of Sojiro Shimada spoke to Hanzo once more: *When the victorious dragon entered his old cave, he found it empty and cold. The tiger had despoiled everything. The dragon realized that he was not seeking treasure or vassals at all. Through his good deeds, he had reclaimed the most precious thing he'd lost: the worthiness to return home.*

Hanzo blinked a few times. The smoke in the air was making them water. "Perhaps we should return to Kanezaka, then."

She looked surprised. "You're coming with me?"

"I am grateful the fox spirit guided you to me, Kiriko," Hanzo

said. *And that the dragon led me to the purpose that I have been seeking.*

Kiriko pulled out a slip of paper and stuck it to Hanzo's chest. He looked down at it with a puzzled expression.

"An ofuda. For healing," she said. "It's kind of my thing."

Hanzo had never been one to do feelings and sentimentality. Maybe he was changing after all. He now owed Kiriko his life, and in so many ways, her parents had forged him into the person he was . . . and they were still setting the example of the better person he could yet become.

Her family had served his for centuries. Now he would serve them, and the people. It was a lesson his father had tried to teach him, but one that he'd needed time to understand.

Hanzo and Kiriko advanced down the street, leaving a trail of broken Null Sector warbots in their wake, slowly clearing a way home.

LOST GHOSTS

MOHALE MASHIGO

LOST GHOSTS

Fourteen years old and filled with rage, Fareeha crossed her arms and looked away from the holoscreen. Ana hadn't spoken to her daughter in weeks, and already the call had become tense.

"I didn't mean to sound so harsh, habibti."

Fareeha wouldn't meet her eyes. "This is what I want to do with my life. I get to decide that."

"You can find a new dream—you're so young." Ana sighed. "Why would you want to join Overwatch?"

Fareeha gave her reasons, but Ana wasn't listening. All she wanted was a better life for her daughter. Ana should have just heard her out, or at least paid attention to the tone, the urgency in Fareeha's voice. Maybe then she would have heard it: the desperation for a connection.

MOHALE MASHIGO

"The Crisis is over," Ana cut in. "You don't have to fight! You can be anything you want to be—I gave everything so you could have that."

Fareeha's tone rose as she launched into a new round of arguments. They didn't speak again for two more months, and Ana never heard more of her daughter's dreams.

Ana peered through the scope of her rifle at the woman below, helpless, surrounded by Null Sector warbots. Red hair fraying from a bun and a navy suit indicated that she'd been in the middle of a workday when the attack began. Invasions, war, any kind of violence just interrupts your life and has not even the slightest care for what you do afterward. Thoughts fired rapidly, one after another. How long had Red been displaced, desperately seeking refuge? Was she separated from her family? Did she leave a pet at home, thinking it was just another day and she would return after work? Was her home destroyed, her family lost?

Jack had insisted that they move between the shadows and occupy spaces that were partially destroyed. They were leaving one of those buildings when Ana spotted Red from the fifth-floor window. Standing barefoot in the streets with her hands raised, a sign that she meant no harm. This scene had become all too familiar for Ana.

LOST GHOSTS

Will there ever be peace? she wondered as she crouched in a nest of shattered glass and dispatched the warbots in the street. The sound of gunfire jolted the red-haired woman from her terror, and she scurried away, screaming the kind of terrified primal scream that had kept Ana up the first time she'd heard it in a war zone.

Never hesitate and never look away—rules of warfare from what seemed like a lifetime ago. Ana didn't look away until the woman disappeared between two buildings and Jack touched her on the shoulder.

"She's good. We can go now."

Ana knew that Jack was talking about Red, but Ana's mind called back to Fareeha. After their brief reunion in Cairo, Ana had longed to hear any kind of positive update about her daughter.

Then, a wink of hope. They had been passing through a ruined diner when they saw it. Electricity flickering on and off, there was even still smoke coming from some of the rooms. Ana wasn't paying attention to the diner or to Jack; she was too focused on ensuring they were not followed. It was another old rule from basic: *cover your team at all costs.*

"Take a look at this," Jack grunted, leading Ana through a wide crack in the wall.

The crevice opened into an abandoned kitchen. It told the story of a breakfast service rudely interrupted: A carton of

MOHALE MASHIGO

eggs overturned with its contents spilled and long dried out, a weirdly resilient spatula perfectly balanced in a pan, and tables and countertops peppered with shattered crockery. Over the bar a newsclip was playing on the holovid: Busan, by the look of it, though the news ticker said the footage was from some time ago, earlier in the attack. The reporter was speaking Korean, but the word *Overwatch* was very clear.

Ha! Ana held back a smile as she saw Cassidy's familiar hat passing through the scene. *He did it*, she thought. *He followed my bread crumbs.* His team of new agents were fighting in sync alongside the Korean military, pushing back a swarm of Null Sector forces. The drone footage was shaky and cut out just as a woman with a rocket launcher appeared in the left-hand corner of the screen.

Fareeha!

"She's good. You did good," Jack said, putting a hand on her shoulder. He so seldom smiled these days, amid their grim work, but the warmth on his face was genuine—he knew what this meant to her. Ana wanted to watch it again, to see her daughter swoop in and join the team.

Team. She and Jack once had a team, knew what it was to work together, to think as one but move independently, to *trust*. Something like the fine line between the Tahtib dance and the stick-fighting martial art it was born from. *Winston loved this kind of sentimental nonsense—*

LOST GHOSTS

Ana shook her head, wincing when her nostalgia was interrupted by a feeling that was less pleasant: *regret*. One might mistake the mission she and Jack found themselves on for heroism, but Ana knew better. She used to be captain, and Jack, the strike commander of Overwatch. At some point they'd become symbols: their faces plastered on recruitment posters, children's cartoons, on the receiving end of too many letters from people who'd been rescued by their agency. They'd protected humanity through the Omnic Crisis and had given their very lives to the cause . . . but it wasn't enough. The world was still broken, still needed heroes. And everything they'd built had crumbled, whether that end was hastened by their own hand, or by Talon, or by someone else entirely.

Now they fought where they could, made a difference where they could, but *good* did not drive them. Vengeance was leading Jack, and compassion for an old friend was leading Ana. Jack felt that he was getting closer to finding out what or who had brought Overwatch down. Ana helped him make headway: this new informant he was talking to seemed to have good information, and the source had promised something even bigger to prove the quality of their intel. That was what had brought them back to Zurich, a place neither of them had seen for many years.

It was like the setup to a joke: Two ghosts walk into a city where both of them lived and one of them died. She'd never

had a great sense of humor, but there was something darkly comedic about a ghost chasing the past. She had worked in Zurich for many years but never really thought of it as home. *Home* would always be Cairo, where her mother, Fareeha, and Sam (until he left) waited patiently for her to return. She always did . . . until the day that Ana broke one of her rules and hesitated. She was taken out by a Talon sniper in Poland—Amélie—someone she'd known, trusted, more than once tried to save. Her bullet found its mark, and Ana had laid in a coma under a stranger's name for years. Presumed KIA, she had died a hero with full honors, blissfully spared the downfall of Overwatch.

But Jack wasn't. He was there until its final moments, when Gabrielle Adawe's dream of an international peacekeeping force went up in smoke, along with Overwatch's Swiss Headquarters.

Lost ghosts, that's what Jack called them. Although, they were not really ghosts anymore. Cole, Fareeha, and Gabe knew she wasn't dead. *Talon, too, must be aware of my resurrection; which explains why they chased us through Cairo, Istanbul, Budapest . . .*

Jack and Ana walked in an extended silence until Ana finally asked the question she was hoping Jack would have already answered. He was being stubborn—but that was his nature.

"What are we getting up to tonight?" She swallowed hard because she could tell from his face that they were headed into an unsavory situation. One mind, independent bodies.

"According to our informant, Talon is taking someone out."

LOST GHOSTS

Ana narrowed her eyes at him in the gathering dark. "Who?"

"I don't know, but we are on our way to getting the time and place."

"Jack." Ana stopped walking; Jack walked a few steps ahead of her and turned. She could be stubborn too. "I can't help you if you don't tell me what the plan is. I'm on *your* side, you know."

There was an anger and pain that Jack was carrying with him. Ana felt sometimes it was too deep to heal. She was at his six, keeping him alive and focused, because of how deeply she cared for him—decades of friendship, a witness to the sacrifices each had made to build a better world, but also to the joy and refuge Overwatch represented to them. The world knew the agency for its heroes, but Ana and Jack knew it for Cassidy's office pranks, Mirembe's baby shower, Singh's mother's cooking, Vivian's dry humor . . . There was trust, solidarity, understanding in all they'd been through. Jack was determined to find out who was responsible for the fall of Overwatch—the old Overwatch, *their* Overwatch. It was good to see him so determined, but anger made even the best soldiers sloppy.

"My informant didn't give me the name. They left it somewhere for me to find." He opened his mouth to continue, but Ana put up a hand.

"So, we're walking into an ambush." She sat down at what was left of a bus stop. "I'm not taking another step until you tell me where we are going." Ana saw mischief in Jack's eyes,

and she would have jokingly punched his arm if not for the pain in her knuckles.

"Come on, Ana, where's your optimism?"

"I buried it twenty years ago, when you let me eat those questionable kebabs in Hyderabad."

That, at least, got half a smile from him.

"The intel is high priority. They couldn't risk transmitting it online, so it's been left at a drop point."

Ana put her head in her hands. "Where, Jack?"

"You're not gonna like it."

He was right; she did not like it. Jack was huddled outside a mausoleum, furiously scanning the inscriptions of various burial chambers, where supposedly MARIA CHERISHED MOTHER, SISTER, AND CAT LOVER was interred, along with the encrypted data drive of Jack's informant.

Ana was leaning against a gargoyle on the roof of another tomb set farther back, atop the hillside of the cemetery, watching Jack through her scope.

Ana swept her crosshairs over the space while Jack ran like a much younger man to another mausoleum. *Funny, what makes him happy*, she thought. As Jack was jiggling a capstone loose—he must've found the right Maria—Ana spotted a small

LOST GHOSTS

Null Sector squadron marching toward Jack's position from the street above. Instinct and adrenaline kicked in; she took a deep breath and held it. Ana dispatched the warbot that was nearing Jack's position, then took out the one beside it as it searched for their attacker. She squeezed her trigger, aiming for the third warbot just as a fourth appeared and opened fire on her.

Dammit. She slid down the pitched roof of the tomb, hearing a shout of pain in her earpiece. She chanced a peek and saw Jack, bloodied, leaning weakly against the wall of crypt plates. Careless.

Ana dispatched the other two warbots and abandoned her cover to get to Jack. When she finally reached him, he was still struggling to catch his breath, his whole body racked by a spluttering cough.

"Come now, Jack," Ana said, trying to find the source of the bleed. "A cemetery is no place to die." Ana put a bloody hand on Jack's lips, her heartbeat like a drum in her ears. She focused on the laceration and the bloody bubbles coming from Jack's chest. Had they hit a lung? For a long time Ana could do basic medical, the kind all military personnel were required to learn. Stop a bleed, keep them awake, wait for the medical evacuation team, if you can move the injured stay out of sight. Jack let out a scream as she injected nanobiotics into the wound. Jack never used to need any kind of patching up; he healed faster than anyone she had ever met, save Gabe. Probably why he

always rushed into danger; he knew he could bounce back. Ana looked at the scars on his chest and wondered how long it would take for his wound to heal. She pressed gauze over the wound and held her hand there.

The pair sat next to Maria, in silence for what seemed like an hour. Jack's breathing finally returned to normal. Ana pulled a thermos out of her backpack and handed it to her friend. He took it, opened the top, and sniffed it before taking a long swig of the tea Ana insisted on carrying with her.

"Don't keep me in suspense. What's the information you almost died for?"

"An address and time."

"And we can trust the information?"

"We've trusted the source up to this point. I'd like to see this one through, stop this hit." Jack tried to get up.

Ana stood and extended him a hand. Jack was clutching his still-tender left side. Ana wanted to tell him to slow down, but she asked a question instead. "What will you do when all this is over?"

Jack looked down. "We're soldiers, Ana. War's never over."

Fareeha was seven years old, her voice shaking over an encrypted video call. "Come home. I'm scared, Mama."

LOST GHOSTS

Wanting to do the thing and actually doing the thing, that is where Ana was.

After weeks of nonstop omnic attacks, there would be a quiet night when it felt like the machines were regrouping. It was those quiet nights where, if Ana closed her eyes, she could pretend they were a bunch of misfits who were out camping together. Gabriel was convinced that the strike team had become immune to the rush of adrenaline, that their so-called quiet nights weren't that quiet at all, since they had become accustomed to a certain level of combat.

"Let us hope not," Reinhardt would answer. "Our sniper needs adrenaline to focus."

Ana was huddled in a Ståltäcke tent—back then it was just another innovation Torbjörn had brought with him, something the engineers had dreamed up in Gothenburg. A compact shelter that could travel well and withstand combat.

Jack had been doing push-ups when she walked past him—the operation was still rudimentary. "Tell Fareeha I'm already on my five hundredth push-up."

Ana chuckled. "Shame the devil, and stop lying, Jack."

Fareeha was not in a particularly talkative mood, so Ana told her about Jack's push-ups. "Why is he always doing push-ups?" she asked, masking a giggle. But Ana could see her daughter's happiness evaporate when an explosion went off. It was in the distance, a good kilometer or so. Ana could hide injuries and

manipulate light in a video call, but the sounds of combat were less easily hidden. "What's that?"

"It's just an explo—"

"Is it the omnics, Mama? Are they gonna get you?"

Ana could have lied, but Fareeha would have seen right through it.

Gabriel ran into the tent to let her know he was going to take care of it. "Heading out with a small team. Stay. We'll be back in no time. Probably some stragglers that lost their hive."

Fareeha was watching her mother's face intently. "Who was that?"

"It was Gabriel. We will be fine."

"How do you know?" Her daughter, too smart, always with the follow-up question nobody wanted to answer.

"They make themselves heard long before you can see them, the omnics." Fear is a great strategy. Fear brings doubt and doubt turns humans into easy targets. During Ana's first few nights of combat, she didn't sleep. The others fell asleep easily, but Ana needed to figure out how to quiet the fear. It was almost two weeks later when the answer came to her.

"Fareeha, did you hear another explosion?"

Her daughter just stared at the screen, hugging her legs to her chest.

"The time between explosions is important because it tells you how many omnics there are and how far away they are. At

LOST GHOSTS

least, that's how I've figured out the attack patterns lately."

"Like thunder?"

Ana knew she would get it.

"Yes."

Fareeha's shoulders relaxed a little, but Ana could tell she was about to throw another question at her.

"Are the omnics going to attack us here?"

Ana didn't remember how the call ended, but it was then that she decided Fareeha would never feel fear like that again.

Gabriel was surprised when he realized that Ana had left base to join the night raid he was leading. If her daughter could not sleep, neither would Ana. Not until Fareeha could sleep in a peaceful world.

The sun had long set when they neared their destination. They were far from the city (and the grave that had given them secrets) now, deep in the suburbs where the Null Sector invasion hadn't yet touched. The citizens here were still under a shelter-in-place order. *From one ambush to another.*

Ana scowled. "I don't like this. It's a residential area, too many civilians. Do we have a plan?" Night missions used to be her favorite, but she couldn't shake the feeling that Jack was keeping something from her. She didn't like entering an

op without a full briefing, but Jack insisted that they were running out of time and couldn't afford the hours it would take to regroup, rest, and strategize.

"Same as always: find a good vantage point," Jack said. "I'll scout below, see if I can shake loose any Talon operatives. Stay on the comms and cover me when I go in."

"So we have half a plan. I suppose it will do," she whispered as she picked up her bag, slung it over her back, and started running.

A sleek, modern home lay below, nestled in a wooded hillside. *Who lives in this house?* It looked like a glass cube with warm light coming from a few lit rooms. Maybe it was the sniper in her, but there was no way Ana would ever live in a house like that. She'd learned long ago that windows are just invitations to an enemy.

She slipped into an abandoned property forty meters from the house, where she could stay concealed and get a better view, but also move in quick if Jack did something reckless.

"Glass house? I'm making it easy for you." Jack laughed on comms as she ran up the stairs.

Breathe. Focus. Null Sector invasion, a cemetery ambush, and a Talon hit in one day? Maybe nothing has changed from the old days.

Jack grunted. "Ana, are you in position? What do you see?"

A woman and a child, asleep in front of a holoscreen in the

LOST GHOSTS

living room. The woman was holding the child, who was sleeping on her lap. Ana held her breath. *Focus. Exhale.* Faint yellow light coming from a bedroom and kitchen. The other two rooms she could see from her position were dark.

"Jack, there is a family in there."

"I'm almost in position. Where?"

"Living room."

Before she could turn on her thermal scope, she noticed Talon troopers stirring in the yard, so easy to spot with their flashy laser optics.

Never hesitate and never look away. Ana exhaled and continued sweeping her scope around the perimeter.

"Troopers at three o'clock, moving in. I've got you covered. Find a way inside . . . *fast*."

She watched Jack move from his position, but a second set of troopers had already begun to intercept.

"There is another small group ahead of you—six troopers, ten clicks."

"I've got it," he said. The faint rattle of gunfire followed his words.

Searching frantically and counting how many rounds Jack was firing, Ana tried to find him near the kitchen window and caught a light floating around by his ear.

"Get down!"

Jack ducked and rolled behind a planter, and a Talon trooper

fell a few meters behind where Jack was standing. *Useless armor.*

"You're fast, Ana."

"You got slow. I've got your six. Watch out for the ones ahead."

Two silhouettes scurried from the couch, one toward Jack's position—*No!*

Ana was loath to give away her position, but there wasn't a better alternative. She loaded her rifle with stun rounds and fired, dispatching half the unit. The remaining troopers were looking up toward where the gunfire had come from. *I'm not safe up here. Need to move.* Ana turned back to the woman in the kitchen, who had retrieved a handgun, her child now gone from the room. Ana fired another round this time, hitting a glass of wine on the counter. The woman looked up at Ana's position in shocked recognition. The blonde hair and earnest face, it was like stepping into the past.

"Mirembe," she breathed.

It can't be!

She was older, but that silhouette, the way she held her rifle firm, unflappable? It was her.

"It's *Mirembe*. Jack, Talon is targeting Mirembe."

All she could hear was Jack's breathing while she searched for a new vantage, but none were ideal. There were troopers coming out from the bushes and two breaking into a skylight

LOST GHOSTS

from the roof. Mirembe headed from the kitchen and up the stairs. Ana rose and slung her rifle over her shoulder.

"There's about twenty of them down here," Ana heard Jack say while reloading. There was only one thing to do—even as it went against all their rules.

"Jack, I'm coming. You hold them off—I've found a way into the house. Meet me inside!"

Climbing up the bedroom balcony, all Ana kept thinking about was the child inside. The child who was possibly Mirembe's. A Talon trooper spotted Ana and was aiming for her; she saw the laser before she saw the trooper. With a rifle in one hand, she looked straight to where the laser was coming from, aimed, shot, heard a *thud*, and broke the bedroom window.

"So, this is how I find out you're alive?" Mirembe asked as soon as Ana swung into the bedroom. The furniture was sleek and modern but spaced strategically to make the place feel open. Ana counted all the places where Mirembe could, and probably was, storing weapons.

"Would you rather I stay dead?" Ana said, looking around for the little boy. "He's safe?" she mouthed.

Mirembe nodded and mouthed back, "Panic room." She flashed Ana a hand signal, held up three fingers, and then pointed to the door of her en suite bathroom. Ana lifted her rifle and looked at the closet to her left.

MOHALE MASHIGO

"I'm inside." Jack's voice crackled in Ana's ear; he was out of breath. "Clearing the ground floor." The sound of gunfire downstairs indicated that Jack had his hands full.

"Ready?" Ana whispered. At that, she hefted her rifle and Mirembe steadied herself as three troopers ran out of the bathroom toward her. *Two bodies, one mind.* Mirembe and Ana ducked in and out of cover as they cleared the bathroom and moved into the passage, where a swarm of troopers were rushing up the stairs.

Focus. Mirembe was one of the last people Ana saw before she "died" in Poland. *Three shots to the right of the chair in the hallway.* Her husband had been dying of cancer, and Ana often thought about how her old friend was doing, how *all* her people were doing. Had Kimiko's middle daughter passed algebra? Did Singh's mother still make that wonderful crusty bakarkhani?

Mirembe nudged Ana and shot a trooper who had gotten a little too close for comfort. *Breathe.* They cleared their way down the hall and were running down the stairs when they discovered Jack leaning against the banister.

Ana glanced from Jack to Mirembe, and the ringing in her ears stopped. They surveyed the destruction in silence. "Guess it's time to move again," Mirembe said with a shrug as she walked upstairs. "I'll be back in a minute."

She returned carrying a little boy bundled in a dinosaur

LOST GHOSTS

blanket, wearing a holovid visor. Mirembe looked calm as she approached them, but Ana could see the tension in her fingers as she clutched the boy to her body. In her hands was a fear Ana knew well. Mirembe put him down and took off the headset.

"Kweku, I want you to meet the people who came to help us tonight."

The little boy looked up at Jack and then at Ana; he thought for a moment and then asked, "Are these your friends, the heroes?"

"Why do you have to go to Overwatch, Mama? Are you in trouble?" Fareeha was walking on her tiptoes along a wall that stood as high as her six-year-old frame, and Ana was walking next to her. Her daughter was always a multitasker—chewing and running, reading and singing, solving sums while practicing her pirouettes, and asking complicated questions while pretending to be a tightrope walker. Ana wanted to tie Fareeha's hair up, but she didn't want to get in the way of the game.

No, they want me to work for them.

"Doing what?" Fareeha asked, reaching for her mother's hand when she wobbled.

Ana held her hand and didn't let go. "I'll be doing this"—she gave the little hand a squeeze—"making sure you're safe."

MOHALE MASHIGO

"From the omnics?"

If only it had been that simple. How long did it take to end a war? What unforeseen dangers would that bring with it? Even if they could end this war, the world could not be so easily fixed, and they would eventually be tasked with making the world safe. Peacekeepers, that was what Overwatch was going to become, though Ana didn't know it at the time.

"Yes, and that means that I have to go far away."

Fareeha nodded, and Ana knew a difficult question would follow.

"Is it dangerous?"

No one else had dared to ask the question aloud. Not even Sam. They all knew it was, but hearing her daughter say the words made Ana pause.

"Yes, but sometimes we have to face scary things."

Fareeha stopped and jumped off the wall.

"So . . . you're going to be a hero?"

The word hero *surprised Ana; she was one of Egypt's top snipers and a seasoned soldier. It was all duty for her. She didn't feel heroic at all.*

The authorities had been alerted and were on their way to clean up the scene and give Mirembe a security detail. Kweku

LOST GHOSTS

had fallen asleep on his mother as Jack led them to a safer location. Ana had put her jacket over the boy, even though it was a nice night with an occasional warm breeze. As they settled into an abandoned supermarket a block away, Mirembe looked like she could use a good night's rest and a cup of tea.

"You know, I remember the day I got the recall," Mirembe said. "Kweku was trying to show me something in one of his games, and I missed it, watching Winston's message." She stared off into the night sky, the scattered fires of Zurich in the distance. "Hard to believe Talon is still targeting us, amid all the Null Sector chaos too."

"Feels like nothing has changed," Jack said, bitter.

"Maybe," Mirembe said. "But I haven't changed all that much either. I still feel that call sometimes. Especially now, to make the world better for my boy, to make it safe." She adjusted her hold, cradling Kweku against her. "I would imagine that's why Talon targeted me. If I'm feeling it, there must be others thinking of answering Winston's message."

"Would you do it?" Ana asked.

She sighed. "Losing Kweku's dad has . . . complicated things. The oversight board has been checking in aggressively with all of us since the recall went out. Kimiko said the same. Vivian, too, although . . ."

Jack cleared his throat.

MOHALE MASHIGO

"I heard she was out in Toronto," Ana said, ignoring him.

Mirembe smiled at them. "Seeing Vivian fighting in the field again, it made me wonder if there might be a future for me to get back out there. If after all this, they might ease those restrictions." She sighed. "Who knows? Maybe we'll all be back in Gibraltar soon. I saw Fareeha in the footage of Busan, you know. You must be—"

Mirembe's phone chimed with an alert.

Ana snuck a glance at the screen. "They're close?"

"A few blocks away. Just enough time for you both to get clear. I'll see you again soon?" Mirembe was searching Ana for something. Hope, maybe, or reassurance. "You won't die on us again, will you?"

"Who, us?" Jack said with a grin. "Couple of old soldiers? Not likely."

Ana took Mirembe's hand and squeezed it gently, by way of goodbye. She didn't want to mention Jack's mission and his informant; it was all too complicated. Being the good intelligence operative she was, Mirembe filled in the pieces she thought were apparent: Jack and Ana must be back with Overwatch. That's how they knew Talon was coming, how they knew to intercept them and save her.

"Tell Winston I said hi, and if . . ." She trailed off, then found her resolve. "If he can get us all out from under the UN . . . I think he'd see a lot of familiar faces in Gibraltar."

LOST GHOSTS

Ana smiled. "We'll do a perimeter sweep on our way out."

Ana closed the door gently behind her, but as she followed Jack once again into the cover of darkness, she paused. She had known Jack long enough to sense he was still withholding some information from her. They walked in silence for a few minutes. Ana didn't want to push until they were out of earshot.

"Out with it, Jack. There's more, isn't there?"

Ana watched as he wrestled with whether he should share whatever he was hiding.

"Do me the courtesy of not treating me like a hired gun and a fool. We have been through too much together."

Jack pulled something out of his pocket and held out his hand: the data drive.

This is not good.

"My informant didn't just give me an address. This drive provides the user a secure back door into an active set of Talon project files. Mission briefings, schedules, and a list of names. I had no way of knowing whether the information was any good, so I asked for proof. Mirembe was the first name on the schedule . . . she was the proof."

Jack didn't look at Ana as he spoke.

"Talon has a nearly complete list of Overwatch agents' last

known locations . . . from when they infiltrated Watchpoint: Gibraltar. They've been executing hits for two years now."

Ana felt a bitter taste in her mouth. She'd heard that rumor—had even mentioned it to Cassidy when she saw him in Cairo.

"*This* is going to lead me to more information. It means my informant knows what Talon is up to."

Ana wasn't sure if it was her voice that she heard next; it seemed to come from far away. "You must be joking."

Jack stopped walking, turned to face her. "Ana?"

"Jack. These are *our people*. They've been dying, ambushed, assassinated, for years." At the look on his face, she continued. "Who is the next name on the list? Winston has a new team. We can let him know; he can help."

Jack was already shaking his head. "The minute you involve a larger operation, you're going to arouse suspicion. My informant—"

"What would have happened tonight, had we not been there? They dispatched thirty-eight troopers. Mirembe would not have survived, her son—" Ana felt heat rise from her neck to her cheeks, stopped herself.

Jack said nothing.

"Give me the drive." He didn't argue as she downloaded the data. The names came up, and she felt a cold chill seeing the familiar faces, names crossed off in red.

LOST GHOSTS

"Jack. We lost a lot to the past, but these people . . . I made a vow to protect them."

She passed back the data drive and exhaled. "We are alive, Jack. We are not *ghosts*. Why are you still fighting the past?"

The look in his eyes was far off, but he came back to her for a moment, to meet her gaze. When he spoke, it was barely more than a whisper. "You've always wanted to make the world a better place. For Sam, for Fareeha. You went the extra mile for them. For me," he paused, lost in thought. "The past is all I've got."

"Please be careful, Jack." There was a lot unsaid in that plea, but Ana trusted that he knew what she was trying to say.

"Let me take care of the people I love, my way. I won't rest until I find the people who made this list . . . and the ones who wanted the end of Overwatch."

Ana felt a grief welling up inside her. Even when they had separated on tough missions, she always knew she would see him again. This time, she was less sure, and he knew it too. They were fighting different wars.

"Please, take care of yourself."

Jack only nodded.

Ana watched him disappear into the night.

"Goodbye, old friend."

Ana realized she was wrong when she'd told Fareeha she

had saved the world for her. The truth was that the world would always need saving. That was the greatest illusion of Overwatch: that peace was attainable. In truth, there would always be those who threatened stability, who sought to take advantage of good people.

Fareeha had seen it even then, as a child. Now she was the hero others looked to—that *Ana* looked to. Devoid of hope as she believed herself to be there, standing in the dark alone, with fire on the horizon, Ana felt closer to her daughter in that moment. This was something they shared: a mission of peace, of saving the ones they loved. And if Ana couldn't do it from her side, she would do it from afar, wherever it called to her. She would find the people on that list and protect them. It was, at least, one wrong she could right in this dimming world.

LUCKY MAN

MELISSA SCOTT

LUCKY MAN

Jack darted down the empty street, hugging the buildings to the left where the shadows were thickest. He cocked his head to listen for incoming warbots, and his visor pinged once, then twice: Null Sector troops were moving toward him, along one of the narrow cross streets. He could avoid them if he hurried, but they were between him and the rendezvous. No reason not to deal with them while he could. He looked up, checking the rooflines. This had been—and maybe still was—a residential neighborhood, the buildings three and four stories tall, most with flat roofs that sloped on the sides, topped with what had probably been roof gardens just last week, before the invasion broke out. There were fire escapes, as he'd hoped: take one to the top, creep along the rooflines, and he'd be in a perfect position to ambush the warbots as they crossed the larger street just ahead.

He was moving even before he finished the thought, leaping to catch the metal rungs and hauling himself rapidly up the side of the building. The metal was rusted, and the bolts creaked under his weight, but it held long enough for him to make it to the top. No garden here, just a stand of narrow chimney pots. He glanced up once, checking for drones, then leapt to the next roof over. The dividing walls were too low to offer much cover and were brick besides; he jumped to the next roof, crouching in the shadow of its chimney, then edged forward until he could overlook the streets.

His guess had been good. Three warbots were moving up the cross street in a loose V formation: big artillery units, their shoulder-mounted cannons swinging gently from side to side as they inspected their surroundings. Jack grinned. The artillery units were powerful but painfully slow; take the first out, he thought, and the others would be unable to advance past its wreckage, or retreat with any speed.

He popped up over the edge of the roof to take that first, vital shot, the pulse rifle cradled against his ribs. The bolts smashed into the big machine's midsection, rocking it back on its legs, and he switched targets, aiming for the cannons. The first pair blew out, ripping the weapons off the unit's shoulder, but his next shots just clipped the second pair. He went for a leg shot instead and brought the lead machine to one front knee. The other two artillery units swung their weapons toward him, firing

LUCKY MAN

blindly along the line of the roof. He ducked, scrambling for new cover, and heard a mechanical clattering as something launched itself toward him from the roof across the street: the warbots had had support after all.

He flung himself backward, swearing, and dodged a cascade of broken brick and stone. He righted himself and fired again, catching the Nulltrooper in midleap, but there was another behind it, and another. He brought them down, then turned his attention to the machines in the street. The first unit was rotating blindly, sensors in disarray; the other two fired again, and Jack switched to rockets, laid a pattern at their feet. The street filled with light and heat, and when it cleared, the wreckage of the warbots was sprawled on the cracked asphalt. One had lost all its cannons but still had three legs and was scattering sparks as it struggled to reacquire its target. Jack fired again, one last long burst, and left it smoking on the pavement.

Jack leaned against the roof's edge, his own breath loud in his ears, all too aware of a sharp ache in his ribs from dodging the Nulltroopers. He should have spotted them—should have taken out the first artillery unit completely the first time. He worked his shoulders, trying to ease the tightness there. At least he'd been lucky this time. He lowered himself down the nearest fire escape, lengthened his stride as he turned toward the rendezvous point. He'd just make it.

There hadn't been as much fighting in this part of the city.

MELISSA SCOTT

The power was out, of course, and windows were blown out all along the street, but nothing was actually on fire, and the locals were either in shelters or had abandoned the area. At least no one was calling for help. In fact, it was spookily quiet: his feet the only sound, crunching the shattered glass that carpeted the pavement. He checked his sensors: Null Sector seemed to be focusing their attention on a district about three miles away. And that was good. He'd be able to meet the informant in something like peace.

The rendezvous point loomed ahead, a skinny modern three-story tower wedged between much older buildings. Its door was locked and barred, the ground floor windows shielded with heavy metal shutters, and the upper windows were outlined with shattered neon tubing. There was an advertising display screen on the roof, but it was dark, a corner of the screen shot away. Jack eyed it carefully, but he saw no signs of movement. Nor was there any movement on the adjoining roofs, nor any suspicious heat shadows on his sensors. The informant had said there was access to the roof from the left-hand alley, and sure enough there was a combination of windows and stonework that made an easy ladder all the way to the top.

Jack heaved his way up and circled the perimeter of the roof once, checking the neighboring buildings, then hunkered down beside the screen where he could observe all the approaches. He was early, that was all. The informant would be there, and

LUCKY MAN

this long, bitter hunt would finally . . .

He killed that thought, not daring to get his hopes up, and surveyed his surroundings again. He had more pressing threats to deal with at the moment. He could see smoke in the distance from the vanguard of the Null Sector attack and caught the faint smell of burning plastic as the wind shifted.

Bitter dust—heat, ringing ears, a phantom pain shooting through his thigh—

He dragged himself back from the edge of memory, warded it off with the thought of Ana, new guilt to drive out old. It hurt, to leave her again after they'd so recently found each other, but he understood the need to help, remembered it entirely too well from the Crisis.

The memory of Ana disappeared. Victoria Naughton's face rose to replace it, hard and sharp beneath her carelessly tousled hair. The genius of the Soldier Enhancement Program, who would give the United States the win it so desperately needed during those early days of the Crisis. She had come with them that day in the field, their first Omnic Crisis deployment—come to see her handiwork, she'd said, stepping over bodies as she made her way down the length of the transport. They'd lost more than half the unit, and nearly everyone who had survived was wounded, but even two enhanced soldiers had made a difference. They had held the junction and driven back the omnic wave, small as it was. He'd taken three bullets—grazes

mostly—and not noticed until they were on the transport home.

"Lucky man," Reyes had muttered, fingering a hole in his own sleeve, and Naughton had laughed at both of them.

"Lucky? The only *luck* was that I chose you," she said. "It'll take more than a few hits to take one of you down."

Jack had looked around the transport, stinking of blood and hot metal and filled with regular soldiers—as he had been just months ago—who were dead and dying, too many of them and not enough medics, not enough bandages or anything that would help them. They'd been his responsibility, and he'd let them down. If he'd known what he could do, if he'd understood, maybe he could have done more. "Given what happened today, it's hard to think of the op as a victory for the program," he'd muttered, and Naughton clucked her tongue at him.

"Wasn't it Napoleon who said he'd rather his generals were lucky than good? After today, I'd place odds on you both."

She had turned away then, and he and Reyes had exchanged one searing glance: if this was luck, neither of them wanted it.

Sensors pinged, and he snapped back to the moment, focusing on the distant flicker of motion. There, above the dormer windows, a shift of light and the click of a dislodged roof tile. He shifted to cover that approach, pulling back into the shadows, and a bright piece of metal sailed through the air to land in the opposite corner of his roof, shielded by the ad screen. His finger tightened on the trigger, but he managed

LUCKY MAN

to hold himself back. He'd been waiting a very long time to see who was behind the leaks and whispers, who had laid the trail that brought him one step closer to learning what *really* happened to Overwatch.

Purple light flared, and a slim figure popped into existence. Jack swore under his breath, recognizing her instantly from their run-in at Dorado, and rolled to the far side of the ad screen, leveling his pulse rifle. He would make this quick.

Sombra spied him immediately and raised empty hands. "Not so hasty!"

"What did you do to my informant?" Jack demanded. He checked his visor, searching for a Talon trap. He didn't have time for this . . . If they had killed his source, he'd have to start all over again—

"Think it through." Sombra smirked, keeping her hands raised. "I thought you'd get there a little quicker, if I'm honest."

The pieces shifted into place. Jack furrowed his brow. "*You're* the informant."

"In the flesh."

"Then we're done here." Jack kept his aim steady as he began to step away. She'd been stringing him along for years, kept him chasing his tail and out of her boss's way. "I can't trust anything you've said."

"Take it easy," Sombra said, annoyed. "I work for Talon, yeah, but I'm—well, more of a freelancer than your former—"

"We're *not* talking about Reyes."

"Yeesh, tough subject for you both. Okay, I get it. I wouldn't trust me either, but I've been after something bigger, something I've been chasing for a long, *long* time, and it turns out it's the same thing you're after." She lowered one hand, a twist of light dancing in her palm. "Let me show you."

"Go ahead," Jack said, aiming the pulse rifle at her chest. He knew what she could do.

Sombra rolled her eyes, but the light vanished. "All right, fine. You're a very suspicious cabrón, you know that?"

"Un cabrón *vivo*," Jack answered.

"Un cabrón con *suerte*." She grinned. "We're after the same people."

"Keep talking," Jack said.

"Thing is, my proof is in a UN storage facility here in Zurich," Sombra said. "The one that contains the remains of Overwatch's Swiss Headquarters. The one where you—you know—sort of died? Help me get it, and I'll give it to you."

Jack shook his head. "No deal. That's your kind of mission, not mine."

"Oh really?" She flicked a holoscreen before him.

EXPERIMENTAL WEAPON STOLEN FROM WATCHPOINT: GRAND MESA

LUCKY MAN

Jack shook his head—he'd taken his weapons back from UN custody with good reason, one the world would appreciate soon enough.

"I'm not helping Talon." He took another step backward, curious to see how she'd react.

"I told you, *friend*," Sombra answered, "this is off the books with Talon. I mean . . . what have you got to lose here? Looks like you've already lost a lot."

Jack hesitated. It was stupid even to think about going along with this. It would be hard enough to break in if he was working with a team he trusted. The place would be locked up tighter than ever because of the Null Sector attack, a perfect tomb if she double-crossed him. Sombra was just the sort of person who'd think it was funny to leave him to die among the wreckage of all he'd built. But if he didn't see this through . . . Even if Sombra was lying, even if she'd been lying all along, she'd presented him with a unique opportunity, to return to the scene of the crime, or at least, what remained of it. This was the only chance he'd ever get to examine the wreckage salvaged from that day. That would tell him something—it had to. "All right. But we avoid the guards, and we don't shoot to kill."

"Pinky swear." Sombra shrugged one shoulder. "Besides, the Null Sector attack is good cover. Half the guards have been deployed to deal with them."

That was true, and it made for better odds. "Was this attack Talon's idea?"

"I don't mix business with pleasure," Sombra answered. "Coming?"

She turned and slipped off the roof without waiting for his reply.

Jack swore again, knowing this was stupid—and dangerous—but it was the only lead he had left at the end of a long road. Pulse rifle ready, he followed.

The UN storage facility was in an industrial district, where the cityscape thinned to faceless warehouses, recent construction put up cheaply. The storage facility was better built, sheer windowless walls rising behind electrified fences topped with coils of razor wire. There was a single gatehouse, armored walls reinforced with a layer of sandbags, and a trio of nervous guards with automatic rifles at the ready. *Sombra was right*, Jack thought, scanning the approaches. Most of the guard detail had to have been called away to deal with the Null Sector attack, or there would have been more of them on the gate. Still, any attempt to get past those guys was going to set off all the alarms, and he looked at Sombra. "I hope you've got a better plan?"

"*Pfft.* I'm sure you could take them." She pointed to the right, along a trash-strewn alley that serviced the building next door. "But as it happens, I do."

Jack gave the guards one last glance and followed her down

LUCKY MAN

the alley. Almost immediately, a concrete wall covered in graffiti cut them off from the storage facility; on the opposite side, the warehouse walls were windowless and unpainted, the kind of concrete that was heavily reinforced from within.

"Come on," Sombra said.

He joined her at the alley's end. The wall ahead of them was three stories high, topped with more electrified razor wire. "So, you're wondering why I led you into a dead end?"

"Nope." Jack shook his head.

"Smart man." Sombra pulled up a holoscreen, lights flashing red, fingers working on the virtual controls. A light winked overhead, and Jack looked up to see a rectangular shape set into the top of the wall. "That's a regulator for the security fence. Apparently they had trouble keeping power levels from fluctuating without it—lucky us." Her fingers moved as she spoke, more symbols flashing on her screen. "On the downside, I'm going to need you."

"Why?"

"You are so suspicious!" She rolled her eyes. "Because I have to get up there to cut power to this side of the station, and you are just the boost I need."

"Then over the wall?"

"You're catching on nicely."

Jack sighed, but recognized necessity. He stooped, letting her scramble to his shoulders, then straightened slowly, holding

on lightly to her ankles. She balanced easily, graceful as a cat, and he felt her weight shift as she reached for the regulator. There was a *snap*, and a mechanical voice said, *Access code required. Alarm sounding in ten. Nine. Eight . . .*

"Sombra . . ."

There was another *snap*, and the voice went silent. "You weren't *really* worried?" Sombra said. There was a *ping* of breaking wire, and suddenly her weight was gone. Jack looked up to find her sitting astride the wall, the razor wire peeled back to make a gap big enough for both of them. "Come on."

Jack braced himself and jumped, just managing to catch the top of the wall with both hands. He struggled for a moment, feeling his age again, then hauled himself up to join her, tucking his pulse rifle against his chest as he scanned the facility's windowless walls. "Cameras?"

"Taken care of." Four holoscreens danced in the air in front of her; she flicked from one to the other, making quick adjustments. "There's a loading bay to the left, see it? When I tell you, run for it."

Jack braced for her signal.

"Go!"

Jack launched himself for the loading bay, leaping easily onto the dock and flattening himself into the shelter of the doorway. There was a crackle of current from the fence, and Sombra was beside him, emerging from the shadows with a

cat's grin. She rested her hand on the panel that covered the door's electronic locks and sent a pulse of light through her fingers and into the system. With a *click*, the door beside the loading bay sagged open. Jack grabbed it, and Sombra slipped past him into the installation.

The hallway was dark—backup power was obviously on, but the fluorescent lights were all out. Sombra scanned the area, then called up a palm-sized holoscreen that floated in the air.

"I've got the cameras under control. Next steps—" The holoscreen shifted to a schematic, mapping their path. "The core installations; high-security bays, all underground. They go down fifteen levels, and what we want is on level thirteen. That's where they keep their most sensitive materials."

"I'd say half the security team's been called out to deal with Null Sector," Jack said, examining her holoscreen, "but the ones who are left are going to be on high alert. They'll pull back from the perimeter to protect the core installations and call for backup if there's the slightest sign of trouble."

"So we need a distraction," Sombra said with a grin. "Should pull some of the guards away from where you're headed."

"What about the surveillance tech?" There wasn't much Jack liked about this plan, but he wasn't really seeing any good alternatives.

"Easy. I'm putting the systems in the emergency stairs on a feedback loop; they won't see anything but the image I've

given them." Sombra's hands flashed in the shadows, conjuring windows, scrolling through menus, issuing commands, and flicking windows away again. "Once you leave the stairs, they'll spot you, but by then most of them should be busy elsewhere."

Jack still didn't like it, but he'd come too far. "All right. Just get me in."

Another set of holoscreens flashed into existence, icons flickering, before she swiped them away again. "And there you go."

"How are we staying in contact?"

"I have your comm frequency."

Of course she does. "Don't overuse it. The system here will pick up activity even on non-UN bands."

"Good to know." Sombra flicked a final window out of her way and pointed to the door that led into the body of the facility. "Emergency stairs are ten meters on your left once you enter. Alarms are off, surveillance is hacked. I'll handle the distraction and join you as soon as I can."

Jack nodded and pushed open the door before he could change his mind. No alarm sounded; he looked out into cavernous space, at least five stories tall and crisscrossed by shadows that had to be access catwalks and the rails for cargo-moving frames. The main lights were out here too—with the Null Sector attack, the whole complex would be running on

LUCKY MAN

generators—but through the emergency lighting he could tell nothing was moving on this level. It was harder to judge the higher levels, but he'd have to take that chance.

Ten meters on your left, Sombra had said. He edged that way, scanning the shadows above him for any sign of movement. Protocol dictated that the guards should have withdrawn to the control spaces and the core of the secure area, but he had no guarantee there wouldn't be someone wandering loose. Nothing moved, however, and he fetched up against the stairwell door without drawing attention. He put his hand on the lock plate, bracing himself for an alarm, but the door eased open silently. There was a dull *boom* in the distance, metal falling on metal, and he stepped hastily through, pulling the door closed behind him.

The stairwell was even darker than the main body of the facility, only a distant pinpoint of light two levels down glowing faintly red. He waved his hand, but Sombra had disabled the motion sensors as part of her hack. He swore under his breath and switched his visor to night vision, looking around the confined space until he was sure he was alone. Thirteen levels; time to get moving.

He made his way down the stairs, moving as fast as he dared without letting his footsteps echo off the metal treads. He heard another distant *thud*, and then Sombra's voice spoke in his ear. "Hey, friend, I hope you're in the stairs now."

MELISSA SCOTT

"Oscar Mike."

"And a Carlos Robert to you."

Jack sighed; he'd been working too long with Ana. "Affirmative, on the move."

"Good. I've disabled the motion detectors on the thirteenth level."

"Got it."

There was a *click*, and the frequency went dead. Jack reached the level thirteen door at last and eased it open. The emergency lights were brighter here, and he slipped through, darting across the corridor to take cover in a meager patch of shadow. He was in a corner, the featureless halls stretching left and right, and he risked triggering the comms. "Sombra. Guidance?"

"Hang on." A new schematic popped open in his visor, startling him. *What doesn't she have access to?* It showed a single corridor running around the perimeter, forming a square, and multiple corridors running from it into a central square. "You're here." A blue star appeared in the lower right corner. "Security's there." A handful of red lights appeared around the central square. Most of them were clustered by one corridor, presumably the main access point for the secure storage bays inside the central tower, but a few were separated, scattered around the edges of the square: patrols.

"How many?" Jack asked.

"Want their shoe sizes too?" Sombra answered. "I make

LUCKY MAN

it—ten. Might be a dozen if they're clustered together." There was an explosion, close enough to Sombra that Jack instinctively hunched his shoulders. "Oops, gotta go!"

The frequency went dead, but the map stayed hanging in his visor. Jack eyed it warily, hoping he was still getting good information, then switched it down to a smaller view, considering his options. Take out one of the patrols, maybe, then circle around and take the ones on the door while they were trying to figure out what was going on; that was betting on their breaking protocol to go after the attack instead of staying by the main post, but that was a mistake his soldiers had always made in Overwatch. And even if these guards didn't go for the distraction, he could still take them. He checked his gear and switched to stun rounds; no need to kill anybody if he could avoid it. He turned left, hoping Sombra had in fact disabled the motion detectors, and sprinted for the cross-corridor that would intercept the first patrol.

The motion detectors were out, but some other sensor was still working. The alarm went off as he reached the end of the cross-corridor and readied to face the patrol. There were three of them, likely on edge from the Null Sector invasion and rattled by the sudden alarm. Jack fired three quick shots, and the first two men went down, knocking the third man off his feet. Jack fired again, and the third man collapsed, unconscious. He left them lying there and darted back down the cross-corridor,

running full-out now. He reached the perimeter and turned back, hoping the guards at the door would use the inner corridor, and sprinted for the path that led to the main guard post.

"Sombra!" he barked into the comms. "Keep this alarm from spreading!"

There was no answer at first, and then her voice came in, suddenly breathless. "Some *active* boys up here! I'll do what I can!" Automatic weapons fire punctuated her words, and the frequency went dead again.

Right, Jack thought. *I need to make this fast.* He could see the guard post at the end of the corridor, a half dozen UN troopers in body armor, one of them bent over a control console, and he loosed a burst of fire at them. The leaders fell backward, and he charged. The guards closest to the door recovered, fired back, and he grunted at the impact against his shoulder. He fired again, sweeping low, visor guiding the shots, and saw the guards go down, sprawling along the corridor. He counted quickly: six, plus the three he'd taken out before. If Sombra's count was right, that left three more to go—

He heard the scrape of boots on metal, flung himself around and sideways, firing in the same moment. He missed the shot, but the concussive blast of his rocket knocked the last group of guards off balance. Jack rolled away from their answering fire, came up shooting, and brought them down as well.

He stood for a moment, listening, then expanded Sombra's

map to see the level clearly. All the guards were accounted for—the first three he'd attacked, and the rest in the guard shack, all unconscious or too injured to fight. Logic said to finish the job, that any of the survivors could identify him. And the more information they collected, the easier it would be to track him down. It wasn't like he hadn't killed before this, but the circumstances had been different; this would be a killing in cold blood, and he wasn't going to cross that line today.

The guards all carried binders of some kind, and he moved methodically among the bodies, securing each one with their own ties. It was a risk, maybe a stupid one, but he was willing to take it. The last one secured, he turned his attention to the console. It didn't seem to have been damaged, but the displays were all dark: an automatic shutdown, or maybe the guard had had time to shut it down. He poked experimentally at the buttons but got no response.

"Sombra. I need some help here."

"Busy, Jack, I'll have to get back to you." Sombra's words were almost drowned out by the sound of a firefight, at far too close range, and Jack cursed. That didn't sound like a distraction, it sounded more like they'd spotted her, and if they had . . . the only sensible thing was to bail. He could retrace his steps easily enough, be out of the facility before any of the other guards knew he'd been there. But if he did that, he'd never get another chance at this storage area. Even if Sombra had lied, even if her

intel was no good, there was bound to be something of value to his mission in the wreckage. This was the closest he'd come to getting an answer, and he wasn't about to let it go now.

One of the guards was stirring, straining against the plastic cuffs even before he was fully conscious, and Jack went to one knee beside him, hands skimming expertly over the pockets and pouches of the UN uniform. He didn't turn up anything useful, not that he'd expected to, and he heaved the man onto his side, turning his face toward the wall. "I want through that door."

"I don't have clearance." The guard winced as Jack shifted his weight, pressing him harder against the unyielding floorplates.

"Who does?"

"None of us—"

Jack growled at that, and the guard hastily added, "We're just guards. It takes two keys—if anybody wants in, they have to get extra clearance and bring the first one. The lieutenant has the companion key, but it's no good on its own."

Jack slammed his hand into the floor, cursing. The guard yelped and curled into the fetal position, but Jack ignored him. That kind of double lock was UN protocol for secure installations. He pushed himself to his feet, keying his mic.

"Sombra." There was no answer, just the empty air, and he resisted the urge to shout into his transmitter. "Sombra, come in, dammit."

LUCKY MAN

Still nothing. He tasted bitter dust and shoved memory back into its box. This was probably the sign that he should run for it, get the hell out before reinforcements arrived, but instead he looked around for the lieutenant. The man was still unconscious, sprawled awkwardly by the control console. Jack hauled him into the recovery position and went through his pockets, hoping either the other guard was wrong or someone had made a mistake and let the lieutenant get his hands on both keys. No such luck. He found the lieutenant's companion key, a black plastic rectangle covered in fine gold lines, and after a moment's study inserted it into the correct reader on the console. A couple of displays lit, flashing warnings, but the lock system remained stubbornly offline.

"Sombra, answer me." He searched the other guards quickly but found nothing. "Sombra!"

It was time to bail. There was no point in waiting any longer. Sombra's plan had obviously gone wrong, and he was going to be lucky to get out of this one alive. He glared at the door, a plug of concrete and reinforced steel, assessing its strength. The pulse rifle was no good against it, but maybe a rocket or two—

He reined himself in. The guard post was hardened, as close to blast proof as the UN could make it; if he tried to blow the door down, he'd set up a pressure wave that would kill everyone in here and wouldn't do him a whole lot of good either. More to the point, it wouldn't do enough damage, not to this setup.

MELISSA SCOTT

What he needed was some kind of super-efficient laser cutter—or for Sombra to hack the system, but she'd abandoned him. He slammed his fist against the door, hard enough to feel it in his bones. So close, so terribly close to all the answers he'd been searching for—revenge for the ones he'd lost, justification for everyone he'd been responsible for . . .

The bitter taste was back in his mouth, the deafened silence that had followed the explosion, pain everywhere, worst in his leg—but that was then, not now. There was no haze in the air, it was all illusion. He was the lucky man who'd walked away. He shook himself hard, tried the comms again.

"Sombra—Sombra, answer me!"

There was no answer, and he'd expected none. He turned his attention back to the console, scanning the controls for something, anything, he might have missed. The warning lights flashed back at him, mocking him: intruder alerts, breach warnings—time and past for him to get out of here.

Something clattered against the floorplates at the end of the corridor, and he swung around, pulse rifle ready, managed to swing the barrel aside as he recognized one of Sombra's devices. It flared, emitting a V of purple light, and Sombra materialized out of the brilliance.

"Where the hell have you been?"

"Excuse me? One of us had the hard job here. Distractions aren't easy," she answered. "But I'd never leave a friend behind."

LUCKY MAN

Jack ignored her, gestured to the door. "We've got to get this open, fast. We don't have much time before the rest of the guards get here."

"So true, so true," Sombra said. She pulled a thin slip of plastic from a pocket, ran her hand over it so that lights danced across its surface. "Oh, good, you got the first one already." She slid her card into the other open slot and drew a line from it to a window she opened in midair. Lights flashed on the console; she clicked her tongue, fingers working. Behind her, the door sighed open.

Jack hauled it back, feeling counterweights shift inside the walls. "Which bay?"

"Hang on." Sombra did something else to the console, nodding to herself as the lights changed their patterns, then hurried to join him. "Should be 4A."

Jack was already moving, sprinting down the catwalk. It ran between what looked like two enormous stacks of boxes, each heavily sealed and reinforced with its own climate control system clinging to the outside. Isolated environments, he thought, dredging up memories of the old protocols for evidence collection and storage. Each one set apart from the others, each containment unit individually fitted into the framework, so that breaching one or even two wouldn't affect the others. There was no logic to the labels, FG10 next to 052 next to C-17, but then he saw it, red letters above the sealed door. "There."

MELISSA SCOTT

"I see it." Sombra skidded to a stop beside him, pulling holo-screens out of the air. There were warning symbols next to the labels: BIOHAZARD, FLAMMABLE SUBSTANCES, CARCINOGENS, CORROSIVES. Jack gave her a look.

"What the hell is in there?"

"I told you, it's the wreckage from Overwatch HQ," she said impatiently, fingers flying.

"Yeah, but—"

"Look, if they're warning for everything . . ." She frowned at her window, and then at the door controls. "Kind of makes it seem like they don't want anybody taking a look, right?"

Jack frowned, but he thought she was right.

"Got it!" The lights on the door controls glowed green, and Sombra swung to face him. "You're up, Jack. Time to play your part."

"I already helped you get down here. What—"

He paused. For the first time, her expression was entirely serious. "This is where I need *you*. There's something in there I need, something that doesn't belong . . . and I have no way of knowing what it is."

"Then how the hell do you expect me to find it?" Jack demanded.

"Because *only* you will know it." Sombra pointed one elegant finger at him. "You were the strike commander of Overwatch. You *lived* at HQ, knew everyone, took care of those people.

LUCKY MAN

You know what was there, what *should* be there. You were there when it happened. You're the only one who can possibly recognize something that doesn't belong."

Jack stared at her for a moment. "You'd better be kidding."

"Listen, my information tells me there's something here that shouldn't be. The UN has to retain this evidence as part of its ongoing investigation into that explosion, yet it's been sealed up like this so nobody will ever take the time to sift through it properly. But you, you're the wild card, the one who's not supposed to exist. You can see what no one else can. You'll know."

That was a lot of guessing. And it was still worth the chance—it was worth any chance if he could find justice among the ruin . . . Jack hauled open the door and stepped through.

The scent of burnt concrete and scorched metal filled his lungs, choking him as the door slid closed behind him. Lights flashed on, bright as an explosion; he shook his head, ears filled with phantom ringing, drowning out anything Sombra might have said on the comms. He'd been in the middle of this before, nearly died before, buried under a slab of concrete, a piece of rebar thicker than his thumb punching through his thigh to pin him in place. He had healed long ago, but the pain of that injury haunted him, unlike the thousand lesser bruises and cuts that covered him. He remembered heaving at the concrete, certain he was trapped—dying, dead—and equally

certain he deserved exactly that for all the stupid things he'd done leading up to that point. He'd never gotten it right, not in time to save his people, and he'd been too much of a fool to avoid fighting Reyes when they should have been working together—

He could still feel Reyes's punch, feel himself block the following blow and launch a punch of his own, but before it landed the world dissolved into smoke and flame. He'd had one last glimpse of Reyes's face before he was blown backward, tumbling with the debris into unconsciousness, to find himself trapped under the rubble, bleeding and beaten and sure he was dead.

Naughton's luck had run out at last, and he deserved everything he had coming to him.

Except it hadn't, not quite. He wasn't dead, and if he wasn't dead, Reyes might still be alive and trapped—there would be others too, people who'd been farther from the explosion. He moved his arms experimentally, then with purpose, then, with more effort, freed his good leg. That gave him room to work, and he levered a slab of concrete up and off, raising more dust to mix with the thickening smoke. He could feel heat too, though he was still too deafened to hear the flames or the screams, and he extracted the rebar from his leg. He staggered to his feet, shielding his eyes, and looked into an inferno where the walls had been—

LUCKY MAN

It was a storage bay, the air hazed with drifting dust where he'd disturbed the layer that coated the metal floor. The space was full of crates and boxes of every size, jammed in on top of each other in no apparent order. A couple of garbage skips had been pushed up against the nearest pile of boxes, and chunks of concrete and twisted strands of rebar jutted out of them. A storage bay as chaotic as the explosion, and yet the explosion was years in the past, and he had a job to do.

Sombra's voice was sounding in his ear. "Hey, Jack, talk to me . . . you all right in there?"

"Fine." Jack cleared his throat, tasting bitter dust: the real thing this time, not the memory. "You're sure you don't know what I'm looking for?"

"If I knew that, I wouldn't have needed you," Sombra said. She paused. "You know I hate to rush you, but we don't have all the time in the world."

"Yeah." Jack scanned the room. There was so much here, and in no order; it looked as though whoever had cleared the disaster site had just boxed up everything and locked the door. And that was maybe a good sign, or at least a sign that Sombra was right—there was something here, something important enough to keep. He worked his shoulders, feeling muscles crack, and turned to the nearest box. "Working on it."

He ripped back the lid, dust and ash flying into his face, and began sorting through the contents. Burned particleboard that

might have been from someone's desk, a packet of half-burnt papers, the Overwatch logo still prominent . . . Bayless's coffee mug labeled #1 DAD, the one his kids had gotten him the last Father's Day before, miraculously unbroken: all ordinary, painfully familiar, nothing out of place. The next box was the same, and the next; the one after yielded a melted stapler with a scrap of burnt paper still taped to the melted plastic. He knew what it had said: *Do not remove from 4th floor!!!!* Cassidy had brought it to Saipan, had taken a picture of himself with it on the beach.

"Security is breaking off from the Null Sector attack," Sombra said, in his ear.

"It'll take time for them to get back here," Jack said, ripping open another box.

"And it'll also take *us* time to get out of here," Sombra said sharply. "Factor that in, Jack."

"Understood." Jack rifled through the box—more papers, a smashed data drive, blobs of melted plastic—and moved on again. Sombra was right, he needed to hurry, but he needed to find this whatever-it-was even more.

The next boxes were piled with papers and shards of fire-stained glass and, at the very bottom, the ruin of Keller's fancy coffee machine, the one she charged everyone else a euro to use, the coins piling up in the paper cup beside her phone. The next one looked like the contents of someone's desk, with

a melted keyboard and a smashed phone and an Overwatch-issued lanyard with a tag still attached. The ID picture was smeared and blackened, unrecognizable; he set it aside and moved on.

"We've got ten minutes left," Sombra said. "And that's cutting things really close."

Jack straightened, the dust clogging his chest like the memory of the explosion, his leg burning where the rebar had pierced it. Something that shouldn't be here—but everything he had seen so far was perfectly familiar, the wreckage of Overwatch and nothing more. He went through another couple of boxes—more melted data drives and scorched keyboards, finished off with a handful of brass cartridge cases, flattened and fire-stained.

"Five minutes," Sombra said.

"Okay."

"I mean it. They're moving quick."

"I hear you," Jack said. It was all he could promise, and he kept moving, climbing over a section of concrete that had to have been a piece of floor. The next skip was more shattered office machinery, smoke-blackened; the box beside it was papers and a stained chunk of metal that, when he pulled it out, proved to be a desktop clock that had once been topped with a palm tree. The head of finances had had one just like it, a prize for coming in second in a golf tournament. Beneath

it was a layer of paper and shards of wood, and beneath that, something metallic that ate the light.

He pulled it out, frowning: a flat disk, the size and shape of a mine, but definitely *not* a mine. Most of the casing was matte black, and it felt almost rubbery, and heavy for its size; it was the silvered edge that had caught the light. There were no identifying marks, no obvious seams, nothing to give him a clue as to its purpose. It wasn't Overwatch, and it wasn't UN—he'd never seen anything like it. This had to be what Sombra had meant.

Jack turned toward the door, keying his comm. "Got it."

"About time." The door slid open, Sombra's hands weaving patterns in the air. "We've got three minutes."

"Then we'd better hurry."

They made it back up the stairs and out of the building with seconds to spare. Sombra led the way, down an alley and up onto the nearest rooftop. She stopped there, pulling up another holoscreen, frowning at its images as she entered commands. Over her shoulder, Jack could just see captured security footage, his running figure only too recognizable, and he grimaced. But the clip dissolved into static, and the screen flashed green before Sombra waved it away. "You erased that."

"Of course I did," she answered, and jumped for the next rooftop.

There was no "of course" about it, but Jack wasn't going to complain. He followed, leaping from building to building until

LUCKY MAN

at last Sombra slowed. The sky was lightening—sunrise, not fires—and Jack looked back the way they'd come. There were drones circling the storage facility, but they were still far enough away that they shouldn't draw notice. Sombra saw where he was looking and flipped her hair.

"Don't worry, I left a little present in their system. They'll ignore us."

"Let's hope no one spots it," Jack growled, but it was more reflex than real concern. He knew how good Sombra was. The air was stirring with the dawn, the stench of burning fuel and broken concrete and cordite fading. To the east, the towers of smoke that had marked the main Null Sector attack on the city had thinned, were faded from oily black to gray as the firefighters asserted control. They'd been lucky: Null Sector was refocusing its efforts on some shinier target, and Zurich had—mostly—survived. This time.

Sombra cleared her throat. "Now. I think you have something for me?"

"Yeah." Jack reached into his jacket and held out the silver-edged disk. The black coating seemed to absorb the rising light, making it look more sinister than before.

Sombra's gaze sharpened, but she made no move to reach for it. "You're sure?"

"You told me to look for something that didn't belong," Jack said. "This isn't anything Overwatch made, and it's not anything

out of the UN arsenal either. So unless *you* know what it is . . . here we are. And it's time for you to pay up."

"I don't recognize it," Sombra said. "Can I scan it?"

Jack shook his head. "Payment first."

"Fair enough." Sombra paused. "Tell me, who do you think brought down Overwatch?"

Jack hesitated. "At the time, everyone said it was Talon, with Reyes's help, maybe O'Deorain's. That's still the obvious answer, but it never felt right. And the information you gave me doesn't point that way. So, not Talon. Someone else."

"And you believed that," Sombra said. "Even before I started sharing what I found."

Jack paused again, the memory sweeping through him, the taste of blood on his lips and Reyes's unbridled anger. And then the explosion, the instant of wide-eyed shock on Reyes's face before everything was swept away. "I was with Reyes when everything exploded. I saw him. He was as surprised as I was." He shook his head. "If it had been Talon, he would have known."

Sombra nodded. "Let me scan the casing."

Jack held out the disk. Sombra moved forward to scan it, the light from her hand seeming to vanish into its surface. She pulled up a holoscreen, data churning on its surface for a moment before disappearing . . . and a strange mark slowly appeared: a stylized eye with three dots above the pupil and another three dots below it.

LUCKY MAN

"I've seen that before," Sombra said. "The threads that should lead to Talon, but go beyond, hints and whispers of something, someone even more powerful than they are. That's why I started sending you the information too. I knew you had pieces of the puzzle I didn't, and I knew you wouldn't work with me unless I offered something in return. And this—" She nodded to the disk. "That mark, that's the proof. That's their symbol. Find that, track that down, and you'll have them. I'd start in Oasis. And once I crack this beauty—you'll hear from me." The screen closed, and Sombra held out her hand. "Fair payment?"

Jack looked at the disk, and then at Sombra's hand. This was the break he'd been looking for, something solid—something real to track, instead of the hints and whispers and theories. It wasn't much, but he was the man who could leverage it, could turn a single mark into something more. He was the only one left who could do it, and he'd do it for the ones who hadn't made it, all the deaths that weighed him down. He held it out, nodding. "Yeah."

"Thanks, then." Sombra sounded almost surprised, as though she'd expected more of a protest. Her other hand moved, tossing something over the edge of the roof, and an instant later she vanished.

Jack shook his head. It didn't matter. She'd given him what he needed, something real to chase. He might be old and beat up, but he'd find a way. After all, he'd always been a lucky man.

ABOUT THE AUTHORS

CORINNE DUYVIS is the award-winning, critically acclaimed author of the YA sci-fi/fantasy novels *Otherbound*, which Kirkus called "a stunning debut"; *On the Edge of Gone*, which *Publishers Weekly* called "a riveting apocalyptic thriller with substantial depth"; and *The Art of Saving the World*, which Kirkus called "impossible to put down." She is also the author of the upcoming YA sci-fi novel *#VIRAL* and the original Marvel prose novel *Guardians of the Galaxy: Collect Them All*. Corinne hails from the Netherlands. She's passionate about representation in literature, especially disabled characters, and is the originator of the #ownvoices hashtag.

LYNDSAY ELY is the author of *Gunslinger Girl*, a YA genre-bent dystopian Western, and *Overwatch: Deadlock Rebels*. She spent her teenage years wanting to be a comic book artist, but as it turned out, she couldn't draw very well, so she began writing novels instead. She is a geek, a foodie, an avid convention-goer, and has never met an antique shop or flea market she didn't like. Boston is the place she currently calls home, though she wouldn't mind giving Paris a try someday.

JUSTIN GROOT is a senior narrative designer at Blizzard Entertainment. He specializes in reactive voice line systems, Junkrat, and rock climbing. As an author, his proudest accomplishment is the Forest trilogy, set on an alternate-universe Earth with forests instead of oceans. He needs a literary agent—please, God, does anybody have an extra literary agent they can spare? Currently, Justin lives in Los Angeles with his lovely fiancée and two ridiculous cats.

GAVIN JURGENS-FYHRIE is a lead narrative designer at Blizzard Entertainment. He has written short stories for *Overwatch*, *StarCraft*, *Warcraft*, and *Diablo*, and contributed wondrous things—and terrible things—to *Diablo III*. His other projects include *Horizon: Zero Dawn*, *Torment: Tides of Numenera*, *Wasteland III*, *Baldur's Gate 3*, and more. Currently, he is leading the Overwatch narrative design team and will continue to do so until someone defeats him in ritual combat.

SANGU MANDANNA is the author of the Kiki Kallira series; *A Spark of White Fire* and its sequels; and the bestselling, critically acclaimed *The Very Secret Society of Irregular Witches*. She is a contributor to several anthologies and cowrote Season 2 of *The Vela* for Realm. Sangu lives in Norwich, a city in the east of England, with her husband and kids.

MOHALE MASHIGO is a bestselling multi-award-winning writer. Her work includes *The Yearning* (University of Johannesburg Debut Prize for South African Writing in English 2016) and a collection of speculative fiction short stories, *Intruders*. Mashigo also writes children's books and comic books. Some of her comic book work includes *Kwezi* and various projects with both DC and Marvel Comics.

MIRANDA MOYER is a narrative designer on the Overwatch team. When she is not writing the Overwatch heroes, she is usually playing them, considered to be "one of the Ana players of all time." She helped many gamers find love with Genji Shimada in the *Loverwatch* experience. Miranda enjoys drawing, long walks, and Dunkies.

E. C. MYERS won the Andre Norton Nebula Award for his first novel, *Fair Coin*, and is the author of the S0S Thriller series and RWBY young adult books: *After the Fall*, *Before the Dawn*, *Fairy Tales of Remnant*, and *Roman Holiday*. His short fiction has been published in various anthologies, including *Tasting Light*, *Mother of Invention*, and *A Thousand Beginnings and Endings*. He has also cowritten several podcast serials, including *Orphan Black: The Next Chapter*, *CTRL+ALT+Destroy*, and *ReMade*.

TOBI OGUNDIRAN is the Shirley Jackson, British Science Fiction Association, Nommo, and Ignyte award–nominated author of *Jackal, Jackal: Tales of the Dark and Fantastic* (Undertow Publications 2023). He's called many places home, including Lagos, Russia, and now Oxford, Mississippi. Find him at tobiogundiran.com and @tobi_thedreamer on Twitter.

Prior to joining Blizzard Entertainment, **ANDREW ROBINSON** had been a development executive and talent manager before becoming a television animation writer and creator, working for companies like Marvel, WB, Hasbro, Cartoon Network, Sony, and others on IP like Transformers, Spider-Man, Avengers, Young Justice, G.I. Joe, and many more. Andrew joined Story & Franchise Development at Blizzard Entertainment in 2014, excited to tell stories that enhance and enrich various games. He loves story development and world-building, and has written animated shorts, songs, comics, and short stories for *World of Warcraft*, *Overwatch*, *Diablo*, *StarCraft*, *Hearthstone*, *Heroes of the Storm*, and a few incubation projects as well. He looks forward to all the amazing storytelling Blizzard has in store for fans.

MELISSA SCOTT was born and raised in Little Rock, Arkansas, and studied history at Harvard College. She earned her PhD from Brandeis University in the comparative history program with a dissertation titled "The Victory of the Ancients: Tactics, Technology, and the Use of Classical Precedent, 1536–1789." She also sold her first novel, *The Game Beyond*, and quickly became a part-time graduate student and an—almost—full-time writer. Over the next forty years, she published more than thirty original novels and a handful of short stories, most with queer themes and characters, as well as authorized tie-in work. She has won four Lambda Literary Awards, four Spectrum Awards, the Campbell Award for Best New Writer (1986), and has been short-listed for the Otherwise (Tiptree) Award.

WRITTEN BY:
"Rebuilding Ruins" by **CORINNE DUYVIS AND SANGU MANDANNA** / "Unity" by
TOBI OGUNDIRAN / "Luck of the Draw" by **LYNDSAY ELY** / "A Friendly Rivalry" by
JUSTIN GROOT, GAVIN JURGENS-FYHRIE, AND MIRANDA MOYER / "Thoughtless Gods"
by **ANDREW ROBINSON** / "Where Honor Lives" by **E. C. MYERS** / "Lost Ghosts"
by **MOHALE MASHIGO** / "Lucky Man" by **MELISSA SCOTT**

ILLUSTRATED BY:
"Rebuilding Ruins" by **SARAH LULL** / "Unity" by **THOMAS ISTEPANYAN** /
"Luck of the Draw" by **HANNAH TEMPLER** / "A Friendly Rivalry" by
HANNAH TEMPLER / "Thoughtless Gods" by **THOMAS ISTEPANYAN** /
"Where Honor Lives" by **BORG SINABAN** / "Lost Ghosts" by
BORG SINABAN / "Lucky Man" by **BORG SINABAN**

COVER ART ILLUSTRATED BY:
KEVIN HONG

EDITED BY:
CHLOE FRABONI

DESIGN BY:
JESSICA RODRIGUEZ

PRODUCED BY:
BRIANNE MESSINA, AMBER THIBODEAU

LORE CONSULTATION BY:
MADI BUCKINGHAM, IAN LANDA-BEAVERS

GAME TEAM CONSULTATION BY:
**JEFF CHAMBERLAIN, GAVIN JURGENS-FYHRIE, PETER C. LEE,
MIRANDA MOYER, JEN STACEY, DION ROGERS, JOSHI ZHANG**

SPECIAL THANKS TO:
IAN LANDA-BEAVERS, MADDIY COOK

BLIZZARD ENTERTAINMENT

Associate Manager, Consumer Products: **PETER MOLINARI**
Director, Manufacturing: **ANNA WAN**
Direct Manufacturing Project Manager: **CHANEE' GOUDE**
Senior Director, Story & Franchise Development: **VENECIA DURAN**
Senior Producer, Books: **BRIANNE MESSINA**
Associate Producer, Books: **AMBER THIBODEAU**
Senior Manager, Editorial: **CHLOE FRABONI**
Senior Editor: **ERIC GERON**
Book Art & Design Manager: **COREY PETERSCHMIDT**
Senior Manager, Lore: **SEAN COPELAND**
Senior Producer, Lore: **JAMIE ORTIZ**
Associate Producer, Lore: **ED FOX**
Associate Historians: **MADI BUCKINGHAM, COURTNEY CHAVEZ,
DAMIEN JAHRSDOERFER, IAN LANDA-BEAVERS**